RAFFLES' ARK REDRAWN

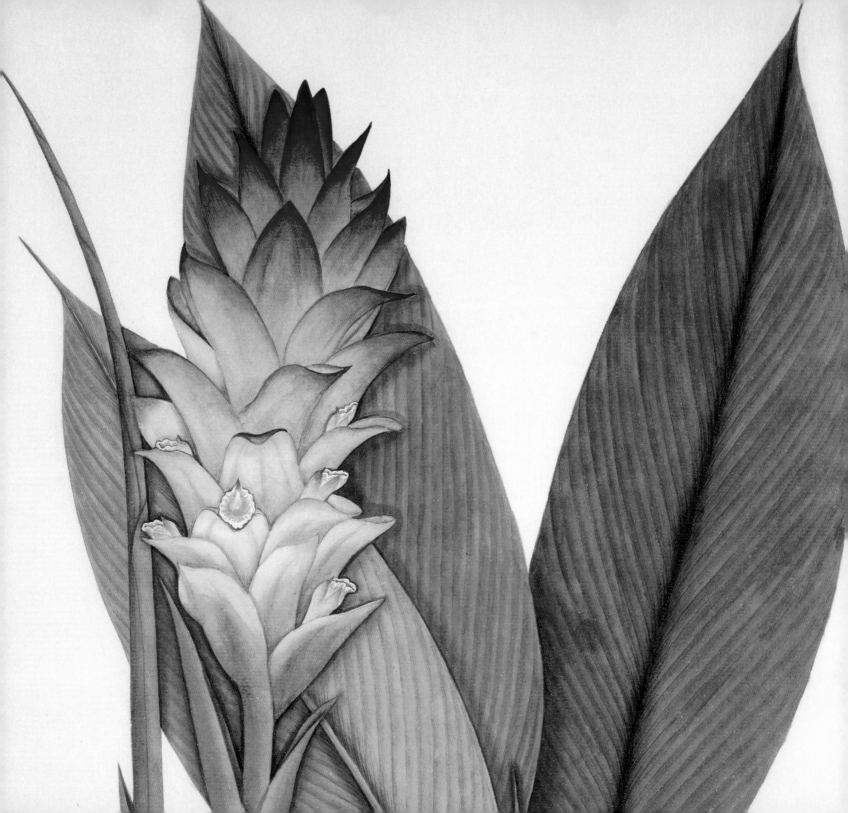

RAFFLES' ARK REDRAWN

Natural History Drawings from the Collection
of Sir Thomas Stamford Raffles

H. J. NOLTIE

The British Library and the Royal Botanic Garden Edinburgh
in association with Bernard Quaritch Ltd · 2009

Dedicated to Dr John Bastin and the late
Mildred Archer who almost wrote this catalogue
in the 1970s and were much better qualified
to have done so.

First published 2009 by The British Library,
96 Euston Road, London NW1 2DB and the
Royal Botanic Garden Edinburgh, Inverleith Row,
Edinburgh EH3 5LR; in association with
Bernard Quaritch Ltd, 8 Lower John Street,
Golden Square, London W1F 9AU.

ISBN 978 0 7123 5084 6 [BL]
ISBN 978 1 906129 22 4 [RBGE]

Designed and typeset in Custodia by Dalrymple
Printed in Belgium by Die Keure

ABBREVIATIONS
EIC East India Company
RBGE Royal Botanic Garden Edinburgh
NHM Natural History Museum, London
NMS National Museums of Scotland
BL BRITISH LIBRARY (shelfmarks cited as,
e.g., NHD 48.8, Add. Or. 4628)

NOTE
Spellings of place names as used by Raffles
and his contemporaries are, for historical reasons,
employed throughout this catalogue: thus Bencoolen,
not the modern Bengkulu; Malacca not Melaka;
Penang not Pinang.

Foreword

The acquisition in 2007 of the Raffles Family Collection was a major achievement for the British Library. It secured for the nation a large and valuable archive of private papers and natural history drawings connected with the single most iconic figure in British relations with Southeast Asia, Sir Thomas Stamford Raffles. This was all the more pleasing to report when a similar collection of drawings, that formed by William Farquhar and long held by the Royal Asiatic Society, had left the UK in 1995 to become part of the National Museum of Singapore. The British Library would once again like to express its grateful thanks to the Heritage Lottery Fund for its most generous support, and also to the other donors who helped to make the acquisition possible, including The Art Fund, Friends of the British Library, Friends of the National Libraries, and John Koh of Singapore.

The Raffles Family Collection had been on permanent loan in the India Office Library and subsequently the British Library since 1969/70, but it is only now with the publication of this magnificent catalogue that the natural history drawings in that collection have at last been fully documented. This is due to the remarkably thorough and meticulous research of Henry Noltie, his powers of deduction and interpretation, and not least the lively and elegant style of his writing. His work is a wonderful tribute to the earlier efforts of Mildred Archer and John Bastin. The drawings have now been individually described in detail, and the whole collection set in the scientific, political and social context of the period of its formation. The connections to other collections and collectors have been laid bare, and the identities of the various artists involved in what Henry Noltie himself has termed the 'Straits School' of botanical art have been uncovered. We are extremely grateful to the Royal Botanic Garden Edinburgh for allowing the necessary time for such detailed research to be undertaken.

The terms of the Heritage Lottery Fund grant required the British Library to arrange for selections from the Raffles material to be exhibited outside London, and this it has done as part of its Regional Programme. The first exhibition *Spice of Life: Raffles and the Malay World* was held at the Central Library, Liverpool in 2007 in recognition of the city's long-established Malay community. We would like to thank Joyce Little, John Keane, John Edmondson, and Wan Mohamed Rosidi Wan Hussain of the Merseyside Malaysian & Singapore Community Association, for their enthusiastic response to the original proposal and for all their help in organising the exhibition and the series of public talks, school visits and community workshops that were held alongside it. We are delighted also that the present exhibition *Raffles' Ark Redrawn: Natural History Drawings from the Collection of Sir Thomas Stamford Raffles* will be shown at the Royal Botanic Garden Edinburgh in 2009, and are grateful for the assistance received from Professor Stephen Blackmore the Regius Keeper, Paul Nesbitt and Hamish Adamson. It is also a pleasure to acknowledge the support of Bernard Quaritch Ltd in the publication of this catalogue. Finally I must thank my British Library colleagues: Annabel Teh Gallop for her sterling work in securing the collection's acquisition and in organising, with Stephanie Kenna, the Regional Programme; Michele Burton for helping to compile the original application to the Heritage Lottery Fund; Robert Davies, John Falconer, Jody Butterworth, Helen George and Lydia Seager for preparing the drawings for exhibition; and, as ever, to David Way and staff in British Library Publications.

GRAHAM SHAW
Head, Asia, Pacific and Africa Collections
The British Library

Acknowledgements

Dr John Bastin, the great authority on Thomas Stamford Raffles, without whom this work could not have been accomplished. He has given unstintingly of his vast knowledge by letter, telephone and email, and generously supplied copies of many of his own lavishly footnoted publications and Mildred Archer's unpublished notes on the collection.

Dr Annabel Teh Gallop, who first suggested the exhibition and has been hugely supportive throughout; also for her transliterations of the Jawi annotations on the drawings. Her colleagues at the British Library have been equally helpful and enthusiastic, especially Graham Shaw, John Falconer, David Way, Helen George, Jody Butterworth, Frances Wood and Imaging Services who photographed the drawings.

Dr Andrew Kitchener, National Museums of Scotland, who has most generously helped with the zoological parts of this catalogue. He has prevented many blunders, but any that remain are the author's responsibility, for which a botanist craves the reader's indulgence.

Professor Stephen Blackmore of the Royal Botanic Garden Edinburgh for allowing the author to undertake the sort of interdisciplinary research necessary to understand collections such as the Raffles one. Also to colleagues in the herbarium and library for help in numerous ways. In the Publications Department: Hamish Adamson for overseeing the project, Caroline Muir for help with the map and improving some bad photographs, Lynsey Wilson for other photography, and Paul Nesbitt and Amy Dennis for supervising the exhibition.

Staff of the Royal Botanic Gardens Kew, especially Professor David Mabberley (who first spotted the link with William Hunter), the library and illustrations team (Marilyn Ward, Julia Buckley), archives (Michele Losse, Kiri Ross-Jones) and Paul Little for photographing the durian feast.

At the Natural History Museum, London: Dr Robert Prys-Jones, Paula Jenkins, Daphne Hills and Kathie Way for information about Raffles mammals, birds and mollusca in their collections; and librarians in the Botany (Malcolm Beasley, Armando Mendez) and General Libraries (James Hatton).

The library of the Scottish Ornithologist's Club, where the captions for the bird drawings were researched, in a wonderful setting overlooking Aberlady Links.

The Earl of Cranbrook for unpublished information on the fate of Raffles' zoological specimens. Ron and Susan McBeath for reminiscences of the Drakes at Inshriach, and permission to reproduce Mrs Drake's watercolour of Inshriach Forest. Mrs Lucy Micklethwait for a tour, and permission to reproduce a photograph, of Inshriach House.

For help with botanical identifications: Dr Gemma Bramley, Dr Matthew Jebb, Dr Gudrun Clausing, Dr Ruth Kiew, Professor David Mabberley, Dr David Middleton, Dr Mark Newman, Dr Axel Poulsen, Dr Jana Skornickova, Professor E. Soepadmo. And for the zoological drawings: Dr Andrew Kitchener, Dr Anita Malhotra (who provided the note on the pitviper), Dr Geoff Swinney.

James Simpson for photographing the Jack monument in Calcutta. Jan Wisseman Christie for permission to reproduce her translation of the curse on the Minto Stone. Mrs Bridget Atkins for permission to reproduce the portrait of William Farquhar. Yu-Chee Chong of Yu-Chee Chong Fine Art, London, for helpful information and a copy of the catalogue relating to the Hunter collection. Kathy Lazenbatt of the Royal Asiatic Society for information on their copy of the *Rafflesia* engraving.

Robert Dalrymple and Nye Hughes for their customary flair and efficiency in designing and producing the book.

To any others whose names have been omitted through inadvertence.

Lastly, but crucially, to John Koh of Bernard Quaritch Ltd, without whose enthusiastic support this publication would not have been possible.

H.J.N.

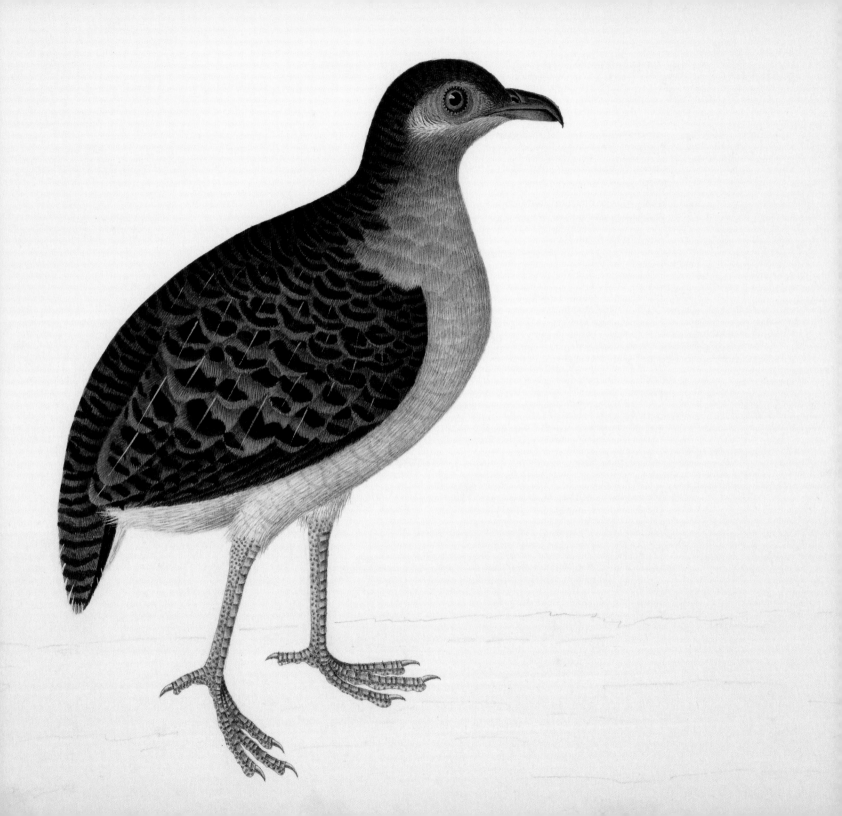

I Introduction

In January 2007, with generous support from the Heritage Lottery Fund, the Art Fund, and other benefactors, the British Library was enabled to purchase the Raffles Family Collection, of which the natural history drawings catalogued in this volume make up an important, but previously almost unstudied, part. One of the conditions of the Heritage Lottery grant was that the material should be exhibited in venues outside London, the first such exhibition taking place in Liverpool in autumn 2007.

The Royal Botanic Garden Edinburgh (RBGE) has had long connections with Indonesian and Malaysian botany, undertaking floristic and ecological work in the region, not least because some of the plant genera and families (notably gingers, gesners and 'vireya' rhododendrons), in which it has particular interests and expertise, achieve spectacular diversity in the region. Even a cursory look at images of some of the drawings showed that they would make a wonderful exhibition for the Garden's art gallery in Inverleith House – and from such considerations this catalogue arose. The title alludes to the fact that at least a majority of the drawings were made in the remarkable space of ten weeks, after the tragic burning of the ship *Fame* off the coast of Sumatra in 1824 (Fig. 1). In this were stowed the priceless collections of Raffles and his naturalists Arnold and Jack, including more than 2000 natural history drawings: the presence of animals including 'a living tapir, a new species of tiger, splendid pheasants ... domesticated for the voyage', led Raffles to refer to the *Fame* as a 'perfect Noah's ark'.

The collection represents a remarkable snapshot of the colourful flora and fauna of Sumatra, some of it unknown to Western science when these drawings were made, but to which Raffles responded both emotionally and in a spirit of enquiry. In these drawings major components of a tropical ecosystem are represented: the plants that sustain the whole, both as primary fixers of the sun's energy, and as providers of 'products' for man and other animals – from luscious fruits, to scents (augmenters of pheromones) and spices (to enliven dull foods). The tapir that feasts on durian, the sunbird that pollinates the *jambu kelampok* and pigeons that eat (and disperse) its fruit – behind each is a tale of fecundity and diversity – some well known, others awaiting discovery. The drawings also represent a healthily international effort in the recording of this diversity, with Raffles' patronage of French, Scottish and English scientists – and French and Chinese artists.

The author has recently been involved in a series of projects concerning botanical drawings made for Scottish East India Company (EIC) surgeons by Indian artists. The Raffles project seemed something of an extension of this work – both geographically 'to the eastward', and also, as the drawings include depictions of birds and mammals (not to mention a snake), biologically. The latter, especially, gave room for qualms concerning the author's lack of faunistic knowledge, and the former, given Raffles' origins, the idea that there would be few areas of overlap with the Indian work, and even less with Scotland and surgeons with 'Enlightenment' backgrounds. To be honest, I thought it would be a relatively quick and easy matter to make a selection of drawings, write a few captions, and come up with some introductory text to set the context, then get back to my Indian work. However, the deeper the delving, the more complex and interesting it all became, and a whole series of unlooked-for links entirely demolished preconceived boundaries.

This started as soon as one looked at the collection as a whole, with the privilege of being able to strew the drawings across the *sanctum sanctorum* of the Prints and Drawings Room of the Asia, Pacific and Africa Collections of the British Library. It was strikingly apparent that the collection was more than slightly heterogeneous: within the botanical material alone were three major, and some minor, groups (on a variety of papers and differing in style), then there were

the birds and mammals, and finally a small number of real oddments – including something that resembled a sea urchin (that eventually proved to be the anal gland of a civet), an unfinished painting of a hornbill, and a charcoal sketch of the head and hands of an orang utan. One is used to anonymity in the case of such collections, so it was a surprise to find an artist's name on the bird drawings, and a French one at that ('J. Briois'); the others were all considered to be the work of a Chinese artist or artists. Although the drawings had been on 'permanent' loan to the Library for 40 years, at least recently they seem to have been regarded as almost *sui generis*. No documentation relating to them was available, so it appeared that no serious work on them had ever been undertaken. This was later found to be untrue and Dr John

Bastin, with great generosity, provided copies of the excellent preliminary notes on the collection made by the late Mildred Archer in the early 1970s. At this time Bastin and Archer were working on the architectural and ethnographical drawings of this same part of the Raffles collection. Mrs Archer had not failed to distinguish the major groupings of the natural history drawings, but other interests must have claimed her attention, and she took the matter no further. The continuation and development of this pioneering work is therefore long overdue.

The fears on embarking upon this project were not only over the identification of the birds and mammals, but a total ignorance of Southeast Asian geography and history, to say nothing of Raffles' biography. A steep learning curve was

Fig. 1 · Burning of the *Fame*, engraving by T.H. Brown, from the *Stationer's Almanack* for 1825.
BL P 411

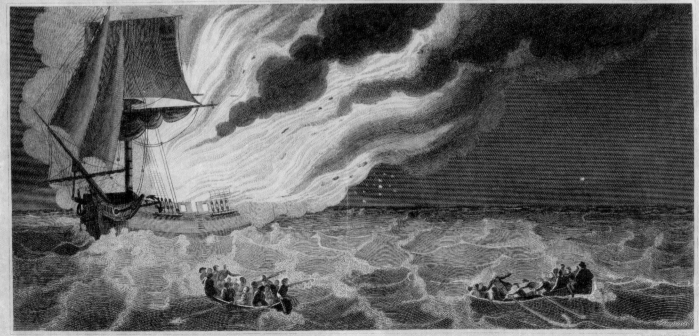

STATIONER'S ALMANACK FOR 1825.

LOSS OF THE FAME, EAST INDIAMAN.

This Vessel in which Sir Stamford Raffles & Family were coming to England, with a vast Collection of Natural Curiosities, was destroyed by Fire on the 1st February 1824.

called for. Despite worries about a lack of routes into such information from a Scottish perspective, some relevant collections and stories proved to be there – awaiting only investigation and interpretation. Although seemingly small, and perhaps oblique, these have proved to be a useful framework for the present investigation. It therefore seems worth outlining some of the steps on this journey, as a way into understanding the collection, and the personality and motivation of its creator. The reader will have to forgive a somewhat personal approach, and accept that this been adopted for practical, rather than nationalistic, reasons.

RELATED COLLECTIONS IN EDINBURGH

Preliminary investigations started with relevant RBGE collections – among the dried botanical specimens of the herbarium, and in the illustrations collection of the library. As already noted, the Garden has close links with Southeast Asia, and the herbarium is rich in recent herbarium specimens, especially from Borneo (Sarawak, Sabah, Brunei, Kalimantan), New Guinea (Papua New Guinea, West Papua), Sulawesi, the Philippines, and even some from Sumatra itself. There are also some older specimens from Java, collected in the 1840s by Thomas Lobb for the English nursery firm of Veitch. From the late nineteenth and early twentieth century are specimens from Peninsular Malaysia, sent as duplicates from the Singapore Botanic Garden, and with these is a more direct link, as this Garden's predecessor was founded by Raffles, with advice from his friend Nathaniel Wallich, superintendent of the Calcutta Botanic Garden. Wallich, for the sake of his health, visited Singapore during Raffles' third and last visit to the burgeoning settlement in 1822, and collected many specimens there (Fig.23). These, along with specimens made by collectors such as George Porter in Penang, and George Finlayson in Malaya and Siam, were amalgamated into the vast EIC herbarium that Wallich brought from Calcutta to London in 1828. This he curated and distributed – the top set has ended up at Kew, but duplicates were sent to several Scottish botanists and these, over the years, have been incorporated into the RBGE herbarium. However, of greatest relevance to the present subject is the small herbarium of William Jack (only about 60 specimens), the story of which will be told more fully later. Here it is enough to point out that this collection was made while Jack was working for Raffles in Sumatra. A former assistant Regius Keeper, J.M. Cowan, did some work on the Jack herbarium in the 1950s and related the fact that the collection was sent to Edinburgh in 1820 as something of a joke, to 'humbug a Marchioness'. Cowan was unaware that the titled lady was the Governor-General of India's wife, Lady Hastings, but he did realise the importance – strictly by default – of the collection, as Jack's serious herbarium would go up in flames on the *Fame* in 1824, along with his related notes.

The collection of historical botanical drawings at RBGE consists largely of Indian plants drawn by Indian artists. There is, however, a scattering of drawings from Southeast Asia, nearly all of which came from Kew in the 1890s. This was an indirect result of the final tragic dispersal of the India Museum in 1879, when botanical material was sent to Kew, but most of the zoological drawings were retained by the India Office and have now passed to the British Library. At Kew drawings are stored by family and genus, in taxonomic order (in the same sequence as the herbarium specimens), so individual collections were split up, though, fortunately, the source was noted (cryptically) in pencil on each drawing: 'Court', 'Horsfield', 'Finlayson', 'Marsden', 'Crawfurd & Prince', 'Chinese Plants'. If a drawing was considered to be a duplicate, it was sent to Edinburgh, so in this way a small number of Southeast Asian drawings were available – enough to form some sort of insight into the style of the painters, and a means of 'getting to know' their commissioners.

Another group of drawings of relevance to the present enquiry was presented to Kew in 1894, by the daughter of the maker of the collection, Janet Hutton (*née* Robertson, a 'cadet of the Struan family'). Mrs Hutton lived in Penang with her husband Thomas, a Company official who was Malay translator to the Prince of Wales Island Government at the time Raffles arrived there in 1805, and they must certainly have known each other. At this point a curious

coincidence threw interesting light on the whole question of what might be called the 'Straits School' of botanical art. Two drawings of the very same breadfruit specimen, clearly by the same hand, made only a few days apart (as shown by the slight expansion of the terminal leaf bud) were contemporaneously exhibited in two London galleries – one in the sale of Niall Hobhouse's collection at Christies, the other in the inaugural exhibition of the new botanical art gallery at Kew. The former was correctly attributed to a 'Chinese artist', the latter to 'Janet Hutton'. This shows the difficulty of such attributions – though Mrs Hutton's drawing was almost certainly purchased, rather than painted, by herself.

Such stylised drawings of exotic fruit were popular among Company servants, produced in large numbers, and over a long period. It is therefore not surprising that drawings of this genre make up one of the groups within the Raffles collection. Some were also among the duplicates sent by Kew to Edinburgh, for example a drawing of a rambutan from the Hutton collection (Fig.2), and a drawing of cocoa (Fig.3) from the collection of Charles Court (at one time stationed at Mindanao, Sulawesi), both with the tell-tale blue wash around the floral details – revealing the hand of a Chinese artist. Both of these showed affinities with drawings in other collections, notably that of William Farquhar to be discussed

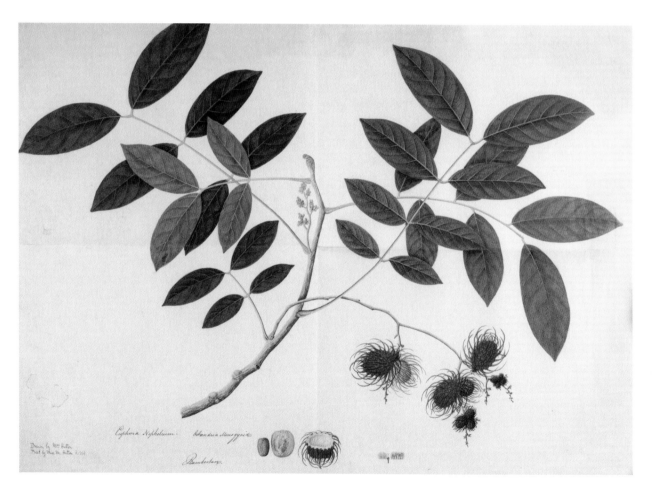

Fig.2 · Rambutan, *Nephelium lappaceum*, drawing in the 'Straits School' style by a Chinese artist for Janet Hutton, Penang, *c.*1805.
Royal Botanic Garden Edinburgh

below. The scale of the enterprise required to meet the demand for such paintings was met by extensive copying (but with variation in terms of details and layout). This was most dramatically revealed on a visit to Kew, where I was kindly allowed to spread collections from their taxonomically delimited portfolios. The most spectacular was that of the family Malvaceae containing drawings of the durian, with no fewer than seven variations on a basic theme (Fig.4). Of those with annotations are examples from the Marsden collection (Sumatra, 1770s), a group probably sent to the EIC by William Kerr from China in 1806, and the Hutton collection (Penang, c.1805). Two similar examples are in

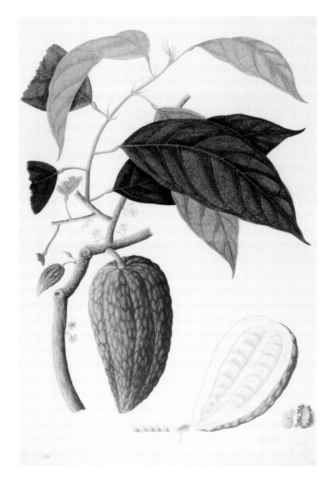

Fig.3 · Cocoa, *Theobroma cacao*, drawing in the 'Straits School' style by a Chinese artist for Charles Court, possibly made at Mindanao, Sulawesi.
Royal Botanic Garden Edinburgh

the Raffles collection, one in the Reeves collection at the Natural History Museum, and yet others in the Wellesley and Hastings collections at the British Library. It seems that such drawings are the work of Chinese artists, but that in Penang, Malacca, and later Singapore, they evolved a much quicker way of working to produce the number of drawings required – the panache of the layout is self-evident, but the quality of the painting crude in comparison with the work of more traditional artists working in Macau and Canton. One of the durian drawings at Kew is annotated 'H. Low, Borneo'. Hugh Low first went to the east in 1844, so this is the earliest possible date for this drawing and related ones of cocoa, rambutan, coffee, breadfruit, jak, custard apple, nutmeg and black pepper, all similar to the early nineteenth-century examples. These are slightly smaller in scale and rougher of execution than the earlier ones, but clearly based on the same models, demonstrating the longevity of the tradition.

One result of the fission of zoological from botanical drawings of the India Museum is that the former, now in the British Library, were documented by Mildred Archer in her pioneering *Natural History Drawings in the India Office Library*. This should, however, have been entitled 'Zoological Drawings in the India Office Library'. No attempt has yet been made to document the botanical drawings at Kew or relate them to their siblings at St Pancras, and none to relate either to allied collections at the NHM. The present project has powerfully demonstrated the need for such an approach. Mrs Archer found evidence of the employment of a Chinese artist called 'A Kow' in Singapore, who had previously worked for Raffles in Bencoolen and a civil servant called John Prince, and tentatively suggested that Kow might be responsible for some in the present collection. One of the most striking of the drawings in the Raffles collection is of a *Strophanthus* (p.111), and the discovery at Kew of a more complex version, but undoubtedly in the same hand (Fig.5), annotated 'Recd. from J. Prince Singapore, 1827' puts it almost beyond doubt that A Kow is the artist of the best of the Raffles botanical drawings – the 'post-*Fame*' set.

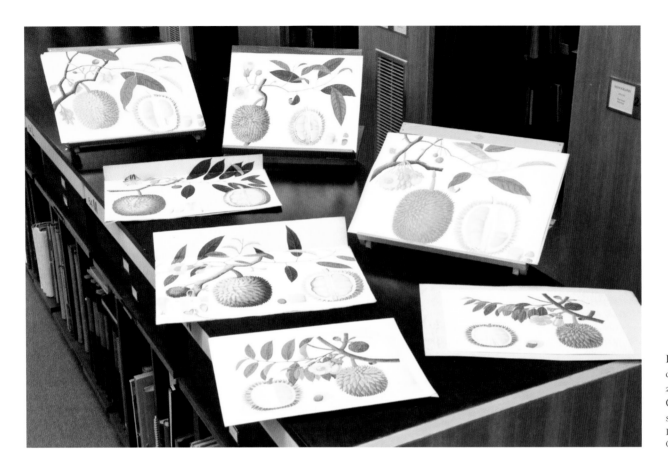

Fig.4 · A feast of durians: drawings of *Durio zibethinus*, by a variety of Chinese artists, made in SE Asia, *c*.1770 to *c*.1850. Paul Little, Royal Botanic Gardens Kew

SCIENTIFIC

In the matter of scientific studies Raffles considered himself, at least in the first half of his eastern career, as patron and facilitator, inspired by a passion for gardens and plants, and, in the case of animals, a love that was decidedly anthropomorphic. It was in the 'professional' scientists he chose to employ or collaborate with – all surgeons, and whom he came to count among his closest friends – that the links with Scottish and north European enlightenment traditions lie. The first of these was Thomas Horsfield, an American with a Moravian education, who made pioneering botanical, zoological and geological studies in Java over a period of 18 years, supported initially by the Dutch East India Company, but enthusiastically continued by Raffles as

Lieutenant-Governor of Java (1811–16), during the British occupation of the island. Relatively little in the present collection appears to relate to the Javanese period, so Horsfield (and the botanical drawings of his Dutch artists, large numbers of which are at Kew and a few at RBGE) cannot be discussed here in the detail that his merits deserve. It is with Raffles' next two naturalists that the strongest Scottish link is to be made – Joseph Arnold, and William Jack, both of whose names sadly belong to the litany of botanical martyrs. Although Arnold came from Beccles in Lancashire, he studied medicine at Edinburgh University, graduating MD in 1807, and must have studied botany under Professor Daniel Rutherford at the RBGE then in Leith Walk. William

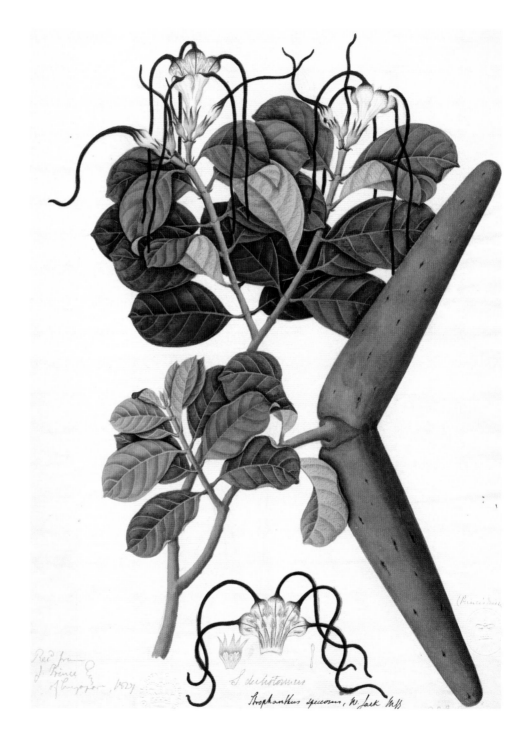

Fig.5 · *Strophanthus caudatus*, drawing, almost certainly by A Kow, made for John Prince.
Royal Botanic Gardens Kew

Jack would, but for scarlet fever, also have studied medicine at Edinburgh, but, instead, after a general education at the University of Aberdeen (where his father was Principal), obtained his medical training in London.

Arnold lasted only four months in Sumatra before succumbing to fever, but in this short time he made the sensational discovery of the 'stupendous flower' to which Robert Brown, who had earlier also studied botany at Edinburgh under Rutherford, gave the name *Rafflesia arnoldi[i]*, a binomial aptly commemorating both patron and naturalist. In preparation for his Sumatra expedition Arnold had studied the copies of William Roxburgh's drawings of Indian plants then kept at Sir Joseph Banks's house in Soho; Roxburgh, the 'father of Indian botany', had trained at Edinburgh under Rutherford's predecessor John Hope. In 1817 the final part of Roxburgh's lavish *Plants of the Coast of Coromandel* was still in preparation (though its 'author' had been dead for two years), with which the great Brown, 'Jupiter Botanicus', Banks's librarian was assisting. In this latter role Brown had, almost inevitably, also become known to Horsfield, and they collaborated, in Brown's habitual procrastinating manner, along with Brown's assistant and successor, John Bennett, over the publication of *Plantae Javanicae Rariores*, based on (a tiny fraction of) Horsfield's botanical collections. Brown was also botanical mentor to William Jack, whom Raffles recruited in Calcutta in 1819, when Jack was recuperating with Nathaniel Wallich, another giant of Indian botany, and (indirect) successor of Roxburgh as superintendent of the Calcutta Botanic Garden.

POLITICAL AND SOCIAL

The sort of science that Raffles and his collaborators pursued was part of the grand project of the 'statistical' documentation of natural resources. The area in which he happened to find himself was a traditional battleground between the British and Dutch over the control of access to (and trade in) pepper and spices – historically one of the most valuable of all plant resources, and therefore, not surprisingly, illustrated in the present collection. Such science cannot be pursued in a vacuum, and Raffles' career as an EIC servant (with all that that implies) shows the tension between the Company's rigid fiscal agenda, and that of an idealist who saw how his position could be used to benefit acquisition of knowledge (including archaeological and scientific) as an end in itself, and social responsibilities such as 'native education', eradication of 'vice' and the introduction of Christianity. Raffles paid a high price for attempting to carry out such 'enlightened' ideals against reactionary elements in the Company administration both in London and Calcutta. His difficulties with the Marquess of Hastings typify this tension, but his relations with Hastings's predecessor as Governor-General, Gilbert Elliot, first Earl of Minto, were much happier. Minto was a son of the Scottish Enlightenment (David Hume, a friend of his father, supervised his education and that of his brother Hugh), and was a true friend and patron to Raffles. Elliot's recognition of Raffles' talents led to his appointing him as 'Agent of the Governor-General with the Malay States', allowing the acquisition of information crucial to two of Raffles' greatest achievements – the administration of Java, and the negotiations that led to the acquisition of Singapore as a free port under British control. The latter came to pass in Hastings's era, by which time he and Raffles had (at least superficially) made up, but there is a curious Scottish link here, as Lady Hastings (*née* Flora Mure-Campbell) was, in her own right, Countess of Loudoun, who had met her husband while he was commander-in-chief of the army in Scotland. The Marchioness was a supporter of Robert Jameson's Edinburgh University Museum, and while Raffles was no particular friend of hers, he deferred to her wishes, and to this is certainly owed the presence of William Jack's specimens in the RBGE herbarium, and, possibly, the skeleton of a tapir in the National Museums of Scotland.

Raffles' thirst for knowledge about the Malay people, their ancient cultures and natural environment, with a biodiversity among the richest of the world, was greatly helped by the efforts he put into acquiring the language. He taught himself Malay on his eastward passage in 1805, but these studies were stimulated and encouraged by a fortuitous meeting in Penang with an outstanding Scot. John Leyden

can be seen as an embodiment of the 'Enlightened Scot' – born in the village of Denholm, close to the seat of the Elliots of Minto, but from a much humbler background. He typifies the mobility then possible to someone of outstanding ability, by means of the Scottish educational system, and the opportunities presented by the EIC. Although best known for his perhaps unequalled linguistic skills (he is said to have been acquainted with 45 languages), and in the field of literature (encouraged by Sir Walter Scott), Leyden also had a medical training and interests in natural history, and in 1804 was appointed medical assistant and naturalist on the Mysore survey, following in the footsteps of another great Edinburgh-trained botanical surgeon, Francis Buchanan. Colin Mackenzie, the great surveyor and collector of manuscripts, directed this survey, and also later worked in Java under Raffles. Leyden stayed with Raffles for three months in Penang in 1805/6, encouraged his host in the study of Malay, and later accompanied him on the Java expedition. Leyden lasted only two days in Batavia before succumbing (in Raffles' arms) to fever, caught while examining documents in a stifling library. He was only 35, and was interred at Batavia in the presence of Minto and Raffles. Another victim of eastern climate and disease of Raffles' Javanese period was the Scottish surgeon William Hunter, of whom more anon.

Raffles' relations with a second female Scottish aristocrat were altogether warmer than those with Lady Hastings. It was during his leave in 1817 (between his Javanese and Sumatran periods) that Raffles met the Duke and Duchess of Somerset, who were great patrons of science (the Duke later become a president of the Linnean Society). A warm and informative correspondence between Raffles and the Duchess ensued, much of it published in Lady Raffles' 1830 *Memoir* of her husband. The Scottish connection? The duchess was born Lady Charlotte Hamilton, daughter of Archibald, ninth Duke of Hamilton & Brandon, whom Raffles visited on his only visit to Scotland, in 1817, when he is also said to have visited Edinburgh – perhaps the occasion he came to know Robert Jameson and his museum.

In 2001 an Edinburgh assets management company, with interests in Singapore, kindly deposited on loan a pair of lavish volumes, then recently published, which they thought would be more appropriately housed in the RBGE library. These describe and illustrate a sumptuous collection of 477 natural history drawings made for William Farquhar, a Scottish military engineer from Newhall, Kincardineshire. Farquhar started his career in the Madras army, but from 1803 to 1818 was Resident and Commandant of Malacca, where he commissioned Chinese artists to make drawings of flora and fauna. The resulting collection was presented by Farquhar to the Royal Asiatic Society (to which Raffles also belonged) in 1827, but was sold by the Society in 1995. It was bought in its entirety by Mr Goh Geok Khim, who generously presented it to the National Museum of Singapore, where a selection is always on display. Farquhar has been unfairly overshadowed by Raffles, the result of an unfortunate falling out between two men of widely different temperament and ethos. Raffles failed to pay adequate credit to Farquhar's influence in several different areas, one of which is Farquhar's role as a mentor in natural history studies, and its documentation through art. Although Raffles tamed and kept animals from his early days in Penang, and must have started acquiring drawings such as Mrs Hutton's, he must surely also have been influenced by Farquhar's large collection of drawings and his very serious zoological interests.

THE RAFFLES COLLECTION'S SCOTTISH SOJOURN

A retired colleague, who periodically unearths paper 'skeletons' at home, and returns them to RBGE, had deposited some papers in my office. I didn't look at these at the time, but prior to a visit to London to select the drawings for this exhibition, I decided to clear my desk, and what should one of the skeletons prove to be but a foolscap typescript entitled 'Paintings of Flowering Plants which Sir Stamford Raffles caused to be made in Bencoolen, Sumatra, March 1824', written 'for private circulation to scientific institutions concerned with the botany of Malaysia' by E.J. H. Corner in 1957. The timing could not have been more auspicious, for

it would reduce the enormous amount of time required had the plants in the drawings had to be identified from scratch; moreover, they were the work of one of the greatest experts on the Malaysian flora. It was also extraordinary for another reason. To make the identifications Corner had had to travel to Scotland, by train from Cambridge, as the drawings were then in the possession of 'Mrs Drake, of Inshriach' near Aviemore (Fig.6). Given my ignorance of Raffles family history this came as a shock, for to me the names of Drake and Inshriach meant only one thing: one of the most important alpine garden nurseries of the post-war period, created, to her husband's consternation, by Mrs Drake's son, Jack. Several RBGE gardeners trained at Inshriach, and as a youth I sent there for plants and seeds of primulas and meconopsis. It emerged that 'Jack' Drake, was actually John Raffles Flint Drake, and that his mother, Muriel Rosdew *née* Raffles-Flint, was Raffles' great great niece. It was Jack Drake and his mother who deposited this collection on loan to the India Office Library in 1969/70, partly because it had then recently acquired the correspondence between Raffles and Lord Minto (purchased from the father of television chef Clarissa Dickson Wright).

CORNERIAN BOTANY

John Corner was one of the most original and prolific botanists of the twentieth century, and his mycological papers and specimens came to RBGE after his death in 1996. He is closely associated with Singapore and Malaysia, where he undertook his most important work while Assistant Director of the Gardens Department of the Straits Settlements, based at Singapore Botanic Garden from 1929 to 1946 (including, controversially, the period of the Japanese occupation). As with Raffles, 124 years previously, Corner's first sight of tropical vegetation was on the island of Penang. In the old cemetery there he collected specimens of the mahogany *Melia* (now *Azadirachta*) *excelsa* from trees he thought were probably the very ones from which William Jack had collected the 'type' more than a century earlier. It was through David Mabberley, one of his research students, that I learned of Corner's 'Durian Theory' on the nature of

the primitive flowering plant. It was therefore particularly apt that when Corner identified the Raffles collections it should include two drawings of the durian, one of which he noted as 'particularly excellent'. While some of the details of the Durian Theory have not stood the test of time, the colourful and thought provoking writing in which it was expressed continues to inspire (as, for example, in his *Life of Plants*).

The Durian Theory is a broad one, encompassing tropical ecology, co-evolution of plants and animals, and even the role of 'the hairless arboreal mammal that lurched from the forest in its increasing austerity, to slaughter the wild herds, to harvest the wild grains, and to hack down the testimony of his origin'. It takes the 'pachycaul' (thick, unbranched) stem as the primitive condition, but the durian (*Durio zibethinus*) itself forms only a part – referring specifically to the edible, fleshy outer coat or 'aril' of the seed, and the massive, spiny fruit:

> *The fruit smells of a mixture of onions, drains, and coal-gas, but the aril has no smell and tastes of caramel, cream, and, as some say, strawberries and raspberries. Usually the fruits detach when ripe and crash to the ground, where the*

Fig.6 · Inshriach House, near Aviemore, home of the Drake family, and the Raffles Family Collection from 1939 to 1969. Courtesy of Mrs Lucy Micklethwait

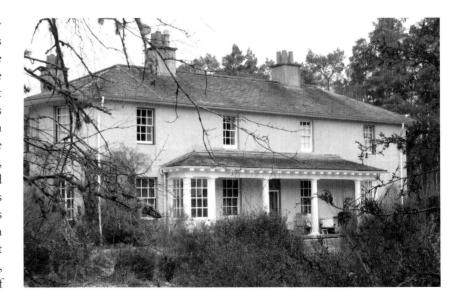

pulp turns rancid in a day or two. In Malaya the smell of fruiting trees in the forest attracts elephants, which congregate for first choice; then come tiger, pigs, deer, tapir, rhinoceros, and jungle men. Gibbons, monkeys, bears, and squirrels may eat the fruit in the trees; the orang-outan may dominate the repast in Sumatra and Borneo.

Like Raffles before him Corner found the lush diversity of tropical forest, with its exotic plants and animals, a source of inspiration. For Corner it was the cradle of evolution of the flowering plants, where evidence of these processes still awaited discovery and analysis by the observant naturalist. With hindsight, after this tropical epiphany, Corner could be scathing about the depauperate nature of the northern flora. While this has been the only possible inspiration for those who happen to be born there, because modern scientific taxonomy arose in this repeatedly ice-scraped zone of cold and seasonal climate, knowledge of plant morphology, what is 'normal', and how it is classified and named, has been peculiarly slanted and constrained. It is therefore somewhat poignant to quote Corner's 1975 thoughts on what lay outside the study window – the beautiful Caledonian pine forest of Inshriach (Fig.7) – as he identified Raffles' Sumatran fruits and flowers:

In northern lands coniferous forest! In tropics, subtropics and southern lands broad-leaved flowering forest, but a sprinkling of conifers! That is the way in which I think of land-vegetation. Pine and palm, cone and flower, needle and broad leaf, or deal and hardwood, are the two efforts at making forest. The first is the "dark and gloomy forest", with little to eat and no inspiration, cluttered in its lower reaches with almost impenetrable debris and serving as a hiding place rather than a store.

THE HUNTER DRAWINGS

The variety within this collection has already been noted, as has my initial impression that it would have no direct link with drawings made for Scottish EIC surgeons. One of the more extraordinary discoveries was the fact that 24 of the botanical drawings of the 'Raffles' Collection, were,

in fact, made for William Hunter, a Scottish EIC surgeon, by a Chinese artist in Penang, in the three years prior to Raffles' arrival there, and most probably acquired by him following Hunter's death in Java in 1812. The identification of this group emerged when images of the drawings were shown to David Mabberley, who immediately recognised the (problematic) name '*Volkameria fastigiata*' on one of the drawings (NHD 49.52). Hunter, a Company surgeon and Orientalist who published in *Asiatic Researches*, was well known to me as one of that quite extraordinary group of intellectuals raised in and around the small east-coast seaport of Montrose in the second half of the eighteenth century: the historian James Mill, Robert Brown the botanist, the radical politician Joseph Hume, Alexander Gibson, botanist and forest conservator, Sir Alexander Burnes, explorer of Afghanistan, and Edward Balfour, medic, economic botanist and founder of the Madras Museum. But to turn up in this context was a surprise indeed.

EPILOGUE:

THE MINTO STONE, OR STELE OF SANGGURAN

Despite initial doubts, traces of Raffles had been found, even in Scotland – tangibly in the form of the William Jack specimens in the RBGE herbarium cabinets; and as a memory at Inshriach, where the natural history drawings lived between 1939 and 1969. Reading Lady Raffles' *Memoir* of the 'life and public services' of her husband, the vision of an altogether weightier memento of Raffles and his patron Lord Minto, leapt out from page 188. A 'great stone from the interior of your Island [Java]' that Raffles arranged to be sent to Minto in Calcutta in June 1813, and which the Governor-General, in a flight of romantic fancy, admitted to being 'tempted to mount this Java rock on our Minto craigs, that it may tell eastern tales of us long after our heads lie under smoother stones'. The stone concerned was collected by Lieutenant-Colonel Colin Mackenzie, son of the postmaster of Stornoway, who surveyed the antiquities of Java on Raffles' behalf, and is rough only for its lengthy inscriptions in Old Javanese script (Fig.8). It was dedicated in a ceremony on 2 August 928 in which a local king granted rights (*sima*)

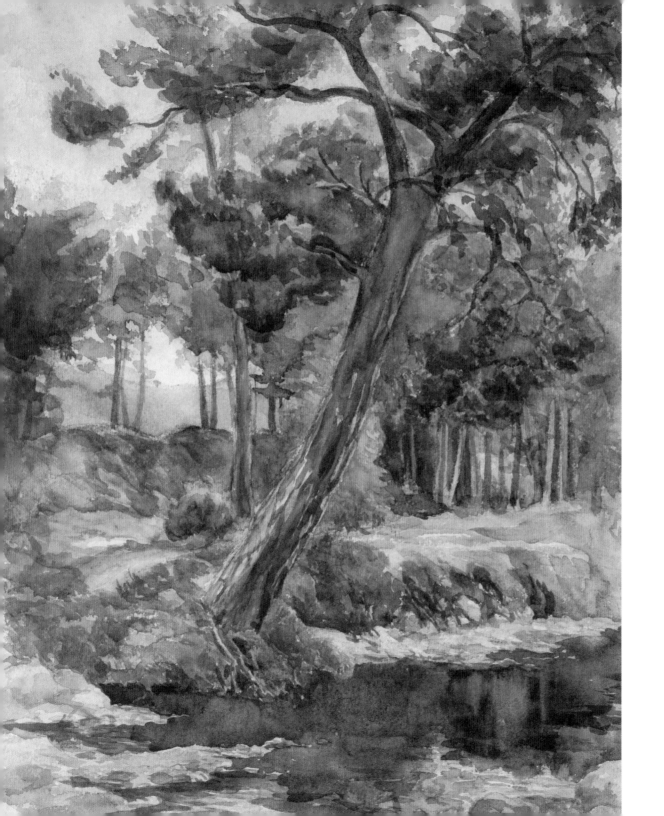

Fig.7 · Caledonian pine forest at Inshriach, water-colour by Muriel Rosdew Drake *née* Raffles-Flint.
Courtesy of Ron & Susan McBeath

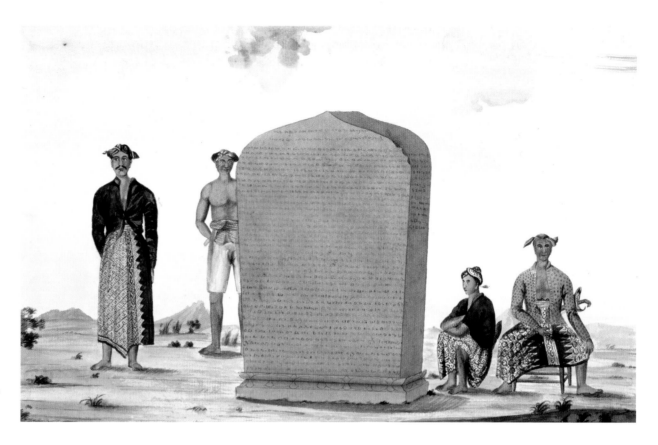

Fig.8. The Stele of
Sangguran, when still in
Java. Watercolour by John
Newman, 1812.
WD 953 f. 83

to a community of metal smiths: the inscription ends with a
blood-curdling curse:

> *Should anyone uproot the sacred sima stone, may the*
> *resulting bad karma cause them to be killed by Ye holy*
> *spirits. May they thus meet their death unexpectedly*
> *from behind, meet harm from the side, be struck down*
> *from the front, be beaten senseless, have their nose cut*
> *off, their head split open, their belly ripped open, their*
> *entrails torn out, their innards exposed, their liver ripped*
> *out, their flesh eaten, their blood drunk, and only after*
> *that to die ...*

Lord Minto had not mounted the stone on the 'craigs': he
never made it back to Scotland, dying at prosaic Stevenage
en route, but it is certainly still at Minto. The place is now a
sad one: a wooden house sits incongruously on the scraped
ground where the mansion once stood, but its terrace garden
has been saved, and it was there I imagined the stone might
stand. Not so, and exploration of the policies one damp au-
tumnal day seemed inadvisable in view of an approaching
pheasant shoot. Retreating from the guns I stumbled on the
surreal sight of a man in the drive of another of the houses
recently built in the demesne giving his blue *Boxster* a blow-
dry. Although the stone is not well known in the neighbour-
hood, he happened to know it, as it stands in the garden of
a friend of his, and he kindly drove me to see it. Here I was
in the presence, not only of an extraordinary artefact more
than a thousand-years old, 'collected' by the great antiquar-
ian Colin Mackenzie, but one sent as a diplomatic gift to his
patron Lord Minto by Thomas Stamford Raffles.

II Raffles: a Brief Chronology

1781

6 July: born on his father's ship off Port Morant, Jamaica, son of Captain Benjamin Raffles and his wife, Anne (*née* Lyde); baptised Stamford Bingley (and later Thomas).

1795

Becomes clerk in the East India Company.

1805

19 September: arrives at Penang as Assistant-Secretary to Prince of Wales Island government; Secretary from August 1806 (to 1810); kept a menagerie including a siamang.

22 October: John Leyden stays with Raffles, encouraging his Malay studies.

1807–8

To Malacca on sick leave; stays with William Farquhar, Resident and Commandant, who kept a menagerie and commissioned natural history drawings from Chinese artists.

1810

June: from Penang makes visit to Calcutta to try to obtain the Residency of the island of Ambon. Stays with Leyden for four months; has discussions about planning the Java expedition.

October: appointed Minto's secret 'Agent of the Governor-General with the Malay States'.

November: returns to Penang to sell house ('Runnymede'), and leaves for Malacca to prepare for Java expedition. In Malacca (at Bandar Hilir) employs natural history collectors and a Chinese artist from Macao; kept animals including two orang utan given him by the Sultan of Pontianak.

1811

18 June: joins Lord Minto on HMS *Modeste* to sail for Java.

26 August: British victory over Dutch forces at Meester Cornelis.

28 August: death of John Leyden.

11 September: Raffles appointed Lieutenant-Governor of Java.

23 December: meets Dr Thomas Horsfield, an American Naturalist who has been working on the natural history of Java for the Dutch since 1801. Raffles continues to support his work.

1812

Revival of the Batavian Academy of Arts and Sciences.

December: death of Dr William Hunter (Superintending Surgeon of Java); Raffles acquires material from his library.

1814

26 November: death of first wife Olivia Mariamne.

1815

9 September: Dr Joseph Arnold arrives at Batavia on *Indefatigable*, stays on Java for 3 months, during which botanises and stays with Raffles.

22 October: *Indefatigable* destroyed by fire, Arnold's collections lost.

13 December: Arnold leaves Java on *Hope*, with living plants for Sir Joseph Banks from Raffles.

Court of Directors of EIC accuses Raffles of injudicious and extravagant behaviour, Governor-General (Lord Moira) activates

transfer to Bencoolen, an appointment originally made by Minto as a failsafe should Java return to the Dutch.

1816

25 March: sails to England on *Ganges*.

11 July: arrives at Falmouth.

1817

22 February: marries Sophia Hull.

20 March: elected F.R.S., proposers included Sir Everard Home, William Marsden and A.B. Lambert.

10 April: Raffles' *The History of Java* published.

29 May: knighted at Carlton House by the Prince Regent.

20 November: Raffles and his wife sailed from Falmouth on *Lady Raffles* for Bencoolen, with Dr Joseph Arnold as naturalist and personal physician.

1818

15 February: birth of daughter Charlotte Sophia Tunjung Segara at sea.

20 March: lands at Fort Marlborough, Bencoolen.

19 May: Malay servant with Arnold and the Raffleses discovers *Rafflesia* on an excursion to Pasemah ulu Manna; Arnold contracts fever.

8 July: Horsfield (on visit from Java), Arnold and the Raffleses sail to Padang for excursion to Menangkabau highlands, Arnold left at Padang.

26 July: death of Arnold.

2 September: Raffles and his wife to Calcutta to persuade Lord Hastings to establish a free port at the southern entrance to the Straits of Malacca. Meets Nathaniel Wallich and William Jack.

7 December: sails on *Nearchus* to Penang, with Jack as physician / naturalist, two French zoologists Pierre Diard & Alfred Duvaucel, and Baptist missionary (the Rev. Nathaniel Ward) with a printing press.

1819

January / February: Jack left in Penang with a pregnant Lady Raffles; Raffles to Singapura with William Farquhar to negotiate its use as a British base from local rulers (treaty signed 6 February). Farquhar left there as Resident. Raffles discovers a *Nepenthes* later named for him by William Jack.

March / April: Raffles and zoologists to Aceh in northern Sumatra.

June: Raffles, Jack and the zoologists spend a month in Singapore.

31 July: the party finally arrives at Bencoolen (via Rhio).

October / November: Raffles to Calcutta (with Jack), following death of Governor of Penang to press claims to be his successor with Hastings, and discuss political plans for region: fails in these and returns to Bencoolen.

1820

3 March: Raffles and Jack (via Tappanooly) arrive back in Bencoolen. Supreme Government has not agreed to employment of Diard & Duvaucel, leading to a falling out. Raffles seizes their Sumatran zoological collections and despatches them to London (March and June), along with 'his' (largely Jack's work) zoological 'Descriptive Catalogue', read to Linnean Society by Sir Everard Home in December 1820 (mammals) and March 1821 (birds, etc.).

June: Raffles sends the zoological drawings to London (via Bengal), which arrive in April 1821, including the 129 bird drawings of NHD 4. Around this time Raffles founds Agricultural Society of Sumatra (Jack as secretary).

October (to January): excursion of Jack, with John Prince, to acquire Pulo Nias as a British possession.

1821

10 June: Jack and Captains Auber and Salmond start expedition to ascend the accursed Sugar Loaf mountain (Gunung Bengko).

27 June: death of Raffles' eldest son Leopold ('*le jeune Aristote*').

11 July: death of Captain Harry Auber.

1822

3 January: death of Marsden ('Marco Polo') Raffles.

14 January: death of Charlotte Sophia Tunjung Segara Raffles.

March: Ella, Raffles' only surviving child, sent back to England. Jack sent on mission to Moco-Moco, where he contracts a fever.

July: Jack to Java to recover health, but to no avail and returns to Bencoolen.

15 September: death of William Jack on the *Layton* in Bencoolen harbour.

October 10 (to 9 June): Raffles third and last visit to Singapore, spends time with Wallich who is there for a month's sick leave. Wallich proposes establishment of a Botanic Garden. Raffles sacks William Farquhar over administration of Singapore.

1823

July: Raffles arrives back in Bencoolen, with many specimens from Singapore, having not been allowed to land on Java *en route*.

19 September: birth of Flora Raffles

28 November: death of Flora Raffles.

1824

2 February: Raffles leaves Sumatra; burning of *Fame*, with loss of all collections. Artists set to work to replace some of the 2–3000 lost drawings.

10 April: they set sail for a second time, on the *Mariner*.

1825

15 February: elected Fellow of the Linnean Society (proposers included Samuel Goodenough, Thomas Hardwicke, Thomas Young and Henry Colebrooke).

1826

26 February: founding of Zoological Society of London (with Sir Humphry Davy, Hardwicke, Colebrooke and Horsfield): Raffles elected President.

5 July: died at 'Highwood', near Hendon, Middlesex.

Map of Raffles' East Indies

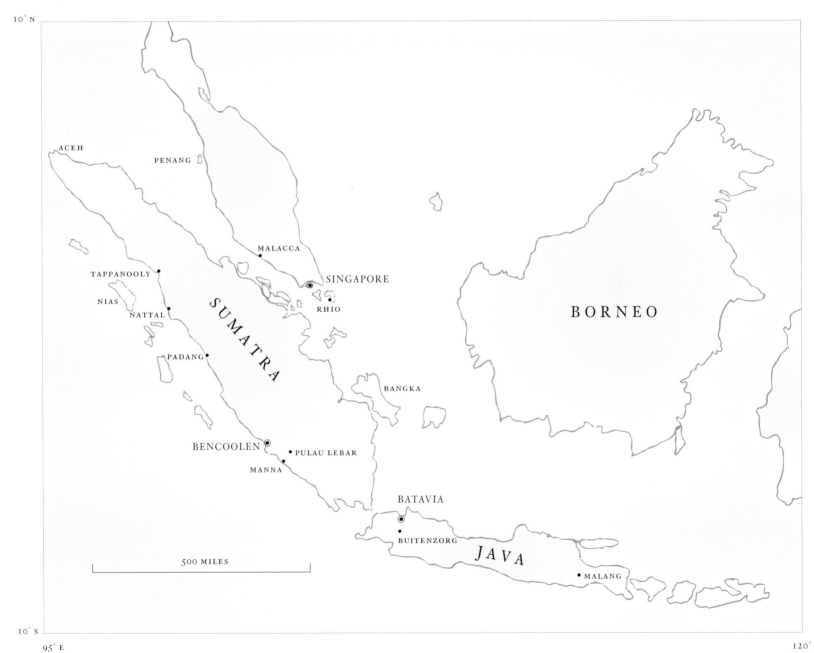

IO° N

ACEH

PENANG

MALACCA

SINGAPORE

TAPPANOOLY

NIAS

NATTAL

RHIO

SUMATRA

PADANG

BANGKA

BORNEO

BENCOOLEN • PULAU LEBAR

MANNA

BATAVIA

BUITENZORG

JAVA

MALANG

500 MILES

IO° S

95° E

120° E

III Raffles: Patron (and Practitioner) of Natural Science

This chapter relies largely on the work of others, most notably the huge contribution to Raffles studies made by John Bastin. The use of references or footnotes would clutter the text and give it a spurious air of scholarship, so have not been used. The sources are all cited in the Bibliography and will be easily traced.

Raffles' most important role as a natural scientist (until the founding of the Zoological Society of London, shortly before his death) was undoubtedly as a patron, collector of specimens and commissioner of illustrations. When summarising this aspect of his life, following the appalling destruction of his collections from Sumatra and Singapore in 1824, Raffles was realistic about his role as patron, rather than practitioner, of science, stating that only after the failure of his political ambitions (that is, after his visit to Calcutta in autumn 1819) was he able to devote significant time to scientific activities (which included agricultural improvement) and the formation of natural history collections. Raffles had little formal education – only two years of schooling are recorded, and he had to start work as a clerk in East India House at the age of 14 – but his outstanding intelligence and capacity for hard work more than compensated for this. Nonetheless, his largely fortuitous meeting in the East with a series of outstanding individuals with more formal (Linnaean) scientific training, was in a large part responsible for Raffles' reputation in such matters. The individuals concerned were Thomas Horsfield and Joseph Arnold (both of whom he first met in Java), and William Jack and Nathaniel Wallich (whom he met in Calcutta). His connection with the Cuverian zoologists Pierre Diard and Alfred Duvaucel, also recruited in Calcutta for his Sumatra establishment, is more complex and controversial, but forms an essential part of the story. But it would be quite wrong to imply a negative spin on Raffles as 'autodidact', at a period when distinctions between the amateur and professional in science scarcely existed: indeed, when they did, the professional was the more likely to be viewed with suspicion. An unsought testimonial from the great Sir Joseph Banks, citing Raffles as 'among the best informed of men ... [who] possesses a larger stock of useful talent than any other individual of my acquaintance', attests to the esteem in which he was held in the metropolitan scientific circles of 1817.

In order to understand the natural history drawings of the Raffles Collection, a pale shadow of the 2–3000 that there would have been to discuss had the *Fame* not burned, it is necessary to describe Raffles' work (direct and indirect) in the field of natural history. This is an aspect of his life that was stressed in his widow's *Memoir* (to the extent of publishing the documents relating to the squabble with the French zoologists); valuable information is also to be found in the scintillating epistles of Jack to Wallich, and in Raffles' own letters to the same correspondent: this trio shared a strong mutual devotion and the letters are exceptionally informative. The manuscripts just about survive in the library of the Calcutta Botanic Garden, but fortunately both sets have been published in lavishly annotated editions: the Jack–Wallich correspondence, in 1916, by Isaac Henry Burkill; the Raffles–Wallich by John Bastin in 1981. The latter author, in 1973, also edited (with no fewer than 339 exceptionally interesting footnotes) the letters of Joseph Arnold to Dawson Turner. Lastly, small, but uniquely valuable, insights into Raffles' collecting and use of artists are to be found in the autobiography, the *Hikayat*, of Raffles' 'munshi' (scribe) Abdullah bin Abdul Kadir, published in a translation by A.H. Hill in 1955. In 1990 Bastin made an excellent summary of this material, telling all there is to know of Raffles' 'study of natural history in Penang, Singapore and Indonesia'. The following account is almost entirely based on that work, to which (and to monographs on Horsfield and William Farquhar, by the same author) readers are referred for more detailed information.

PENANG AND MALACCA

A love of natural history in childhood is the necessary basis for all those who develop serious interest in the subject in later life and Lady Raffles not surprisingly recorded in her *Memoir* that it was as a child that Raffles first came to love gardens (and necessarily the plants contained) and animals.

On being appointed as Assistant-Secretary to the government of Prince of Wales Island (Penang) in 1805, he could not have failed to be entranced by the rich tropical flora and fauna of this island situated close to the coast of the Malay Peninsula. Penang had been a British possession since 1786, administered by the East India Company, which meant that in overall charge was the Court of Directors in London, but immediate control was by the Governor-General and the 'Supreme Government' of India based in Calcutta. The island's position gave it a strategic importance in terms of politics and trade, so Raffles' job was an important one, and one with great potential. Penang's climate and position also gave it a strategic botanical function, and it had been the location of a spice plantation administered from the Calcutta Botanic Garden, to which large numbers of clove and nutmeg trees were brought from the Moluccas, under instructions from the Calcutta superintendent William Roxburgh, by the collectors Christopher Smith and William Roxburgh

Fig.9 · Glugor House and the Spice Plantations, Prince of Wales Island, 1821, aquatint by William Daniell, after a painting by Capt. Robert Smith, c.1815.

BL × 685.15

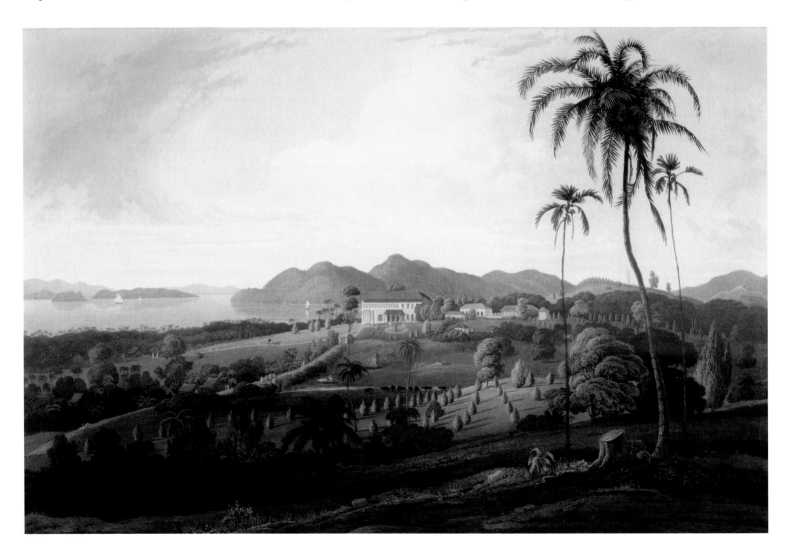

junior. The plantations were sold the year of Raffles' appointment, though were re-established some years later (Fig.9).

In 1802–4 the Bengal surgeon William Hunter found himself stationed in Penang, and, being an Orientalist with wide scientific interests, used the time to compile a Flora of the island and commission a Chinese artist to draw the more interesting plants; he was also asked to superintend the spice plantations (though the commission was withdrawn when Smith protested). The Flora, dedicated to the Governor-General, Lord Wellesley, and the drawings went back with Hunter to Calcutta. Neither was published at the time, though no fewer than five (at least partial) sets of copies of the drawings were made, including one for Wellesley himself, another for John Fleming (a Company surgeon, who had temporary charge of the Calcutta Garden in 1805–7); the Flora was eventually published by H.N. Ridley in 1909. Hunter appears to have kept a set of the drawings for himself, which, by a curious twist of fate, ended up in Raffles' hands. Hunter had left Penang the year before Raffles arrived, but there was at least one person there collecting botanical illustrations by a Chinese artist, and copying these herself – this was Janet (*née* Robertson), wife of Thomas Hutton, a Company official who was Raffles' predecessor as Malay translator to the Penang government (Fig.2). Raffles must have known the Huttons, and may even have seen Janet's collection of drawings. It was also in Penang that Raffles' love of the keeping of exotic animals as pets, began – an endearing, and unashamedly anthropomorphic habit that he continued in Malacca, Java and Sumatra. From this date is an account of a siamang (a type of gibbon) that Raffles believed to have committed suicide, following a reprimand and banishment from his house – an anecdote later transmitted to the Linnean Society for publication in his zoological catalogue, but editorially omitted from the printed version.

Raffles' outstanding abilities were quickly recognised and he was promoted to Government Secretary, but a combination of climate and overwork took its toll, leading, in 1807, to a period of sick leave further down the Straits at Malacca. The Resident and Commandant here was Major William Farquhar (Fig.10), a Scottish military engineer with a passionate interest in natural history. Like Mrs Hutton he was assembling what would eventually become a large collection of natural history paintings (including plants, birds, mammals and fish), which Raffles must have seen for the first time on this occasion, and was doubtless inspired by. Although Farquhar discovered a strange fern that was new to science (*Matonia pectinata* on Mount Ophir),

his zoological interests were more serious. He was the first Westerner to discover and describe several animals that, for various reasons, were first published by the French (in the case of the tapir), or by Raffles himself (Raffles' gymnure or moonrat). Raffles did acknowledge in print Farquhar's priority in these cases, but in general was less than generous with reference to the older man's influence, which continued when Raffles stayed with him in 1810 as Governor-General's secret 'Agent with the Malay States', during preparations for the invasion of Java, when Raffles must have picked his brain, though assimilated the information as his own in reports to Lord Minto. This less than generous behaviour of Raffles thus existed long before his public falling out with Farquhar (whom Raffles referred to as 'King Malachi') over the administration of Singapore in 1822; the silence became deafening when a widow came to promote the posthumous reputation of a beloved husband.

It was during his Malacca stay of 1810–11 that his scribe Abdullah recorded (in picturesque language) Raffles' employment of four men to collect a wide range of natural history specimens and 'a certain Chinese from Macao who was very expert at drawing life-like pictures of fruits and flowers'. The near identical versions of a pineapple in the Raffles (NHD 48.28) and Farquhar collections (SHM 1995.3138) suggest that (with the possible exception of a drawing to be described below) Raffles' set of fruits with black borders (NHD 48 18, 27–40) was made during this period, probably even by one of Farquhar's artists, and that they came back with the Javan collections in 1816, despite the fact that these drawings were later mounted by Raffles in the volume with drawings made post-*Fame*. At Malacca Raffles was sent gifts of animals by various Malay rulers, which he kept as pets, including two orang-utan sent by the Sultan of Pontianak (NHD 49.31).

JAVA

The French invasion of the Netherlands gave Britain the excuse to take Java from the Dutch, which was accomplished by August 1811, and the Governor-General himself accompanied the expedition. With Lord Minto, as personal translator, was his *protégé* John Leyden, who was also a close friend of Raffles and his wife Olivia, having stayed with them in Penang in 1805/6. Also of the invading party was another keen naturalist, William Hunter, last heard of in Penang, but who in the intervening period had been employed at the College of Fort William in Calcutta, where Leyden worked under him as Assistant Secretary. Hunter was made Superintending Surgeon of the island and Raffles, to the chagrin of Colonel Robert Rollo Gillespie, one of the military leaders of the expedition, was left in charge of Java as Lieutenant-Governor. Almost immediately Raffles gave evidence of the enlightened policies he intended to pursue during his administration, among which was a renaissance of the Bataviaasch Genootschap van Kunsten en Wetenschappen (more euphoniously the Batavian Society of Arts and Sciences), the oldest learned society in Asia, founded by the Dutch in 1778, with the motto 'public utility'. Raffles revived the publication of its *Transactions*, and gave annual discourses in 1813 and 1815, similar in style to those given earlier by Sir William Jones to the Asiatic Society in Calcutta. Due partly to his linguistic studies Raffles had great respect for, and a passionate interest in, the history and archaeology of Java, believing that its ancient civilization gave it a head start onto which Western enlightenment could be grafted – in contrast to the more exploitative attitudes of reactionary elements in either Dutch or EIC administration. The desire to discover more of this history lay behind Raffles' ordering of statistical surveys of the island by Colonel Colin Mackenzie, who had previously undertaken similar work in Mysore and acquired a thirst for collecting manuscripts and drawing antiquities. Raffles also took over the beautiful country house of the Dutch Governor at Buitenzorg (now Bogor), 40 miles south of the capital Batavia (now Jakarta), from which he planned to make botanical explorations with William Hunter. It was in Java at this time that the terrible losses of friends and relations, to disease and climate, that would hound Raffles for the rest of his life, began. Leyden was the first to go, lasting only two days after the defeat of the Dutch, dying in Raffles' arms in August 1811; the projected botanizing with Hunter came to

nought as he died in December 1812. Raffles' beloved wife Olivia followed and was buried next to Leyden in Batavia in November 1814.

The loss of Hunter, who might have achieved much in botany, was, however, more than compensated for by Raffles' meeting in December 1811 with the American surgeon Thomas Horsfield (Fig.11), who had been undertaking botanical surveys for the Dutch government for the previous ten years. The two became fast friends, and Raffles not only continued to pay Horsfield's salary, but broadened the scope of his natural history investigations, both geographically and in the range of natural resources studied – to zoology, geology and mineralogy. During the Javanese period Raffles was too busy with administration to do much in the way of natural history himself, other than keeping pet animals (including two young tigers at his country house at Tjisarua), but his patronage of Horsfield was of major importance. Horsfield's own interests had started with medical botany, and led to an investigation of that most infamous of Javanese plants, the sinister 'Upas tree' (*Antiaris toxicaria*) reputed to emit miasma that killed any who dared so much as approach it; he also employed Dutch military draftsmen to make large numbers of botanical illustrations, ink drawings that resemble engravings, most of which are now at Kew.

The length of British rule in Java was always uncertain (dependent largely on European politics), and, in the meantime, whether it would be administered by the EIC or the British Government. For these reasons Minto, at this point, appointed Raffles to the Residency of Bencoolen in Sumatra, as an insurance policy should he lose his job in Java. Given these uncertainties Raffles was determined that Horsfield's discoveries and collections should go to Britain. Slightly oddly, given that his salary had been paid by the Dutch for ten years, and that he was American not British, Horsfield went along with this and sent zoological specimens, and some remarkably delicate nature prints of herbarium specimens, to the EIC for its museum. These attracted the attention of Sir Joseph Banks, who wrote soliciting further material. Horsfield (and Raffles) was flattered by the approach, and sent Banks herbarium specimens, which he passed to his resident botanist and librarian, Robert Brown. Brown responded unusually quickly (for him) and did the best he could, identifying the majority at least to generic level. This is not the place to describe Horsfield's subsequent career, suffice to say that he retired to London in 1819, and spent much of the rest of a very long life as curator of the India Museum, writing up his zoological work, and producing catalogues of the Museum's collections, which by the end included some of Raffles' Sumatran material. Of his botanical

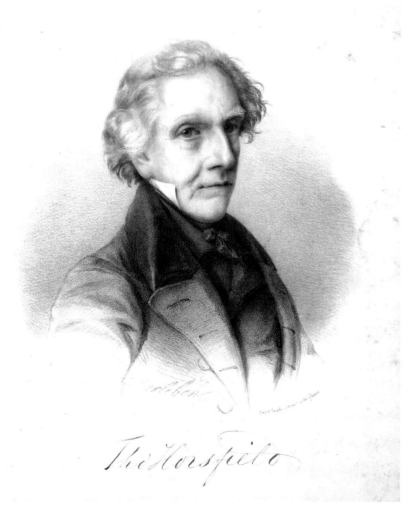

Fig. 12 · Foxtail millet,
Setaria italica, specimen
from the William Jack
herbarium.
Royal Botanic Garden Edinburgh

collections Horsfield made the great mistake of entrusting them to Brown, which, as earlier with Roxburgh's Indian work, Brown sat on for years before eventually handing over to his assistant John Bennett. The result, *Plantae Javanicae Rariores* (1838–52), described only a fraction of Horsfield's collections, by which time Java had long since been returned to the Dutch and Carl Ludwig Blume had published and pre-empted many of what would otherwise have been Horsfield's discoveries. In 1830 Horsfield, as an act of homage, contributed a catalogue of Raffles' zoological collections to Lady Raffles' *Memoir*.

Although Raffles did little natural history in Java himself, a single example of a personal botanical interest is recorded. On 7 March 1815 he wrote to Horsfield from Buitenzorg (*Memoir*, p.616), seeking information on:

The grain, which the Javanese call Java-woot, and from which they pretend the name of Java for this Island to have been derived, cannot be unknown to you: I have it growing in my garden, and possess specimens of the flower and seed. The Javanese support the opinion, that the seed of this plant was the principal article of food before rice was introduced; and I feel some curiosity to ascertain if it be a grain peculiar to this Island, or a grain already described, and common to Western [i.e. Peninsular] India – the grain has much the appearance of millet, and the ears are peculiarly rich and beautiful. You will oblige me by noticing the classical name, if already described, and if not, by classing it yourself, as it is a plant which seems unknown to Europeans at this end of the island.

In the Jack herbarium at Edinburgh is a specimen of a grass annotated with this same spurious etymology for the name of the island (Fig.12). This allows the identification of the plant concerned as the foxtail millet (*Setaria italica*), which, as Raffles seems to have suspected, is, in fact, cultivated almost pantropically – but also the identification, and probable origin, of the strangest botanical drawing in the Raffles Collection (NHD 48.18). Although one of the 'black border' series, the rest of which depict more juicy tropical fruits, this is the only drawing on paper with a Belgian watermark (a

sheet surviving from a Dutch stationery store?), and could thus have been made in Java as a result of Raffles' interest. The artist probably took a dim view of having to depict such a plebeian subject, and made the best of a bad job by making a bizarre millet posy.

Although inextricably linked, both in the name *Rafflesia arnoldii*, and this plant's discovery on Sumatra three years later, it was in Java that Raffles met, for the first time, Dr Joseph Arnold (Fig.13). The circumstances – a fire at sea and loss of a collection – were inauspicious, and foreshadowed a later tragedy. Arnold, a medical graduate of Edinburgh (where he was friendly with the Professor of Natural History and museum curator, Robert Jameson), was surgeon on a ship that had taken female convicts to Botany Bay in 1814. On the outward voyage Arnold collected insects in South America, and further specimens in Australia, returning on

a Whitby ship called the *Indefatigable*. The ship caught fire and sank in the harbour of Batavia in October 1815, with the loss of Arnold's possessions and specimens. Stranded on Java for three months, he used the time in making excursions; Raffles, characteristically, seized the opportunity of cultivating a new scientific acquaintance and invited Arnold to stay, and sent him back with living plants for Banks (which did not survive the voyage). The consequences of this introduction, however, belong to a later part of the story.

Despite Raffles' ambitions to the contrary, British rule in Java was never likely to be other than temporary, and in 1814 it was agreed that it should be handed back to the Dutch, though Napoleon's escape from Elba caused a hiccup and Raffles stayed on. The latter days of his administration were, however, clouded by accusations of corruption

and maladministration, mainly because Raffles had authorised the sale of Government lands to generate revenue to meet the heavy expenses of the military presence on the island. Complaints were made by General Gillespie to the Supreme Government in Calcutta, where Raffles had suffered another loss on Minto's retirement to England (where he died at Stevenage in August 1814, before ever reaching Scotland). The new, more aggressive, Governor-General, Francis Rawdon Hastings, Earl of Moira (later Marquess of Hastings), had to refer the complaints to London, where the Court dithered (eventually clearing Raffles of personal impropriety, but censuring his administration), but meanwhile activated the existing order for Raffles to go to Bencoolen. Instead, partly to defend his reputation and seek absolution from the Court of Directors, and partly due to ill health, Raffles decided to go home, embarking in March 1816 with the first of his large collections – ethnographic and archaeological, with drawings relating to these, but also, it now appears, some botanical ones. He also took some seeds for Banks from Horsfield, who could still not quite tear himself away from Java.

BRITISH INTERLUDE

Raffles had left England as a somewhat timid, but ambitious, twenty-four year old Assistant-Secretary, but returned, after 11 extremely eventful years, as a Lieutenant-Governor. Minto's snobbish son George may have considered Raffles to be 'neither born nor bred a gentleman ... full of trick ... and ... the most nervous man I ever knew', but this reaction seems to have been atypical. The 'sterling stamp' of Raffles' 'active and comprehensive mind that diffuses a portion of its own energy to all around' (as Jack would later put it) was sufficient to give him an *entrée* into at least parts of English society, 'taking the waters' at fashionable Cheltenham, and setting himself up in London, with his Javanese collections, at 23 Berners Street. Undoubtedly Raffles had social aspirations and courted not only aristocracy but royalty, though this could have been due not so much to snobbery as to being a necessary route for realising his serious literary and scientific ambitions. Certainly neither the Duke and Duchess

Fig. 14 · Sir Thomas Stamford Raffles, stipple engraving by Samuel Cousins, of a bust by Francis Chantrey.
By permission of the Linnean Society of London

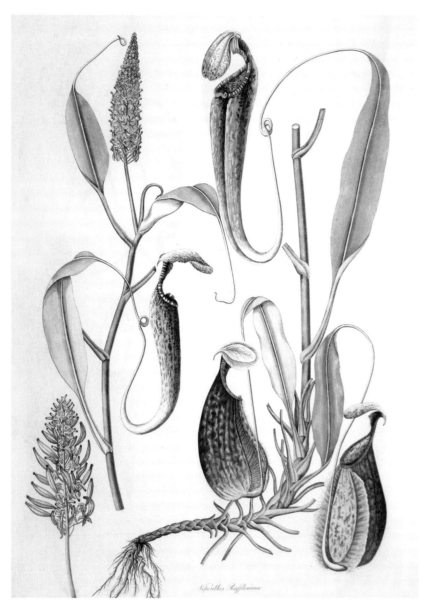

Fig. 15 · *Nepenthes rafflesiana*, etching
with aquatint, double-elephant size, by
Messrs Weddell, from the appendix to A.B.
Lambert's *A Description of the Genus Pinus*,
second folio edition, 1828 or 1829.
By permission of the Linnean Society of London

of Somerset, nor Princess Charlotte and Prince Leopold, were put off in the way the fastidious and 'Honourable' George Elliot had been, and became not only patrons, but real friends, of Raffles. His tales of the Orient doubtless captivated them, and his fund of scientific knowledge led to election as Fellow of the Royal Society, proposed by a distinguished group including Sir Everard Home the anatomist, and William Marsden, historian of Sumatra (with whom Raffles had corresponded since Penang days). Another of the proposers was Aylmer Bourke Lambert, owner of the second most important herbarium in London after that of Banks. This herbarium was unfortunately broken up and dispersed after Lambert's death, and he is best remembered today as the author of the magnificent folio volumes of *A Description of the Genus Pinus*, superbly illustrated (in part, and to the delight of Goethe) by Ferdinand Bauer. This work, in its various editions, is a bibliographer's nightmare, but it was in a supplement to a later edition that (bizarrely, given the title) Lambert included a double plate showing Raffles' major solo botanical discovery, *Nepenthes rafflesiana* (Fig. 15). In a productive (if unofficial) 15-month furlough Raffles married Sophia Hull, published his *History of Java*, was knighted by the Prince Regent and sat for a bust by the fashionable sculptor Francis Chantrey (Fig. 14).

It is time to catch up with Joseph Arnold, who had returned from Java in 1816 and become known as a traveller and naturalist, especially as a geologist. He formed a particular friendship with the Norfolk banker, antiquary and seaweed expert Dawson Turner (and his son-in-law W.J. Hooker) and the young geologist Charles Lyell. Although the plants he brought back for Banks from Raffles in Java had died, Arnold became known to the President of the Royal Society and his librarian Robert Brown – the result of these connections being that Raffles employed Arnold as his personal physician and naturalist when preparing to go to Sumatra in 1817. Arnold purchased relevant Floras, and did some serious homework in Banks's library, making notes on the 2500 drawings made by Indian artists for William Roxburgh, and the accompanying Flora Indica manuscript that Roxburgh had vainly hoped Brown would edit and

publish. Raffles set sail from Falmouth in November, with two dogs, a cage of canaries, and a six-months pregnant wife, with Arnold in medical attendance. The voyage was direct to Bencoolen, the ship's captain being Harry Auber, whose brother was married to one of Lady Raffles' sisters, and on the way Arnold instructed the happy couple in botany and natural history.

SUMATRA

The *Lady Raffles* reached Fort Marlborough, Bencoolen, on the west coast of southern Sumatra on 19 March 1818. This had been an EIC station since 1685, largely concerned with the cultivation and export of pepper, but was (in Jack's later words) 'grievously out of the way' – certainly a major come-down after the responsibilities of Java. Raffles was allowed to keep the title of Lieutenant-Governor (his predecessors had been mere 'Residents'), and he, mistakenly, chose to interpret the EIC's instructions to supply information on Dutch and American activities in the region as a brief for British expansion. Things started well, however, with reforms and improvements to what Raffles found as a pitifully run-down establishment. He also started exploring, and in May, with Arnold, and a very game Sophia, went to Pasemah ulu Manna, about 50 miles east of Bencoolen. It was here on 19 May, at a place called Pulau Lebar on the Manna River, that a Malay servant discovered a huge flower, which, with great excitement he showed in the first instance to Arnold. It was the size that impressed the party, a yard across, of a weird, thick waxy texture, smelling of 'tainted beef', with a volume of twelve pints, a weight of fifteen pounds and (because it was later realised to be a parasite) devoid of leaves; they realised immediately that this was a prodigy of nature. Tragically Arnold caught a fever on this, his first expedition, so never saw 'his' discovery in print. However, the notes

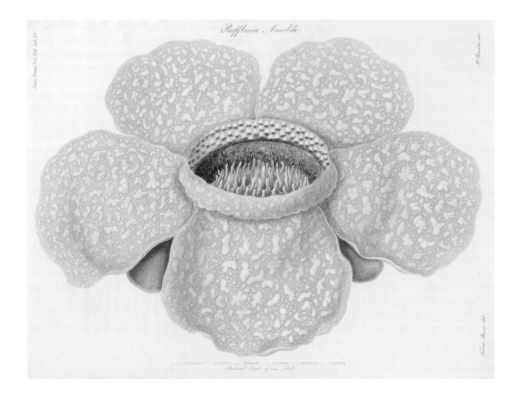

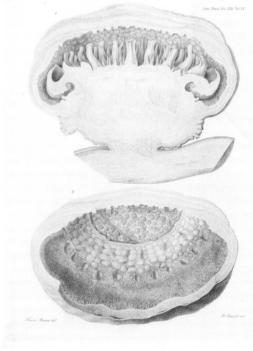

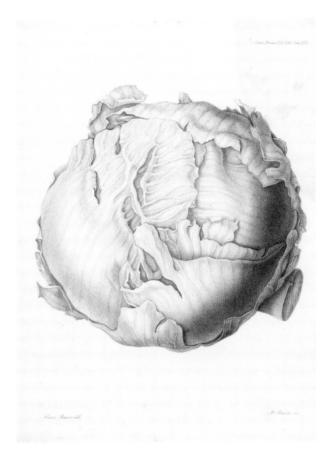

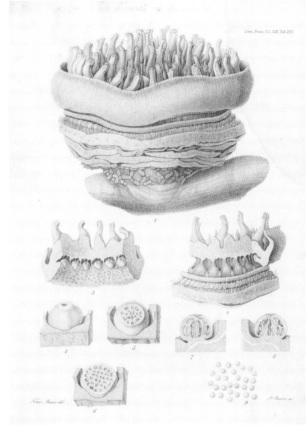

and the large drawing he made (the latter added to by both Raffles and Sophia), and his specimens of flower buds in spirit were all used by Robert Brown in his description of the plant, which he called *Rafflesia arnoldi[i]*, and that caused a sensation. This was published in 1821 in a paper of typically Brownian breadth, depth and complexity, accompanied by virtuosic engravings by James Basire after superb drawings of dissections of the flower bud, and the best reconstruction of the open flower that the great Francis Bauer could make, based on the Arnold/Raffles drawing and the pickled specimens (Figs. 16 A–D). This material reached London by courtesy of Thomas Horsfield when he finally returned from Java in 1819. This came about as Horsfield had visited Bencoolen in July 1818, when he joined the Raffles entourage for an expedition to Padang, to the north of Bencoolen, from which they explored the Central Highlands. Sir Stamford, the ever intrepid Sophia, and Horsfield went into the interior leaving Arnold at the coast, and by time they got back to Padang, the fever that had returned intermittently since May had claimed Arnold's life at the age of only 35. Arnold had had intimations of mortality and written his own epitaph before leaving England, which was duly carved in marble by Chantrey, at the expense of Dawson Turner, on a monument for Beccles church.

Raffles' political ambitions led him to visit Calcutta in October 1818, to press the case with the Marquess of

Hastings for establishing a British port at the southern end of the Straits of Malacca. This visit had huge results not only politically, but scientifically, for it was in Calcutta that Raffles met Nathaniel Wallich (Fig.17), Superintendent of the Calcutta Botanic Garden. Wallich would certainly have been impressed by Raffles' title (he had a weakness for such things), but it was clearly more than this and they became extremely close friends, united by a shared passion for natural history, and, perhaps by their both being something of 'outsiders' – Wallich was Jewish; Raffles 'not a gentleman'. More importantly Wallich at this point happened to have staying with him a brilliant 23-year old botanist, William Jack, a son of the Principal of Aberdeen University, who was recovering from consumption contracted during the Anglo-Nepal war of 1815. Jack was not only a botanical genius but also a surgeon, and Raffles invited him onto his personal staff as a successor to Arnold in both medical (Sophia was pregnant again) and scientific capacities, and, bearing in mind his wider talents, with a view to making him his personal secretary. It was also in Calcutta that Raffles met and recruited two French zoologists, Pierre Diard and Alfred Duvaucel (stepson of the celebrated zoologist Baron Georges Cuvier) to take back for the Bencoolen establishment on a salary of 1000 rupees per month, which included the salary of an artist (who may possibly also have been recruited here, though there is no record of this), on the condition that the first set of specimens belonged to the EIC, and that any resultant publications should appear in England before any subsequent version in France.

The party set sail for Penang where Jack threw himself into botanical work, probably unaware of Hunter's earlier efforts. The party was joined from Malacca by Major Farquhar who brought along his natural history drawings, of which the botanical ones Jack found deficient in the details necessary to make accurate identifications. Interestingly, only at this time is Jack recorded as having employed his own artist, a Chinese. Raffles and Farquhar left Penang in January 1819 and successfully negotiated with the local rulers to acquire the ancient, but abandoned, Malay capital of Singapura ('City of the Lion') as a British port, with notable

Fig.17 · Nathaniel Wallich, chalk drawing by Daniel Macnee, made for Professor W.J. Hooker in Glasgow, c.1830.
Royal Botanic Gardens Kew

consequences. Farquhar was left in Singapore as Resident and Commandant, and Raffles returned to Penang bearing three spectacular pitcher plants – one was already known, but two were new to science, the more spectacular of which was later published by Jack as *Nepenthes rafflesiana*, and which counts as Raffles' only personal botanical discovery (Fig.15). Raffles wrote back to the Duchess of Somerset from Penang, describing his house at this period as:

more like the menagerie at Exeter Change, than the residence of a gentleman. Fish, flesh, and fowl, alike contribute to the collection; and above stairs the rooms are variously ornamented with branches and flowers, rendering them so many arbours. There are no less than five draftsmen constantly employed, and with all our diligence we can hardly keep pace with the new acquisitions which are daily made.

After a political mission to Aceh (Acheen), in northern Sumatra, on which Raffles took the zoologists, the whole party returned to Singapore for a month in June, where much was done by way of collecting (Fig.22).

Finally, in July 1819, the party reached Bencoolen and Jack found himself surrounded by the then virtually unknown natural riches of Sumatra. Despite periodic ill-health (the tuberculosis never left him), he would spend the next three years working prodigiously hard, exploring not only the flora and geology, but, somewhat unintentionally, zoology; and also at political work for Raffles. He had a reasonable botanical library with him, but was let down by Wallich in terms of correspondence. As Raffles had also taken with him a Baptist missionary (whom Jack did not like) with a printing press, Jack was, rather amazingly, able to print some of his own work in Bencoolen. The result was three botanical papers in the *Malayan Miscellanies*, and an additional one that was 'printed but not published'; three further papers were sent back to London and appeared posthumously in the *Transactions of the Linnean Society* – together these seven works include descriptions of one new family, 31 genera and around 200 new species. Numbers are but a crude measure, and all who have subsequently worked on the flora of Southeast Asia (notably Elmer Merrill) have noticed the astonishing accuracy of Jack's work and his descriptive powers, which has allowed the interpretation of almost all of Jack's species – even in the absence of supporting specimens. This ominous statement alludes to another of the tragedies of Jack's brief, yet incandescent, botanical career. He was assiduous in collecting specimens and sent important sets to Calcutta, which Wallich appears grievously to

have neglected, as only a small number are in the 'Wallich' herbarium; a few that Jack sent to Robert Brown in London survive in the Natural History Museum; and a few more, sent to A.B. Lambert, have ended up in Geneva. The top set, with all Jack's notes were destroyed in the burning of the *Fame* in 1824, and so, by a great irony, the largest surviving set of Jack specimens (and this no more than about 60) turns out to have been sent to Edinburgh as a joke.

In August 1820 Jack received an indirect request from the Governor-General's wife, Lady Hastings, to send her an 'Hortus Siccus' for Robert Jameson's Edinburgh University Museum, in which (doubly titled, as a Scottish Countess) she took a personal interest. Jack did not like the Marchioness but had to agree 'on Sir Stamford's account to keep her in good humour' (Fig.12). But the account of the business, as reported in a letter to Wallich, must be told in Jack's own words – as representative of his boisterous spirits and naughty sense of humour, which endeared him to the relatively small circle whom he did not view with the disdain of a youthful genius. Jack complied with the request to send the specimens:

on this occasion, but mean to humbug her [Lady Hastings] *in the matter. My best specimens have all gone home, as you know ... I have therefore put up a parcel of second rate ones, with plenty of good paper, which is of more consequence (Kaleidoscopically!) and sent her such a flaming list, as will make her think she has the most precious and learned collection ever sent from India* [i.e., the East Indies]. *I trust to her indolence never to look into them; indeed if she did, I don't suppose she would know a Mangosteen from an apple, and then as for the most learned body to which they are to go, the name of the Marchioness will humbug them, and I daresay the sapient Professor of Botany* [Daniel Rutherford] *will in reply, extol her Ladyship's skill and discernment in the selection, and sound the praises of that of which he knows nothing about.*

It was noted above that Jack's zoological work was unintended, and it is time to catch up with Messieurs Diard et

Duvaucel. In late September 1819 Raffles learned of the death of the Governor of Penang, and (with Jack) made post-haste for Calcutta to press his case to succeed to the post. This position would have enabled Raffles, at last, to achieve his political ambitions for British influence over the whole of Southeast Asia. Unfortunately Lord Hastings was not able to accommodate him, and though Raffles and Jack stayed in Calcutta for four months, they returned to Bencoolen disappointed. Though it was to the clipping of Raffles' political wings that led to the time he could now devote to natural history. Another outcome of the visit was that the Supreme Government had not allowed the continuation of the salary Raffles had been paying Diard and Duvaucel. Despite offering to pay a slightly smaller amount from his own pocket, Raffles had to remind the zoologists of the terms of their engagement, which led to a major falling out. It is not an edifying tale, and one cannot fail but sympathise to some extent with the Frenchmen when Raffles insisted on taking all their specimens, notes and drawings for remission to London. This may have been what they signed up to, but made no allowance for the intellectual effort they had expended; they passionately wanted their specimens to go back to France doubtless at least in part because they would prefer them to be studied according to Cuverian methods, whereas in England zoologists were either taken in by W.S. Macleay's bizarre Quinarian system, or wedded to the outdated Linnaean. The pair obstructed as far as they could – to the point of claiming their notes had been stolen one night; unfortunately for them these were discovered next day – in a box apparently carelessly dropped by the thief, but in reality waiting to be retrieved by the zoologists. Jack ended up packing the collections for shipping, and writing up the descriptions of the animals, for which he evidently had to overcome a certain innate squeamishness: 'there will be the plague of stowing and arranging them, *cum stinkibus, et filthibus, et ceteris et ceteris*'. Following the example of Rheede (on botanical matters in Malabar) Raffles and Jack convened a committee of Sultans and Rajas to provide local information and names of the birds and animals, but it was agreed that the resulting papers (in reality the work of Jack) would appear under Raffles' name – originally intended for the Royal Society, they were read to the Linnean Society by Sir Everard Home, and published in the latter society's *Transactions*.

Raffles' hopes for a significant political rôle had come to nothing. His schemes for education and social reform (to abolish slavery, gambling and cock-fighting) at Bencoolen, to which he was passionately committed and corresponded about with two members of the Clapham Sect, Charles Grant and William Wilberforce, were also curtailed, as the EIC was interested only in improvements that would 'decrease expenses, and raise immediate revenues'. He now, therefore, threw himself into scientific work, as Raffles explained – with a certain amount of doubtless retrospective rationalization – after the sinking of the *Fame*:

> It has always appeared to me, that the value of these countries was to be traced rather through the means of their natural history, than in the dark recesses of Dutch diplomacy and intrigue; and I accordingly, at all time, felt disposed to give encouragement to those deserving men, who devote themselves to the pursuits of science. Latterly, when political interests seemed to require that I should, for a time, retire from the field, and there was little more to be done for this small settlement [Bencoolen], I have devoted a considerable portion of my time to these pursuits, and in forming extensive collections in natural history.

These pursuits included an Agricultural Society set up by Raffles, with Jack as Secretary, and spice plantations, of which one quarter of the 100,000 nutmeg trees (NHD 48.34) were bearing fruit by August 1820. In 1822 the Society sent 'pineapple varieties, mangosteen and other Malayan fruits' to the Horticultural Society in London. The natural history activities were shared by the whole Raffles family, especially at their country estate, Pematang Balam ('Dove's Ridge'), twelve miles from Bencoolen, where Raffles built a house and made a garden where he grew coffee and spices (Fig. 18). Sophia took 'her full share in these [natural history] pursuits ... Charlotte has her lap full of shells, and the boy [Leopold]

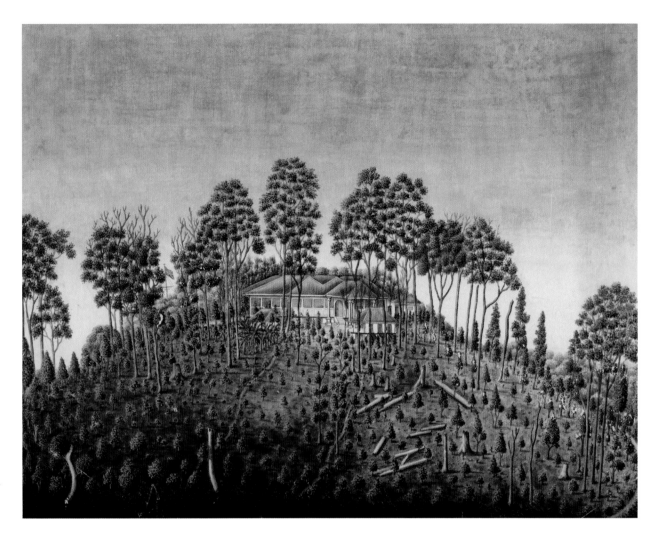

Fig. 18 · Pematang
Balam, front view of
Raffles' country house
near Bencoolen, probably
by a Chinese artist, 1824.
BL WD 2975

is usually denominated "*le jeune Aristote*'". The driveway of
the house, like that of neighbouring country estates, was an
avenue of clove trees (NHD 48.5), which Lady Raffles praised
for their 'noble height, the beauty of their form, the luxuri-
ance of their foliage, and above all the spicy fragrance with
which they perfume the air, produce, in driving through
a long line of them, a degree of exquisite please only to be
enjoyed in the clear light atmosphere of these latitudes'.
Pematang Balam, like Runnymede in Penang, was described
by Raffles as 'on one side a perfect menagerie, on another
a perfect flora; here, a pile of stones; there, a collection of
sea-weeds, shells &c', a 'perfect *regne animale*'. And it was
here that the artists were constantly at work on the natural
history drawings 'taken from life, with scientific accuracy
executed in a style far superior to any thing ... seen or heard
of in Europe' which eventually numbered between two and
three thousand. Lady Raffles recorded her husband's daily
programme of study at this period:

at nine a party assembled for breakfast, which separated immediately afterwards, and he wrote, read, studied natural history, chemistry, and geology, superintended the draftsmen, of whom he had constantly five or six employed in a veranda, and always had his children with him as he went from one pursuit to another, visiting his beautiful and extensive aviary, as well as the extraordinary collection of animals which were always domesticating in the house.

Elsewhere Sophia described a charming nursery scene of 'two young tigers and a bear [that] were for some time in the children's apartments ... without being confined in cages, and it was a rather curious scene to see the children, the bear, the tigers, a blue mountain bird [NHD 47.21] and a favourite cat, all playing together, the parrot's beak [NHD 47.33] being the only object of awe to all the party'. Other animals kept in Sumatra included a sun bear (with a taste for champagne), elephants, and two rusa (a kind of deer).

Meanwhile William Jack went on several more distant excursions, the first in October 1820 to the island of Nias, further up the west coast of Sumatra. The aim was political, to persuade the local chiefs to make the island over to the EIC, and with Jack went John Prince, a Company servant based at Tappanooly. Prince continued to employ one of the Bencoolen Chinese botanical artists after Raffles' departure for England and his own for Singapore, so it is amusing to report what Jack (never one to mince his words) thought of his companion on the trip: 'a freezing mass of ice, out of which all my fire failed to elicit one single spark', a functionary who saw 'more beauties in a well kept ledger ... than in all that ever occupied the thoughts and heads of a Linnaeus or a [Robert] Brown'. The second of Jack's excursions, in June 1821, was closer to hand, 18 miles east of Bencoolen, and botanically more rewarding – to the Sugar Loaf mountain (Gunung Bengko), with Captain Francis Salmond, harbour-master of Bencoolen, and Lady Raffles' brother-in-law Captain Harry Auber. On top Jack discovered that, despite the altitude being little more than 3000 feet, the vegetation was 'decidedly alpine' and from it he described a new rhododendron (*Rhododendron malayanum*) and a new blaeberry

(*Vaccinium sumatranum*). The locals had pleaded with the Westerners not to ascend the mountain, as its summit was the sanctum of the 'Dewas', and dire consequences would follow if the gods' spirits were disturbed. This, needless to say, was pooh-poohed, but the terrible events that followed over the next six months – doubtless coincidental – must have given pause for thought to all concerned. The first to die was the Raffles' eldest son Leopold Stamford, followed closely by that of Captain Auber, the healthiest of the party of mountain defilers. The following January (1822), two of the three surviving Raffles children succumbed to fever, Charlotte (who had been delivered on the outward voyage by Arnold, and named 'Tunjung Segara' – lotus of the sea – in addition to the more conventional Sophia), and Marsden (nicknamed 'Marco Polo'). As a result, in March, the sole remaining child, Ella Sophia, was entrusted to the care of a nurse and an attendant and sent back to England on the ship *Borneo*. The emotional effect of these bereavements on Raffles and Sophia can scarcely be imagined.

However, the losses did not stop there. Jack had never recovered from the consumption caught in the Nepal terai, and, on top of this, had contracted malaria on an excursion to Moco-Moco in March 1822. A spell in Java was tried in July, but to no avail, and Jack was on the point of departing for the Cape of Good Hope in a last, desperate, attempt to regain his health. He died on board the ship *Layton* in the harbour of Bencoolen on 15 September 1822, aged only 27. Thus ended the life of one of the most accomplished and most promising botanists ever to have worked in Southeast Asia. His friend Wallich, despite good intentions, did not serve Jack well: during his lifetime he had ignored his letters and failed to preserve large numbers of his most important specimens; posthumously he failed to write a promised biographical memoir (leaving it to W.J. Hooker, who had never even met him, to do so in 1835). Wallich did, however, raise a handsome monument to his friend, with an inscription by Bishop Reginald Heber, which stands to this day in the Calcutta Botanic Garden (Fig.19).

Jack's death occurred just as Raffles was leaving for his third and final visit to Singapore, which, by now, under

Farquhar's nurturing hand, was thriving beyond either of their most optimistic expectations. Here is not the place to discuss in any detail the falling out between the pair, which led to Raffle's high-handed sacking of Farquhar as both Resident and (more dubiously) Commandant. The older man had, pragmatically, tolerated practices such as gambling and slave-owning on the part of the indigenous population, and the two disagreed over the siting of merchants' warehouses. There was also rivalry (which rumbled on in London after the appearance of Lady Raffles' *Memoir*) over who was the real 'founder' of Singapore. However, in the present context, there is a much happier subject to deal with, because who should Raffles find already in Singapore, for the sake of his health, but Nathaniel Wallich? As many have found before and since, when human affairs are fraught and emotions lacerated by bereavement, great solace can be found in the study of natural history. Raffles and Wallich often breakfasted together and the latter was encouraged to dissect a dugong (a creature, the origin of the mermaid myth, in which Raffles had a particular interest) with the local surgeon Dr William Montgomerie. A dugong skeleton was sent by Raffles to Jameson's Edinburgh Museum in December

Fig. 19 · Monument erected to the memory of William Jack by Nathaniel Wallich in Calcutta Botanic Garden, *c*.1825.
Photo by James Simpson, November 2008

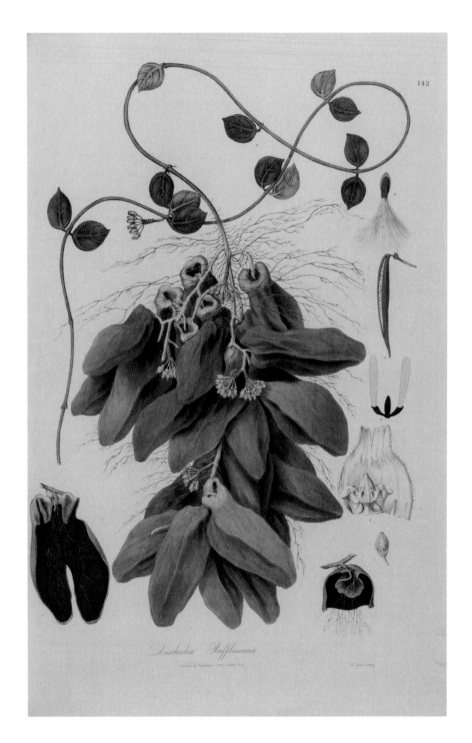

Dischidia Rafflesiana

Fig.20. *Dischidia rafflesiana*, hand-coloured lithograph by M. Gauci, after a drawing by an anonymous Indian (or Chinese?) artist, published by Nathaniel Wallich in his *Plantae Asiaticae Rariores* (1831).
Royal Botanic Garden Edinburgh

1822 and specimens were also sent to Sir Everard Home in London for his famous lectures on anatomy. Raffles and Wallich also made excursions together (Fig.23), and it was on one of these that they found an extraordinary ant-plant, in which some of the leaves are flask-shaped, filled with soil by ants, watered by rain, into which the plant grows roots to absorb extra nutrients. In 1831, in his sumptuous *Plantae Asiaticae Rariores* Wallich illustrated and named this plant after 'that most amiable and excellent man, my dear departed friend and patron' as *Dischidia rafflesiana* (Fig.20). Wallich was also encouraged to write a proposal to set up a botanic garden on Government Hill, and it was a stone thrown by him that marked the spot on which Government House was built – Raffles also assigned him a plot of land on 'Daimebroog Hill', known as Mount Wallich (later flattened). After returning to Calcutta in November 1822 Wallich took no subsequent interest in what was really an experimental garden left under the charge of Montgomerie, and the garden lasted only five years (the present Singapore Botanic Garden being founded in 1857 on a different site).

Raffles still had a 'China Man' painting flowers at this time, but threw himself into an administrative frenzy, writing a 'Constitution' for Singapore, and planning an educational institute 'for the cultivation of Asian languages, the education of the sons of Malay rulers, and the moral and intellectual improvement of the peoples of Asia', which developed into the Singapore Institution. But in these few months Raffles also indulged in what, if his scribe Abdullah is to be relied upon, can only be described as an orgy of scientific collecting:

> There were thousands of different creatures whose insides and bones had been taken out and which had been stuffed with cotton wool, so that they looked just like living animals. There were two or three chests filled with many kinds of birds which had been treated the same way. There were hundreds of bottles, large and small, tall and short, filled with snakes, centipedes, scorpions, worms, and so on. All the bottles contained spirit to preserve the specimens from decay. These also looked just as though they were

> alive. Two more chests were filled with coral, built up from thousands of shells and tiny molluscs of different kinds. Mr. Raffles prized all these specimens very highly, more than gold or diamonds. From time to time he came in to look at them for he was afraid of their being damaged or crushed. When they were all ready the chests were lightered out to the ship.

Raffles and his wife returned to Bencoolen, but a curious incident happened *en route*. Sophia was pregnant and ill, but when they asked permission to land on Java the Dutch Governor expressed mortification that Raffles should be so insensitive even to suggest such a thing, though, given her condition, an exception was made for his lady. The gods of the Sugar Loaf had still not been sufficiently avenged, and the baby, Flora, born on 19 September, survived only two months, followed shortly by the deaths of several of the closest friends the Raffleses had left in Bencoolen, including the last of the defilers of Gunung Bengko, Francis Salmond. By this time they had, not surprisingly, decided to return to England to rejoin their only surviving child. Raffles left John Prince in temporary charge of Bencoolen (which would shortly be returned to the Dutch in the deal that confirmed Singapore as British), and, on 26 January 1824, a eulogy was presented to Raffles 'to express the deep regret which fills our heart under circumstances so calculated to excite such a feeling'. One of the signatories was J. Briois, who worked in the Fort Marlborough Secretary's office, on a salary of 100 rupees, and had painted birds for Raffles. Raffles was originally to have taken the ship *Borneo*, but cancelled this in favour of the more comfortable *Fame*. All the family possessions were loaded, Sophia's music and harp, her clothes and jewellery, but the baubles were not all hers – Raffles had a diamond ring given to him by Princess Charlotte, and more diamonds awarded by the Prize Agents after the shameful sacking of Yogyakarta. Then there were the priceless Malay manuscripts, and 'all my collections in natural history,– all my splendid collection of drawings, upwards of *two thousand* in number,– with all the valuable papers and notes of my friends Arnold and Jack ... there was scarce an unknown

animal, bird, beast, or fish, or an interesting plant, which we had not on board: a living tapir, a new species of tiger, splendid pheasants, &c., domesticated for the voyage'. But on the night of 2 February, after putting out to sea, a careless sailor taking brandy from a cask with a naked candle caused a catastrophe. The people were saved, to a man, and miraculously returned to Bencoolen in small boats, but the animals and every single artefact perished: in the words of the ornithologist Sir William Jardine of Applegirth, 'the most extensive loss of materials ... ever sustained' in the field of Natural History.

This final *coup de grace* would, in Lady Raffles' words, have been 'sufficient to have depressed the spirit and dampened the ardour of the strongest mind', but Raffles' devout Christianity allowed him to accept that 'it [had] pleased God to humble' him by 'overwhelming calamity'. And, to continue the story in Sophia's words, the calamity:

> *seemed to have no other effect ... than to rouse him to greater exertion. The morning after the loss of all that he had been collecting for so many years ... he recommended sketching the map of Sumatra, set all his draftsmen to work in making new drawings of some of the most interesting specimens in natural history ... neither murmur nor lamentation ever escaped his lips; on the contrary, upon the ensuing Sabbath, he publicly returned thanks to Almighty God for having preserved the lives of all those who had for some time contemplated a death from which there appeared no human possibility of escaping.*

To this super-human effort is owed the majority of the drawings in the present catalogue (with the exception of the Hunter, Penang ones and the 'black-border' fruits). More living animals, including a tiger, two 'tiger cats', a clouded leopard, and other preserved specimens were collected in the ten weeks before sailing for a second time from Bencoolen on the *Mariner* on 10 April 1824.

Sir Stamford and Lady Raffles arrived in London in August 1824, and he started to sort and integrate these final collections with material sent in advance that was already in the EIC warehouse, together with the Javanese collections

that had been left with various friends and relations in 1817. These were initially stored in a house in Piccadilly before being moved to his intended permanent home at 23 Lower Grosvenor Street, but which proved too cramped. The collections were therefore moved to a Museum room in a larger house at Hendon, called Highwood. Raffles' health, however, was not good, still suffering from blinding headaches, that had plagued him for several years; nonetheless, he renewed his links with the London scientific community. Banks had died in 1820, but there were still old friends including the Duke and Duchess of Somerset, William Marsden, Thomas Horsfield and Sir Everard Home, and new ones to be made, including the new President of the Royal Society, Sir Humphry Davy. It was from this group, and the Zoological Club of the Linnean Society, that the Zoological Society of London was formed, with rooms in Bruton Street, and of which Raffles was elected as first President in 1826. Ever since a visit to the Jardin des Plantes in Paris in 1817 Raffles had longed to set up something similar for animals, and the

Fig.21 · *Rafflesia arnoldii*, wax model, possibly by William Tuson, made at Raffles' request in 1825 for the Horticultural Society of London, acquired by Kew in 1855. Royal Botanic Gardens Kew

result was the Zoological Gardens in Regent's Park, which still flourishes as London Zoo.

Natural science might be providing a continuing solace for Raffles, but shadows still loomed in the form of a long-running investigation by the EIC into his administration of Bencoolen (and Singapore). The verdict was eventually written dated 12 April 1826 and reads like a report on a gifted, but tiresome, schoolboy – grudgingly and mean-spiritedly allowing his 'zealous solicitude for the British interests in the Eastern Seas', but, 'in his political measures he incurred the strong disapprobation of the Court'. The pension he was seeking from the Company was denied, and, to add insult to injury, Raffles was deemed to owe £22,272 in back pay (with interest), dating largely from his period of unofficial furlough in Britain in 1816/17. His death on 5 July, less than three months after this bombshell, was due to a brain tumour (discovered by Sir Everard Home, who dissected his old friend), but the stress cannot have helped, and the Company doubtless thought they treated the widow handsomely when they let her off with a single payment of £10,000 in a once and for all settlement of Sir Stamford's debt. Such were the thanks given by the pre-eminent multi-national trading company to the 'founder' of Singapore! The British state was no more generous, and Lady Raffles in 1834 had to pay £1500 from her own pocket for the statue by Chantrey that she placed in the national shrine, Westminster Abbey. To reach it in the north choir aisle one steps over the tomb of his patron Minto, and the handsomely youthful statue, with a coyly fulsome epitaph ('he founded an Emporium at Singapore'), is placed among the monuments to musicians, peering down upon the mortal remains of that greatest of all English composers, Henry Purcell.

But there is a more edifying, botanical, note on which to end. Raffles was justifiably proud of his 'stupendous flower of Sumatra' and approached the firm of Weddell, noted botanical engravers who worked for A.B. Lambert, who also made some of the plates for *Plantae Javanicae Rariores*, to make what can only be described as a 'swagger portrait' of his great flower. This was two-thirds natural size, and struck off in an edition of 'no more than 50 or 60'. Shortly before his death it was ready, and hand coloured copies were sent to old friends including William Marsden, and to the Royal Asiatic Society, which received its copy on 18 March 1826. In May 1826 William Hooker enquired of Raffles about having a life-size wax model of a *Rafflesia* flower made, and in reply, Raffles, in one of his last letters, said that for £20 he was happy to supervise another version of the sort that had been made the previous year, for himself, the Linnean and Horticultural Societies (Fig.21). As the surviving model at Kew (acquired in May 1855) is the Horticultural Society version, made for £12, possibly by William Tuson, it would seem that the Hooker commission came to nothing. Raffles also promised to send Hooker a coloured copy of the engraving, but it is likely that Raffles' death intervened and it would appear that Hooker was only able to obtain the uncoloured copy that is still at Kew. After his death Lambert and Weddell produced a final tribute to Raffles, a pair of magnificent double-elephant engravings of two of the pitcher plants Raffles had discovered on his first visit to Singapore, one of which, thanks to William Jack, commemorates his name – *Nepenthes rafflesiana* (Fig.15). Given the astonishing vicissitudes of Raffles' life, it is entirely appropriate that he should be immortalised in a genus named for a drug, *nepenthes pharmakon* cited by Homer as capable of banishing grief from the mind.

IV The Illustrations

The sequence of illustrations is largely as in the album
in which they were placed by Raffles (which within
the groups of animals and plants appears to have been
random). The position of some have been altered in order
to keep related drawings or organisms together (such
changes can be seen from the shelf marks).

Notes on the illustrations are arranged as follows:

Current scientific name *followed by authority*
FAMILY

Vernacular names. The *Malay* names of birds are taken from Wells
(1999–2007) and strictly refer to Peninsular Malaysia; those of
plants largely from Burkill (1935).

Notes on the organisms depicted. Information on birds taken
mainly from del Hoyo *et al*. (1992–2007); on plants from a number
of sources especially Burkill (1935).

Notes on the drawings, including related examples
in other collections.
Exhibition history.

Annotations
Paper type; watermark
Medium; dimensions (height × width)
Artist
British Library shelf mark

Nectarinia jugularis (L.)

NECTARINIIDAE

Kelicap pantai; olive-backed sunbird

The Old World sunbirds superficially resemble the New World hummingbirds in their appearance and habits, especially in feeding on flower nectar. This is a small species about 10 cm in length, widespread in SE Asia from China and the Philippines southwards through the Malay Peninsula to Indonesia, New Guinea and Australia. It is the commonest sunbird in the lowlands of the Sunda region and occurs in coastal scrub, gardens and mangroves, visiting flowering trees and shrubs, including mistletoes (*Loranthus* spp.), in noisy parties. This drawing shows the male, but a pigment change has taken place in the throat area, which should be dark metallic purple. Described from the Philippines, in the genus *Certhia*, by Linnaeus in 1766. The subspecies occurring in Sumatra is *N. jugularis ornatus* (Lesson).

Note. Probably a copy of NHD 47.2.

Inscribed in Jawi: *cecap jantung*
Paper: cream, wove; no watermark
Watercolour, bodycolour, pencil, silver-leaf and gum arabic; 244 × 360 mm
Almost certainly by J. Briois
NHD 47.1

Aegithina tiphia (L.)

CHLOROPSEIDAE

Burung kunyit kecil; common iora

This drawing shows a pair of common ioras – the male, with a black tail, on the left. The bird is up to 17 cm in length, and is widespread in the Indian Subcontinent and SE Asia, where it occurs in disturbed and open woodland, and coastal forest including mangroves, usually only up to an altitude of 800 metres. It usually keeps hidden among the leaves of trees, either singly or in pairs, feeds largely on insects and makes nests, felted with cobwebs, on branches or in the forks of trees. It was described from Bengal (in the genus *Motacilla*) by Linnaeus in 1758. The subspecies occurring in Sumatra is *A. tiphia horizoptera* Oberholser. This is almost certainly the same species of which Raffles sent a drawing to the India Museum in 1821 (NHD 4.614), which Horsfield identified as *Iora scapularis*. The Jawi name appears to be misapplied, as it refers to the species known to Raffles as *Turdus melanocephalus* (= *Pycnonotus atriceps* (Temminck)) which has somewhat similar colouration.

Inscribed in Jawi: *burung lilin*
Paper: cream, wove; no watermark
Watercolour, bodycolour and pencil; 266 × 370 mm
Almost certainly by J. Briois
NHD 47.3

Hemipus hirundinaceus *(Temminck)*

CAMPEPHAGIDAE

Burung rembah sayap hitam; black-winged flycatcher-shrike

The male bird (about 15 cm in length) is on the left, but oxidation of the silver leaf has changed the colour of the metallic black the artist intended to show on the back and upper parts; the female is on the right. Occurring from Peninsular Malaysia and Sumatra through Java to Borneo, in forest canopy, including mangroves and plantations, up to an altitude of 1500 metres. It lives in pairs or small groups, often mixed with other species, and feeds on small insects caught on short flights, or while hovering under foliage. Nests are made on tree branches up to 40 metres from the ground. Described from Java, in the genus *Muscicapa*, by C.J. Temminck in 1822. Raffles recorded this species in his Sumatran *Catalogue* (1822: 308) as an un-named species of *Lanius* (no. 12) that he had 'only very recently procured'.

Note. A related drawing in the 'Diard & Duvaucel' collection (NHD 4.605).

Paper: cream, wove; no watermark
Watercolour, bodycolour, pencil, silver-leaf and gum arabic; 268 × 372 mm
Almost certainly by J. Briois
NHD 47.4

Dendrocopos moluccensis
(J.F. Gmelin)

PICIDAE

Burung belatuk belacan; *tukki lilit* (Raffles); Sunda woodpecker

This, an eastern subspecies (*D. moluccensis moluccensis*) of the s and se Asian brown-capped woodpecker, occurs in western and southern Peninsular Malaysia, Sumatra, Java, Borneo and the Lesser Sunda Islands, where it occurs in habitats such as coastal scrub, light deciduous forest and old plantations up to an altitude of 2200 metres. In Sumatra it has become commoner with opening up of the forests. A small woodpecker, about 13 cm in length, of which the male is depicted here, it is usually solitary, and feeds on insects, fruit and sometimes nectar. It nests in holes excavated in dead tree branches (shown in this drawing), usually between 4 and 10 metres from the ground. It was described in 1788, in the genus *Picus*, by J.F. Gmelin who believed the specimen to be from the Moluccas, but which was actually from Malacca.

Note. A related drawing in the 'Diard & Duvaucel' collection (NHD 4.566).

Inscribed in Jawi: *tuki*
Paper: cream, wove; no watermark
Watercolour, bodycolour and pencil; 265 × 310 mm
By J. Briois (signed)
NHD 47.5

Copsychus saularis (*L.*)

TURDIDAE

Murai kampung; moorai, moorai kichou
(Raffles); oriental magpie-robin

This is a male bird, which takes its English
name from its black and white markings, but
is really a type of thrush. It has a character-
istic habit of lowering and fanning its tail,
before raising it to the position shown in this
drawing. A common species, found through-
out India, China and SE Asia. About 20 cm in
length, it occurs in lowlands up to an altitude
of about 1500 metres, in gardens, mangroves,
and secondary forest. It feeds mainly on the
ground, eating beetles, crickets and other
insects, and invertebrates such as leeches
and earthworms. The magpie-robin has a
wide range of song (including imitations of
other species) and in some areas has become
reduced in numbers due to trapping for the
cage bird trade. The subspecies shown here
is *C. saularis musicus*, described by Raffles as
a species of *Lanius*, which he noted as 'one of
the few singing-birds of India'. The species
was described from Bengal (in the genus
Gracula) by Linnaeus in 1758.

Note. A related drawing in the 'Diard & Duvaucel'
collection (NHD 4. 603).

Inscribed in Jawi: *murai*
Paper: cream, wove; no watermark
Watercolour, bodycolour and pencil; 267 × 366 mm
By J. Briois (signed)
NHD 47.7

Copsychus malabaricus
(*Scopoli*)

TURDIDAE

Murai rimba; changchooi (Raffles);
white-rumped shama

A large thrush, to 28 cm in length (including the
long tail). Occurring in the Western Ghats of
India and Sri Lanka, and from north-east India
through Burma, southern China and Indo-
China through Peninsular Malaysia to Sumatra,
Java and Borneo; the subspecies occurring on
Sumatra is *C. malabaricus tricolor* (Vieillot).
It lives in forest undergrowth, including dip-
terocarp forest, plantations and mangroves,

usually below an altitude of 800 metres. A shy bird, its food includes insects, moths, ants, caterpillars and berries; it is territorial and makes nests in natural hollows of tree trunks, and in bamboo clumps. Described in 1788 by Scopoli (in the genus *Muscicapa*), from Mahé on the Malabar Coast of India. Raffles included this in his *Catalogue* under the name *Lanius macrourus* and he noted the resemblance to the magpie robin. The open beak refers to its prowess as a songster; Raffles noted that this species had 'even a finer and sweeter note than [the *moorai*] ... They are, in fact, the Nightingales of the eastern islands. Both kinds throw up and spread their tails in the manner of Wagtails'.

Note. A related drawing in the 'Diard & Duvaucel' collection (NHD 4.604).

Inscribed in Jawi: *murai batu*
Paper: cream, wove; J WHATMAN 1820
Watercolour, bodycolour and pencil; 270 × 370 mm
By J. Briois (signed)
NHD 47.22

Cyornis cf. turcosus *Brügemann*

MUSCICAPIDEAE

Sambar biru Malaysia; Malaysian blue-flycatcher

There are several very similar species of blue-flycatcher in the Sunda region – insectivorous birds, which catch prey on short flights from a perch. The blue throat shown on this drawing suggests the above identification, but it is also possible that it represents *Cyornis rufigastra* (Raffles), the mangrove blue-flycatcher, described by Raffles in 1822

(of which he sent a drawing (NHD 4.618) to the India Museum). Both of these species occur in the lowlands of Peninsular Malaysia, Sumatra and Borneo, but the slightly smaller Malaysian blue-flycatcher is more widespread, also occurring in Java, Sulawesi, Palawan and the Philippines; it also occurs further inland.

Inscribed in Jawi: *cecap*
Paper: cream, wove; no watermark
Watercolour, bodycolour and pencil; 265 × 310 mm
By J. Briois (signed)
NHD 47.6

Merops viridis *L.*

MEROPIDAE

Burung berek-berek pirus;
blue-throated bee-eater

This medium-sized bee-eater is about 21 cm in length, but with tail streamers to a further 9 cm. It occurs from Indo-China and the Philippines southwards through Peninsular Malaysia, Sumatra, Borneo and Java, but is partly migratory and in summer some populations move northwards into southern China. It was described from Java by Linnaeus in 1758. The bird is found in open countryside and woodland, usually close to the sea, and nests in holes excavated by the birds themselves in sandy banks and dunes, in colonies of up to 1000 nests. Food includes honey bees and dragonflies, caught from perches and wires, and insects that are often taken from the surface of water. In 1822 Raffles described a new species, *M. sumatranus* (of which he had sent a specimen and drawing to the India Museum), but this is not now regarded as distinct from the earlier Linnaean *M. viridis*, of which the typical subspecies is found in Sumatra.

Note. A related drawing in the 'Diard & Duvaucel' collection (NHD 4.575).

Paper: cream, wove; no watermark
Watercolour, bodycolour and pencil; 265 × 366 mm
By J. Briois (signed)
NHD 47.8

Todiramphus chloris (*Boddaert*)

ALCEDINIDAE

Burung pekaka bakau;
collared kingfisher

A noisy, medium-sized kingfisher, to 25 cm in length, the commonest kingfisher in Sumatra, Java and Bali. Widespread in SE Asia and the northern coasts of Australia, with outliers in western India and around the Red Sea, the sub-species occurring in Sumatra is *T. chloris laub-mannianus* (Grote). A mainly coastal species, especially of mangroves, though also in coconut plantations, rice fields and gardens, and spreading along rivers and up to an altitude of 1200 metres. It feeds largely on fish and crustaceans, though inland it eats other food, including insects and lizards; large prey is battered on a perch before consumption. It nests as isolated pairs, and a territory is defended year-round, the nest being excavated in banks, termite mounds or dead trees. It was first described (in the genus *Alcedo*) by Boddaert in 1783, from a specimen believed to come from the Cape of Good Hope, but actually from the Moluccas (Buru). Raffles sent a specimen to the India Museum in 1820. Horsfield knew this as '*Halcyon collaris* Scop.', a name now restricted to the form of the species from Palawan and the Philippines. Quoting George Finlayson, Horsfield noted that in Thailand 'the feathers … are in great request with the Chinese for making ornaments. The skins … sold at the rate of 24 for a dollar'.

Note. A related drawing in the 'Diard & Duvaucel' collection (NHD 4.572).

Paper: cream, wove; J WHATMAN 1820
Watercolour, bodycolour and pencil; 272 × 368 mm
'Par J. Briois' (signed)
NHD 47.11

Ceyx erithaca (*L.*)

ALCEDINIDAE

Burung pekaka sepah; *binti abang* (Raffles);
oriental dwarf-kingfisher

A small kingfisher, about 14 cm length. Oxidation of the silver leaf used on the back and wing coverts has turned what should be a bluish-black into grey. This variable species (including forms with rufous backs) occurs in Sri Lanka and western India, and from north-east India through Indo-China and Peninsular Malaysia to Sumatra, Borneo and the Lesser Sunda islands. It occurs in deciduous and evergreen forests, palm and bamboo thickets, often near streams and ponds, mainly in the lowlands, but sometimes up to 1300 metres. It feeds mainly on insects, including mantises and grasshoppers, which it catches on forays from a low perch, but also spiders taken from the web, and makes shallow dives for small fish, crabs and frogs. It nests in holes in banks, termite mounds or cavities in soil in tree roots, often some way from water; the nest hole is excavated by the pair and can be up to a metre in length. Described from Bengal (in the genus *Alcedo*) by Linnaeus in 1758. This is almost certainly the species recorded under the name '*Alcedo tridactyla* Linn.' in Raffles' Sumatran *Catalogue*.

Note. A related drawing in the 'Diard & Duvaucel' collection (NHD 4.574).

Paper: cream board; no watermark
Watercolour, bodycolour, pencil and silver-leaf;
220 × 250 mm
Almost certainly by J. Briois
NHD 47.9

Alcedo meninting *Horsfield*
ALCEDINIDAE

Burung pekaka bintik-bintik; *binti* (Raffles);
blue-eared kingfisher

A small kingfisher, to 17 cm in length.
Widespread from north-east India, through
Burma and Indo-China to Sumatra, Java,
Lombok, Borneo, Sulawesi and Palawan, also
occurring in western India and Sri Lanka. Its
habitat is along watercourses in evergreen
forest, beside estuaries and in mangrove for-
est, from sea-level up to an altitude of 1000
metres. The nest is dug into an earth bank
and can be up to a metre long. Described by
Horsfield from Java in 1821, the epithet is
taken from the local name there – *meninting*.
Horsfield reported that it fed on fish and
aquatic insects, caught from 'darts in short
rapid flights along the surface, among rivulets
and lakes, emitting as it moves shrill sounds
in a high key'. These sounds are so strong
and acute that 'when the bird is near, they
strike the ear in an unpleasant manner'. The
subspecies occurring in Sumatra is the typical
one.

Note. A related drawing in the 'Diard & Duvaucel'
collection (NHD 4.573).

Inscribed in Jawi: *bengkakum*
Paper: cream, wove; no watermark
Watercolour, bodycolour and pencil; 270 × 368 mm
Almost certainly by J. Briois
NHD 47.12

Cissa chinensis *(Boddaert)*
CORVIDAE

Gagak hijau; green magpie

A large, noisy, bright green magpie, to
24 cm in length. The green parts of the
plumage change to blue after death, so
this drawing must have been made from a
dead specimen or skin. It occurs from the
Himalaya and southern China, into SE Asia
(through Peninsular Malaysia to Sumatra
and Borneo). A shy bird of dense, evergreen
forest of the submontane and montane
zones, on Sumatra it occurs mainly between
altitudes of 700 and 2100 metres, and is
more often heard than seen. It lives in small
family groups and feeds on insects (includ-
ing hornet larvae taken from the nest) and
bird chicks (including those of swiftlets).
Described in 1783 by Boddaert from Burma
in the genus *Coracias*. The subspecies occur-
ring in Sumatra is *C. chinensis minor* Cabanis.

Paper: cream, wove; no watermark
Watercolour, bodycolour and pencil; 270 × 370 mm
Almost certainly by J. Briois
NHD 47.13

Cymbirhynchus macrorhynchos *(J.F. Gmelin)*

EURYLAIMIDAE

Takau rakit; burong palano, tampalano (Raffles); black-and-red broadbill

Broadbills are colourful birds of lowland forest that catch flying insects from perches, with a 'loud snap of the large bill'; this species is about 24 cm in length, and occurs from southern Burma and Indo-China, through Thailand to Malaysia, Sumatra and Borneo. In this drawing the silver leaf used on the head, back and wing coverts has oxidised to grey, but would originally have been a metallic black. Raffles reported it (under the name *Eurylaimus lemniscatus*) as 'found in the interior of Sumatra, frequenting the banks of rivers and lakes, and feeding on insects and worms. It builds its nest pendent from the branch of a tree or bush which overhangs the water, and is said to lay only two eggs'. To this may be added that it occurs up to an altitude of 900 metres, and that it also eats small fruits. Edward Blyth, Darwin's Calcutta correspondent, recorded that the beautiful blue of the beak faded within 'a day or two after death'. Described in the genus *Todus*, from Borneo, by J.F. Gmelin in 1788, the typical subspecies also occurs in Sumatra.

Note. A related drawing in the 'Diard & Duvaucel' collection (NHD 4.662).

Paper: cream board; J WHATMAN 1816
Watercolour, bodycolour, pencil, silver-leaf and gum arabic; 244 × 365 mm
Almost certainly by J. Briois
NHD 47.15

Pycnonotus bimaculatus *(Horsfield)*

PYCNONOTIDAE

Orange-spotted bulbul

A medium-sized bulbul, about 20 cm in length. This species occurs only in Sumatra, Java and Bali, where it is found commonly in montane forests at altitudes of 800 to 3000 metres. It is a noisy, active bird, which moves about in small parties or singly, feeding mainly on fruit, but also some insects. The nest is built in trees up to five metres from the ground. Described (in the genus *Turdus*) in 1821 by Horsfield from Java, where he recorded the local name as *chuchak-gunung*; the typical subspecies also occurs on Sumatra.

Paper: cream board; J WHATMAN 1816
Watercolour, bodycolour and pencil; 205 × 252 mm
Almost certainly by J. Briois
NHD 47.17

Aplonis panayensis (*Scopoli*)

STURNIDAE

Perling mata merah; *biang, kalaloyang, burong kling* (Raffles); Asian glossy starling

The adult male Asian glossy starling shown here is about 20 cm in length; the species is distributed from north-east India and throughout SE Asia to the Philippines and Sulawesi. Raffles included this species in his Sumatran *Catalogue* under the name *Lanius insidiator*. Raffles (or Jack) wrote: 'the name Burong Kling has been appropriated to this bird, because he is black and has red eyes; sure signs, it is said, of a bad character; and also because, when he settles on a tree, he generally leaves behind him the seed of the fig or other parasitic plant, which, growing, in time chokes and destroys the tree that nourished and protected it. Such is said to be the conduct of the men of Kling or Coromandel to those who receive them.'

Note. A related drawing in the 'Diard & Duvaucel' collection (NHD 4.602).

Inscribed in Jawi: *kala' luyang perempuan* [= female]
Paper: cream, wove; J WHATMAN 1820
Watercolour, bodycolour, pencil, silver-leaf and gum arabic; 257 × 370 mm
Almost certainly by J. Briois
NHD 47.19

Aplonis panayensis (*Scopoli*)

STURNIDAE

Perling mata merah;
Asian glossy starling

The glossy starling lives in gardens, open forest, mangroves and coconut plantations and is common in the lowlands up to an altitude of 1200 metres. It feeds in noisy groups of up to about 50, eating insects and fruit, groups coming together in the evening to form large roosts in trees. Nesting was probably originally on cliffs and in tree holes, but is now largely in buildings and other man-made structures. It was described by Scopoli, in the genus *Muscicapa*, from the Philippines in 1783, but the subspecies occurring on Sumatra is *A. panayensis strigata* (Horsfield), originally described from Java in the genus *Turdus*. This drawing shows a female, or immature specimen, with a spotted, pale chest. The Jawi annotations on this and the previous drawing have been reversed, doubtless by a scribe who didn't know the difference between male and female of this species.

Inscribed in Jawi: *kala luyang laki-laki* [= male]
Paper: cream, wove; no watermark
Watercolour, bodycolour and pencil; 257 × 370 mm
Almost certainly by J. Briois
NHD 47.20

Irena puella (*Latham*)

IRENIDAE

Murai gajah; *biang kapoor* (Raffles);
Asian fairy-bluebird

This species, which is up to 26 cm in length, occurs from the eastern Himalaya to Burma, through Indo-China, Thailand and Peninsular Malaysia to Sumatra, Java, Borneo and Palawan; the subspecies occurring on Sumatra is *I. puella crinigera* Sharpe. It lives in tall evergreen forest, up to an altitude of 1800 metres, feeding mainly on fruit, and nesting in the lower to middle forest storey. The open beak of this drawing alludes to the 'loud, ringing, drawn-out, liquid whistles' made by this bird. Horsfield in his *Description of Birds from the Island of Java* realised that this beautiful bird (described in 1790 from Travancore in South India by John Latham, in the genus *Coracias*) belonged to a new genus to which he gave the name *Irena*. Raffles (1822) wrote that 'nothing can surpass the richness of the colours which distinguish the male of this species, they far exceed what any painting can convey. The crown of the head, back, smaller wing-coverts, and upper and lower tail-coverts are of the most resplendent smalt-blue, while every other part is of the finest velvet-black'. On this drawing the silver leaf used on the back and wing coverts has oxidised – making what was once bright, shining blue into a dull grey.

Note. A related drawing in the 'Diard & Duvaucel' collection (NHD 4.590).

Paper: cream, wove; J WHATMAN 1820
Watercolour, bodycolour, pencil, silver-leaf and gum arabic; 270 × 370 mm
Almost certainly by J. Briois
NHD 47.21

Oriolus chinensis L.

ORIOLIDAE

Burung kunyit besar; *tiong alou* or *punting alou*
(Raffles); black-naped oriole

This is the eastern element of a superspecies of which the western form is the European golden oriole. The bird is about 26 cm in length, and is widespread in China, reaching the eastern Himalaya, and southwards throughout SE Asia (Burma, Indo-China, Thailand, Peninsular Malaysia, Sumatra, Java and Lesser Sunda islands to Alor, Sulawesi and the Philippines). The subspecies occurring in Sumatra is *O. chinensis maculatus* Vieillot. It lives in pairs or small family parties, and occurs in mangroves, coastal forests, gardens and plantations, and in open forests inland up to an altitude of 1600 metres. Like other orioles, it has a loud, clear and melodious song, feeds on fruit and insects, and nests in trees. Described by Linnaeus in 1766, from the Philippines.

Note. A related drawing in the 'Diard & Duvaucel' collection (NHD 4.593).

Inscribed in Jawi: *tiung alu*
Paper: cream, wove; no watermark
Watercolour, bodycolour and pencil; 265 × 373 mm
'Par J. Briois'
NHD 47.23

بـيغـلا

Batrachostomus cornutus *(Temminck)*

PODARGIDAE

Sunda frogmouth

This genus of nocturnal bird, with widely gaping beaks, is extremely difficult taxonomically due to variation in plumage colour between individuals and sexes, and there is no agreement on specific delimitation. This drawing was previously identified as Blyth's frogmouth, *Batrachostomus javensis affinis* Blyth, but that species rarely occurs in Sumatra, and the slightly larger Sunda frogmouth was actually described from Bencoolen (in the genus *Podargus*), by C.J. Temminck in 1822.

Inscribed in Jawi: *sikuk balam*
Paper: cream, wove; no watermark
Watercolour, bodycolour and pencil; 267 × 419 mm
Almost certainly by J. Briois
NHD 47.26

Caprimulgus affinis *Horsfield*

CAPRIMULGIDAE

Sang sagan (Raffles); savannah nightjar

A nocturnal, insectivorous species wide‑spread in India and SE Asia. This drawing shows a female or juvenile bird. The species was described by Horsfield from Java, and the typical subspecies also occurs in Sumatra. Raffles (1822) recorded it (under the name *C. europaeus* L., which refers to the European nightjar, or goatsucker), as 'very abundant in the neighbourhood of Bencoolen, and ... always seen flying about in the evening. They make no nests, but lay their eggs on the bare ground'.

Note. A related drawing in the 'Diard & Duvaucel' collection (NHD 4.629).

Inscribed in Jawi: *sang sakan*
Paper: cream, wove; no watermark
Watercolour, bodycolour and pencil; 266 × 370 mm
Almost certainly by J. Briois
NHD 47.25

Pitta guajana *(Statius Müller)*

PITTIDAE

Burung pacat berjalur; banded pitta

This unfinished drawing shows the male of the subspecies *P. guajana irena* Temminck, which is restricted to Peninsular Malaysia and Sumatra (other subspecies occur in Java and Borneo). The species was described in 1776 (in the genus *Turdus*) from eastern Java; but the subspecies shown here was described only in 1836, a decade after this drawing was made, from Sumatra – by Coenraad Jacob Temminck, director of the National Museum of Natural History of the Netherlands at Leiden. The bird, which is about 22 cm in length, occurs mainly in primary forest, up to an altitude of 1500 metres, and feeds on snails, earthworms and insects. The nest is a large, globular mass of leaves with a lateral entrance, made two to three metres above the ground.

Paper: cream, wove; no watermark
Watercolour, bodycolour and pencil; 267 × 373 mm
Almost certainly by J. Briois
NHD 47.24

Harpactes diardii (*Temminck*)

TROGONIDAE

Burung kesumba diard; Diard's trogon

A large, black-headed trogon, to about
34 cm in length. The bird shown here is
a male (the female has a brown head).
The species occurs in southern Thailand,
Peninsular Malaysia, Sumatra, Borneo
and the intervening islands. In Peninsular
Malaysia it is found in the middle and
lower storeys of evergreen and semi-
evergreen lowland forest up to an altitude
of about 900 metres, and in Sumatra in
peatswamp forest. Mainly insectivorous, it
takes prey (including caterpillars, beetles
and stick-insects) on forays made from a
perch, and nests in tree cavities. Described
in 1832, in the genus *Trogon*, from Borneo
and Bangka by C.J. Temminck, the sub-
species occurring in Sumatra is *H. diardii
sumatranus* W.H. Blasius. The name com-
memorates Pierre Diard, one of the zoolo-
gists Raffles took with him to Sumatra in
1818, and with whom he later fell out.

Paper: cream, wove; C WILMOTT 1819
Watercolour, bodycolour and pencil;
272 × 375 mm
Almost certainly by J. Briois
NHD 47.28

Platylophus galericulatus *Cuvier*

CORVIDAE

Burung menjerit;
crested jay

Due to its large crest (the long part of which consists of only two feathers), a very distinctive jay, to about 28 cm in length. It occurs in Thailand and Burma, Peninsular Malaysia, Sumatra, Java and Borneo, where it lives in lowland (including freshwater swamp) forest up to an altitude of about 1200 metres. It travels in small parties, and when encountering people is said to be noisy and repeatedly raise and lower its crest. David Wells reports the call as 'an explosive, shrieking rattle, uncomfortably intense at close range'. The bird feeds on insects, including caterpillars. Described by Cuvier from Java in 1816 in his *Règne Animale*; the subspecies occurring in Sumatra is the typical one.

Note. A related drawing in the 'Diard & Duvaucel' collection (NHD 4.600).

Paper: cream, wove; C WILMOTT 1819
Watercolour, bodycolour and pencil; 362 × 272 mm
Almost certainly by J. Briois
NHD 47.29

Lanius schach *L.*

LANIIDAE

Tirjup ekor panjang; *burong papa* or *tiup api*
(Raffles); long-tailed shrike

A very widespread species occurring from
Iran to China, India, and SE Asia eastwards
to New Guinea. It was described from
China by Linnaeus in 1758, but this drawing
shows the subspecies *L. schach bentet*, the
form occurring in SE Asia (other than the
Philippines). This was originally described
(at specific rank) by Horsfield from Java, the
epithet being the local name *bentet*. A large
shrike, to about 25 cm in length, it is common
in Sumatra and Borneo, occurring in open
habitats such as grassland and scrub up to
about 1600 metres. It is largely insectivorous,
feeding on beetles and grasshoppers on the
ground, and flying insects, which it catches
on darting forays from a low perch on bushes,
fence posts or wires. It sometimes attempts
larger prey including lizards and small birds,
and has been recorded as impaling a frog on a
broken stem (a habit known in other 'butcher
birds'). A specimen of this species was sent
by Raffles to the India Museum with the 1820
collections.

Note. A related drawing in the 'Diard & Duvaucel'
collection (NHD 4.594).

Inscribed in Jawi: *burung papa*
Paper: cream, wove; no watermark
Watercolour, bodycolour and pencil; 360 × 274 mm
Almost certainly by J. Briois
NHD 47.30

Pericrocotus flammeus *(Forster)*

CAMPEPHAGIDAE

Burung matahari besar; scarlet minivet

This drawing shows the male bird; in the female the scarlet parts are yellow and the back grey. Though there are other very similar species the identification is fairly certain, as the drawing shows the distinctive red patch on the secondary wing feathers. The silver leaf on the head and wing coverts has oxidised, so what should be metallic black has turned grey. This species, which is about 20 cm in length, is widespread – occurring in Sri Lanka, western India and the Himalayas, and throughout SE Asia eastwards to the Lesser Sunda islands, Borneo and the Philippines; the subspecies occurring in Sumatra is *P. flammeus xanthogaster*, originally described by Raffles from a female specimen as a species of the genus *Lanius* (of which there is a related drawing NHD 4.606). The bird can occur in flocks (sometimes with other species), feeds mainly on insects, and forages in forest of various kinds in the lowlands and hills up to an altitude of about 2000 metres. The species was described, from Ceylon, in the genus *Muscicapa*, by Johann Reinhold Forster in Pennant's *Indian Zoology* (1781).

Paper: cream board; J WHATMAN 1816
Watercolour, bodycolour, pencil, silver leaf and gum arabic; 204 × 228 mm
Almost certainly by J. Briois
NHD 47.31

Chalcophaps indica (L.)

COLUMBIDAE

Punai tanah; *limoo-an* of the Sumatrans (Raffles); emerald dove

A ground dove, about 25 cm in length, widespread in India, southern China and SE Asia through New Guinea into northern and eastern Australia. It occurs, usually singly or in pairs, in lowland (including mangrove) and submontane forest, up to an altitude of about 1500 metres. It feeds on the forest floor mainly on seeds and fruit, and some insects, and nests in trees. This drawing shows the male; the female lacks the grey crown, white eye-stripe and white carpal patch. Described from Calcutta (in the genus *Columba*) by Linnaeus in 1758, the typical subspecies also occurring in Sumatra. Raffles (1822) gave a detailed account of the means of trapping this species: 'A small mat shed is erected sufficient to conceal the fowler; a space is cleared in front of it, and a tame Pigeon placed on it: a trumpet is then blown within the hut, and the wild Pigeons are attracted to the sound; when they alight they are taken by a running-noose at the end of a wand, which the fowler manages without being seen by the birds'.

Inscribed in Jawi: *punai tanah*
Paper: cream, wove; J WHATMAN 1820
Watercolour, bodycolour, pencil, gold-leaf and gum arabic; 255 × 355 mm
Almost certainly by J. Briois
NHD 47.32

Caloenas nicobarica (*L.*)

COLUMBIDAE

Punai mas; Nicobar pigeon

A large pigeon, to 40 cm in length, with unique long hackles. The adult has a white tail, so this drawing must show an immature bird. This is a strictly coastal species, occurring from the Andaman and Nicobar Islands, throughout the Indonesian archipelago and Philippines to New Guinea and northern Melanesia. Mainly active at dusk, it feeds, often in flocks of up to 85, travelling widely for seasonal fruits, and nests in colonies of up to several thousand pairs. The species was described in the genus *Columba* by Linnaeus, in 1758, from the Nicobar Islands. It occurs mainly on small, wooded, offshore islands, and this drawing may not have been painted at Bencoolen as, significantly for such a conspicuous bird, it was not included in Raffles' paper on Sumatran birds (1822). The bird is such a curiosity that (as with the drawings of exotic fruits) copies may have been in circulation among collectors, and there is a similar drawing in the Farquhar collection (SHM 1995.3215).

Paper: cream, wove; no watermark
Watercolour, bodycolour, pencil, gold- and silver-leaf and gum arabic; 352 × 530 mm
Probably by J. Briois
NHD 47.38

Tanygnathus sumatranus (*Raffles*)

PSITTACIDAE

Kéké (Raffles); blue-backed or Müller's parrot

This drawing shows the blue-backed parrot, described by Raffles in the genus *Psittacus*. There is a mystery over the distribution of this species as Raffles specifically included it among the parrots native to Sumatra, but the name has since been applied to a species native to Sulawesi and the Philippines, where it occurs in a number of subspecies varying in colour. It is conceivable that it occurred as a feral population in Sumatra, having been introduced as a cage bird, as Raffles noted that there were 'numerous species met with in captivity [in Sumatra], which have been brought from the more eastern islands'. One of these eastern species (which he knew as '*Psittacus cyanogaster*') Raffles kept as a pet, which attended 'regularly at table', courted 'the caresses of all, and shows an extraordinary degree of jealousy if the slightest attentions are paid to any other favourite'. In its native habitat the blue-backed parrot is found in lowland and lower montane forest up to an altitude of about 500 metres. It is thought to feed on fruit of *Leptospermum* and figs, but also takes cultivated corn, causing damage to crops, especially at night.

Note. A related drawing in the 'Diard & Duvaucel' collection (NHD 4.549), which Horsfield took as the 'type' of the species.

Exhibited: *Art and the Man: The Raffles Family Collection*, British Library IV–VIII 2008.

Inscribed in Jawi: *bayan*
Paper: cream, wove
Watercolour, bodycolour and pencil; 370 × 273 mm
Almost certainly by J. Briois
NHD 47.33

Phodilus badius (*Horsfield*)

TYTONIDAE

Burung pungguk api; bay owl, or oriental bay-owl

A strictly nocturnal owl, to 33 cm in length, occurring from north-east India and southern China through Indo-China and Peninsular Malaysia, to Sumatra, Java and Borneo (with outliers in southern India and Sri Lanka). The species occurs in evergreen and mixed deciduous forest up to an altitude of 2200 metres. It feeds on small mammals, birds, reptiles, frogs and large insects, and nests in hollow tree trunks. Described (in the genus *Strix*) by Horsfield from Java in 1821, where he recorded the vernacular name as (the presumably onomatopoeic) *wowo-wiwi*; the typical subspecies also occurs in Sumatra. Noting that it resided in the 'closest forests, which are the usual resort of the tiger', Horsfield related that 'the natives' alleged that it had 'no dread to alight on the tiger's back'. It has been described as 'surpassing all other owls in [the] appalling nature of its cries, even sounding like half a dozen cats fighting'.

Exhibited: *The Golden Sword, Stamford Raffles and the East*, British Museum XII 1998 – IV 1999; *Spice of Life, Raffles and the Malay World*, Central Library, Liverpool VIII–X 2007.

Inscribed in Jawi: *sikuk*
Paper: cream, wove; C WILMOTT 1819.
Watercolour, bodycolour and pencil; 372 × 273 mm
Almost certainly by J. Briois
NHD 47.34

Phaenicophaeus chlorophaeus *(Raffles)*

CUCULIDAE

Burung cenuk kerak; *booboot* (Raffles); Raffles' malkoha

A relative of the cuckoo, this species, whose English name commemorates Raffles, is the only malkoha to show sexual dimorphism in plumage. Unusually among birds the female, shown here, is the more strikingly coloured (in the male, of which there is a drawing in Diard & Duvaucel collection (NHD 4.561), the front and upper parts are orange-brown and the tail slightly barred). This insectivorous bird is about 30 cm in length and occurs, rather commonly, in southern Thailand and Burma, Peninsular Malaysia, Sumatra, Bangka, Sumatra and Borneo. It occurs, usually singly or in pairs, in primary and secondary forests and man-modified habitats in the lowlands, up to an altitude of about 900 metres. The species was described (in the genus *Cuculus*) by Raffles in his Sumatran *Catalogue* (1822), so this drawing shows the typical subspecies.

Inscribed in Jawi: *booboot*
Paper: cream, wove; J WHATMAN 1820
Watercolour, bodycolour and pencil; 275 × 376 mm
Almost certainly by J. Briois
NHD 47.27

Phaenicophaeus curvirostris (*Shaw*)

CUCULIDAE

Burung cenuk birah; *inggang balukar* (Raffles);
chestnut-breasted malkoha

This malkoha is up to 49 cm in length, and native
to southern Burma and Thailand, Peninsular
Malaysia, Sumatra, Java, Bali, Borneo and
Palawan; the subspecies occurring in Sumatra
is *P. curvirostris singularis* (Parrot). It occurs in
forest, mangroves and gardens in the lowlands
up to an altitude of 1100 metres, and feeds on
large insects (including beetles, caterpillars and
grasshoppers), crabs, small mammals and lizards,
and is said to swing its tail 'like a squirrel'. The
silver leaf used on the wings, back and tail of this
drawing has tarnished, and would have origi-
nally been a dark, iridescent green. The species
was described from western Java, in the genus
Cuculus, by George Shaw in 1810. It was included
by Raffles in his 1822 paper under the name
Phaenicophaeus melanognathus Horsfield, of which
he recorded that specimens were 'not easily pro-
cured, as it commonly perches on the summits of
the highest trees'. Whoever annotated this draw-
ing in Jawi incorrectly believed this to be the male
of the red-billed malkoha.

Note. A related drawing in the 'Diard & Duvaucel'
collection (NHD 4.559).

Inscribed in Jawi: *selayak laki-laki* [= male]
Paper: cream, wove; no watermark
Watercolour, bodycolour, pencil, silver-leaf and gum
arabic; 362 × 513 mm
Almost certainly by J. Briois
NHD 47.36

Phaenicophaeus javanicus *Horsfield*

CUCULIDAE

Burung cenuk api;
red-billed malkoha

This species of malkoha is up to 42 cm in length;
it feeds on large insects (including grasshop-
pers, beetles, stick-insects and caterpillars) and
small crustaceans, and is usually of a solitary
habit. Native to southern Burma and Thailand,
Peninsular Malaysia, Sumatra, Java and Borneo,
where it inhabits lowland evergreen and semi-
evergreen forest up to an altitude of 1200 metres.
The species was described by Horsfield in 1821
from Java, where he recorded the local name
as *bubut-kembang*. The subspecies occurring in
Sumatra is *P. javanicus pallidus* (Robinson &
Kloss).

Inscribed in Jawi: *selayak*
Paper: grey, laid; VEIC 1819
Watercolour, bodycolour and pencil; 368 × 495 mm
Almost certainly by J. Briois
NHD 47.35

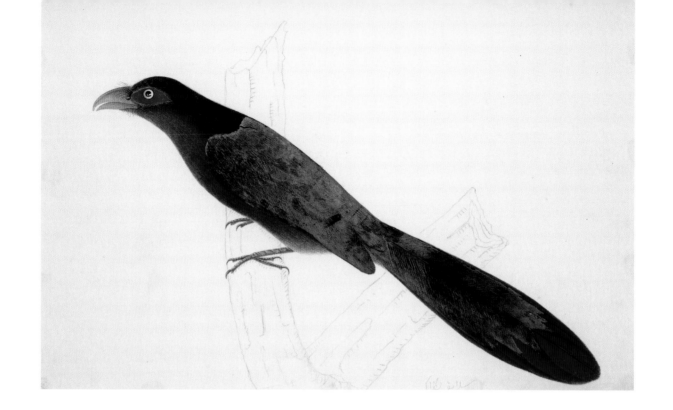

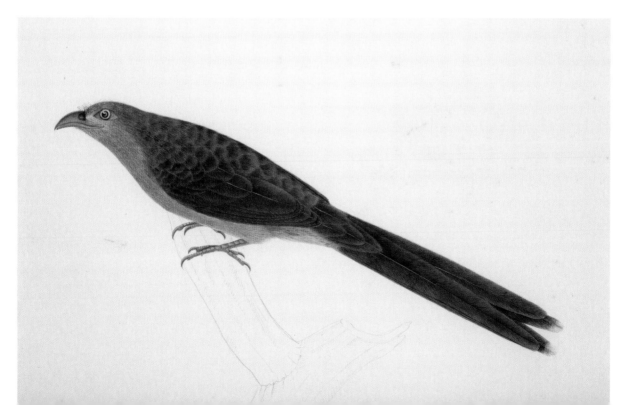

Arborophila orientalis (*Horsfield*)

PHASIANIDAE

Burung sang seruk gunung; grey breasted hill partridge

The identification of this drawing is not certain, as the racial variation of this and closely related species (including the chestnut bellied hill partridge) is considerable. This drawing shows a female or immature bird, most probably the endemic Sumatran sub species of the grey breasted hill partridge, *A. orientalis sumatrana* (Ogilvie Grant). The species was described (in the genus *Perdix*) by Horsfield from eastern Java: a montane, forest partridge about 28 cm in length, which also occurs in Peninsular Malaysia and Sumatra. It occurs in dense thickets of rattan and other undergrowth at altitudes of between 1000 and 1600 metres, and feeds on rattan and other fruit, termites, and small molluscs. Given its habitat preference it is more often heard than seen, but it is threatened by habitat destruction and hunting. The Sumatran subspecies was described in 1891 (at specific rank), based on a Raffles specimen, by Old Fettesian William Robert Ogilvie Grant, who worked at the Natural History Museum.

Inscribed in Jawi: *puyuh hutan* [= jungle quail]
Paper: cream, wove; no watermark
Watercolour, bodycolour and pencil; 275 × 372 mm
Almost certainly by J. Briois
NHD 47.39

Rhizothera longirostris

(*Temminck*)

PHASIANIDAE

Burung siul selanting; *lanting* (Raffles); long billed partridge

A large partridge, to 30 cm in length. This drawing shows a female; the male has a broad, grey collar. The species is native to southern Burma and Thailand, Peninsular Malaysia, Sumatra and western Borneo. It occurs on the floor of mature evergreen and semi evergreen forest from the lowlands to an altitude of 1500 metres, and its diet includes berries and insects. This is the species described by Raffles from Sumatra as *Tetrao curvirostris*, with the common name *lanting*; however, it had been described earlier (1815) by C.J. Temminck (in the genus *Perdix*) in his *Histoire Générale des Pigeons et des Gallinacés*, also based on a Sumatran specimen.

Note. A related drawing in the 'Diard & Duvaucel' collection (NHD 4.645).

Annotations: Terlantine (pencil)
Paper: cream, wove; no watermark
Watercolour, bodycolour and pencil; 310 × 418 mm
Almost certainly by J. Briois
NHD 47.40

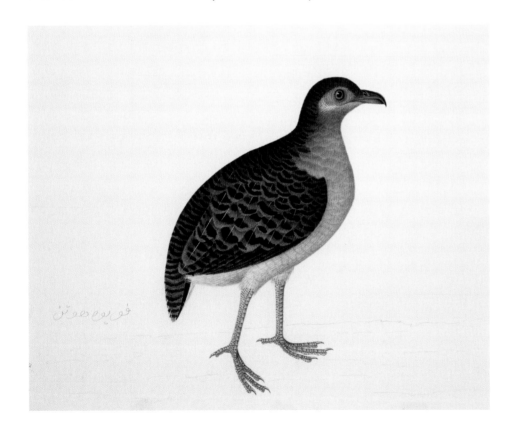

Lophura ignita (*Shaw*)

PHASIANIDAE

Ayam pegar; *burong trab* (Raffles);
crested fireback

A spectacular large pheasant that occurs,
in several races, in Peninsular Malaysia,
Sumatra, Bangka and Borneo. This drawing
shows a female; the body is about 56 cm in
length, the tail about 18 cm. It occurs on the
floor of lowland and lower montane forest up
to an altitude of about 1200 metres, feeding
on fruit and invertebrates. The status of the
species is considered vulnerable – due to
habitat destruction and hunting. Described
in the genus *Phasianus* by George Shaw in
1797 in the *Naturalist's Miscellany*, it was
believed to be from Java, but actually came
from southern Borneo. This is the subspe-
cies *L. ignita rufa*, which Raffles described
as a species in 1822, thinking he was describ-
ing the male of a new species, not realising
that it was the female of the crested fireback
that he also listed under the name *Phasianus
ignitus*.

Note. A related drawing in the 'Diard & Duvaucel'
collection (NHD 4.641).

Inscribed in Jawi: *tugang betina* [= female]
Paper: cream, wove; C WILMOTT 1819
Watercolour, bodycolour and pencil; 422 × 526 mm
Almost certainly by J. Briois
NHD 47.42

Lophura ignita (*Shaw*)

PHASIANIDAE

Ayam pegar; *tugang* (Raffles); crested
fireback

This drawing shows the spectacular male
of the subspecies *Lophura ignita rufa* (also
known as Vieillot's crested fireback), which
occurs in Sumatra and Peninsular Malaysia.
The body is up to 70 cm long, and the tail
a further 30 cm. Males can be aggressive
when displaying, during which they make
'wing-whirring signals'. The silver leaf used
on this drawing, to suggest the iridescence
of the plumage on the bird's back, has
tarnished and would originally have been a
metallic, glossy, dark blue.

Inscribed in Jawi: *tugang*
Paper: cream, wove; J WHATMAN 1820
Watercolour, bodycolour, pencil, gold and silver
leaf and gum arabic; 408 × 548 mm
Almost certainly by J. Briois
NHD 47.43

قره كنك

Polyplectron chalcurum _Lesson_
PHASIANIDAE
Bronze-tailed (or Sumatran) peacock pheasant

This species is endemic to Sumatra, where it occurs in two subspecies. It occurs in primary and logged forest in the lower montane zone between 800 and 1700 metres, but is very shy. The individual shown here is a female, which is about 35 cm in length. The male is larger, with a longer tail that is more conspicuously marked with purplish-blue. The diet of the species includes insects and small fruit. Described by the French zoologist René Lesson in his _Traité d'Ornithologie_ (1831), who took the name from a manuscript by Cuvier, and believed it to come from Java. In fact the type collection was a Sumatran specimen of Diard, and the typical subspecies, shown here, has been taken to have originated from Bencoolen.

Annotation: 'Species of Pheasant' (pencil)
Inscribed in Jawi: _su..._
Paper: cream, wove; no watermark
Watercolour, bodycolour, pencil, silver-leaf and gum arabic; 274 × 426 mm
Almost certainly by J. Briois
NHD 47.41

Aceros corrugatus _(Temminck)_
BUCEROTIDAE
Enggang keredut; Sunda wrinkled hornbill (male)

A large hornbill, to 70 cm in length. The species is native to Peninsular Malaysia, Sumatra and Borneo, where it occurs in lowland evergreen forest, rarely higher than 30 metres above sea-level. The bird feeds on oil-rich fruit including figs, and nests in natural holes in trees, in which the female seals herself up with a cement made of droppings and food remains. The species was first described from Borneo, in the genus _Buceros_, by C.J. Temminck in 1832.

Note. An identical, but finished, version of this incomplete drawing is in the Farquhar collection (SHM 1995.3205).

Annotation: Ingang (pencil)
Paper: cream, wove; SE & CO 1815
Watercolour and bodycolour over pencil, heightened with gum arabic; 475 × 605 mm
Probably by a Chinese artist
NHD 49.30

? Cynogale bennettii *J.E. Gray*

?VIVERRIDAE
?Otter civet

The identity of the carnivorous mammal shown in this drawing is problematic, and various suggestions have been made by a number of zoologists – the most likely possibility seems to be the otter civet. However, the otter civet has a distinctive short tail, whereas the drawing shows an animal with a long one. Daphne Hills has suggested that, perhaps, the drawing was made from a flat skin and the tail was 'assumed to have originally been longer and 'improved' or added to by the artist'. The facial whiskers are correct for an otter civet, which is a secretive, nocturnal, semi-aquatic creature that feeds on crabs, fish and molluscs, but can also climb trees and catch birds. It was described by J.E. Gray in 1837, and occurs in Peninsular Malaysia, Sumatra and Borneo, but is very rare. Other suggestions are a mongoose of the genus *Herpestes*, Hose's palm civet (but this occurs only on Borneo, and not on Sumatra), or even a species of otter. An intriguing, if remote, possibility is that the identification difficulties are due to the fact that the drawing shows an undescribed species that awaits rediscovery in Sumatra.

Paper: grey, laid; STACEY WISE & CO 1822
Watercolour, bodycolour and pencil; 354 × 535 mm
Probably by J. Briois
NHD 47.45

Echinosorex gymnura *(Raffles)*

ERINACEIDAE

Tikus bulan, *ambang bulan*; moonrat, Raffles' gymnure

The body of this curious insectivore is about 30 cm long, and the tail (half of which bears no hair – the epithet means 'naked tailed') a further 25 cm. The first Westerner to 'discover' this animal was William Farquhar 'from the woods in the interior of Malacca'. It was Raffles, however, who was the first to publish it, assigning it, somewhat doubtfully, to the civet genus *Viverra*. This drawing shows the typical subspecies. It is a nocturnal animal that emits 'a strong musky smell', native to Burma, Thailand, Malaysia, Sumatra and Borneo, where it lives in lowland forest and mangrove swamps, feeding on invertebrates including worms, insects and crabs, on land and at the edge of water.

Paper: grey, laid; VEIC 1819
Watercolour, bodycolour and pencil; 342 × 507 mm
Probably by J. Briois
NHD 47.46

Capricornis sumatraensis *(Bechstein)*

BOVIDAE SUBFAMILY CAPRINAE

Kambing gurun, *kambing utan*; Sumatran serow

The serow is widely distributed from Nepal eastwards to southern China, and southwards through Burma and Indo-China, to Malaysia and Indonesia, where it occurs in forested, mountainous country up to an altitude of 2700 metres. This, the typical subspecies described from Sumatra, is now threatened – due to hunting and habitat destruction. It was described (in the genus *Antilopus*) by the German zoologist J.M. Bechstein in 1799. Raffles, in his zoological catalogue of Sumatra (1821), commented that the illustration of this species in Marsden's *History of Sumatra* was 'very accurate, but does not fully

express the character of spirit and vivacity which marks the living subject'. The same might be said of the present drawing. At Bencoolen, Raffles kept a male 'Wild Goat of Sumatra ... for some months, but found it impossible to tame him; and he finally died from impatience of confinement'.

Annotation: Kambing Utan female (pencil)
Paper: grey, laid; STACEY WISE & CO 1822
Watercolour, bodycolour and pencil;
362 × 535 mm
Probably by J. Briois
NHD 47.47

Tapirus indicus *Desmarest*

TAPIRIDAE

Cipan, *badak murai*, *tenuk*; *babi-alu* (Bencoolen), *gindol* and *saladang* (Sumatra) (Horsfield); Asian tapir

This is the only Old World species of tapir, but due to hunting and forest destruction it is now reduced to isolated populations in the forests of Burma, Thailand, Peninsular Malaysia and Sumatra. The adults are black with a broad, white saddle, and have a slightly longer proboscis than the juvenile here depicted. It was first 'discovered' by William Farquhar who sent a description and specimen to the Asiatic Society in Calcutta in 1816. His account was not published until 1821, and meanwhile Raffles had tried to substitute a description of his own as he considered Farquhar's inadequate. Raffles' skulduggery was foiled and both were beaten by the French, when, in 1819, A.G. Desmarest published the species in Paris, from information provided by Pierre Diard – based on Farquhar's description, and a live Sumatran specimen in the Barrackpore Menagerie near Calcutta. Raffles reported that the mature Barrackpore specimen (illustrated in Gallop 1995: 109) 'frequently entered the ponds, and appeared to walk along the bottom of the water, and not to make any attempt to swim'.

Exhibited: *The Golden Sword, Stamford Raffles and the East*, British Museum XII 1998 – IV 1999; *Spice of Life, Raffles and the Malay World*, Central Library, Liverpool VIII–X 2007; *Art and the Man: The Raffles Family Collection*, British Library IV–VIII 2008.

Paper: cream, wove.
Watercolour and bodycolour over pencil; 336 × 374 mm
Probably by J. Briois
NHD 47.48

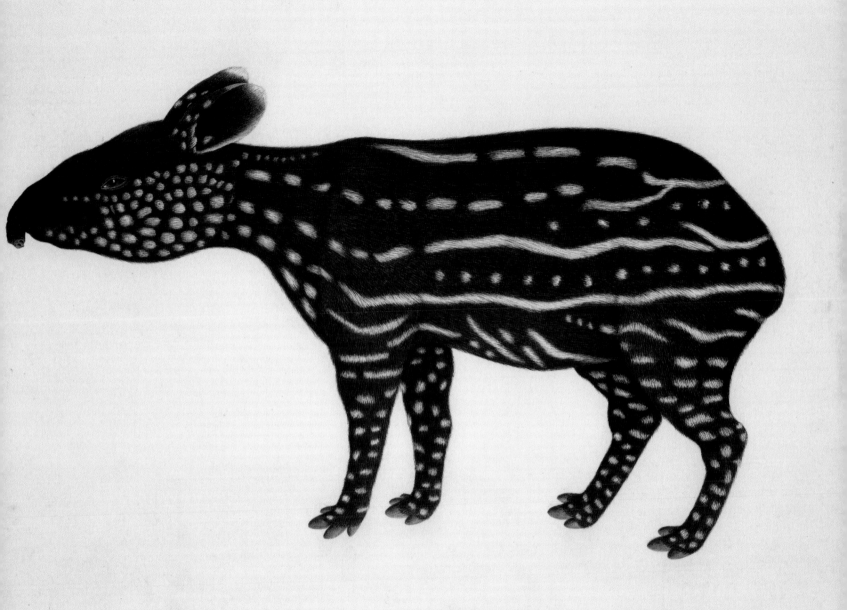

Mustela nudipes *Desmarest*

MUSTELIDAE

Pulasan tanah; Malayan weasel

A widespread carnivore, occurring in
Thailand, Malaysia (Peninsular, Sabah,
Sarawak), Brunei, and Indonesia (Kalimantan,
Sumatra), the subspecies occurring on
Sumatra being the typical one. The body is
about 32 cm long, and the tail a further 25 cm.
The epithet refers to the feet, which lack hair
around the soles. The species was described in
1822 by the French zoologist A.G. Desmarest,
based on a specimen sent to Paris from Batavia
by Pierre Diard, which must have originated in
Sumatra, as the animal does not occur in Java.

Exhibited: *The Golden Sword, Stamford Raffles and the
East*, British Museum XII 1998 – IV 1999.

Inscribed in Jawi: *pisang masak*
Paper: grey, laid; STACEY WISE & CO 1822
Watercolour, bodycolour and pencil; 360 × 540 mm
Probably by J. Briois
NHD 47.49

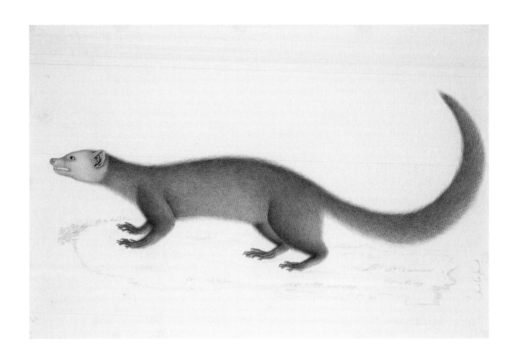

Lutra sumatrana *J.E. Gray*

MUSTELIDAE

Berang-berang berkumis; hairy-nosed otter

In Raffles' *Catalogue* of zoological collec-
tions made on Sumatra (actually the work of
William Jack, based on collections made by
Diard and Duvaucel) he mentioned, without
formally describing, two species of otter,
known under the general name of 'Anjing
Ayer, or Dog of the Waters'. One was almost
certainly the smooth-coated otter (*Lutra per-
spicillata* Geoffroy, of which *L. simung* Lesson,
based on a Raffles Sumatran specimen, is a

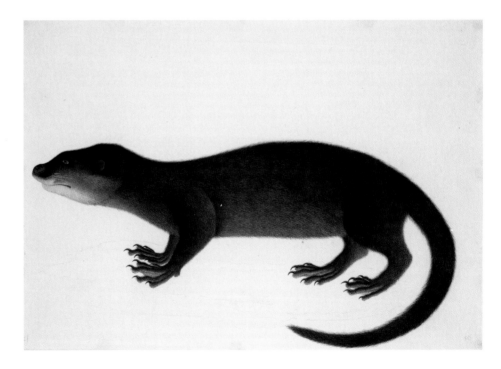

synonym), the other was probably the hairy-nosed otter shown in this drawing, one of the rarest otters in the world. As recently as 1998 this species was believed to be extinct, but it was rediscovered in Thailand, and has since been found in Cambodia, Vietnam and Sumatra. Its main habitat is peatswamp forest, but it also occurs in coastal mangrove swamps, and its prey is presumed to include fish and shellfish. It was described from Sumatra by J.E. Gray in 1865.

Paper: grey, laid; VEIC 1819
Watercolour, bodycolour and pencil; 374 × 540 mm
Probably by J. Briois
NHD 47.50

Viverra tangalunga *J.E. Gray*
VIVERRIDAE
Musang jebat, *musang kesturi*; *tangalung*
(Raffles); Malay civet

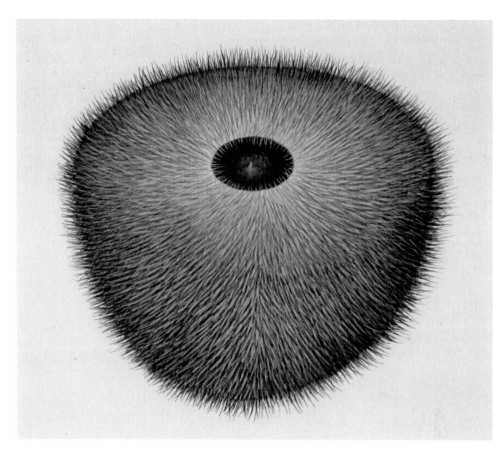

In Raffles' Sumatran *Catalogue* he recorded (under the name *Viverra zibetha* L., which refers to the Indian civet) that 'this animal is kept by the natives for the purpose of obtaining the well known perfume, which they call *jibet* or *dedes*. It is contained in a double sac under the anus' – shown here is one such 'musk pod'. Raffles described the animal as 'above two feet long; the tail shorter than the body, and annulated [ringed]. A black stripe runs the whole length of the back; there are several longitudinal stripes on the back of the neck, and a broad black band encircles the lower part of the throat. The sides of the body are spotted, and the spots become undulated in the limbs'. A nocturnal, carnivorous mammal, native to the Malay Peninsula, Sumatra, Bangka, Borneo, the Rhio archipelago and the Philippines. However, it has been kept in captivity for its musk in other SE Asian countries (and doubtless escaped). The trade in the perfume, produced by several species of civet, was greatly developed by the Arabs, under their name *zabad* – originally applied to the African civet (*Viverra civetta*). The scent is due to civetone (a ketone) that can now be made synthetically.

Inscribed in Jawi: *kam-kam*
Paper: grey, laid; no watermark
Watercolour, bodycolour and pencil; 366 × 258 mm
Probably by J. Briois
NHD 47.51

Pongo pygmaeus *(L.)*

HOMINIDAE

Bornean orang utan

This drawing probably shows one of the pair given to Raffles in Malacca, on 22 March 1811, by the Sultan of Pontianak in western Borneo. If this is the source the subspecies depicted is *P. pygmaeus wurmbii*, which commemorates Friedrich Baron von Wurmb, the first to make a description of 'the East-India Pongo' in 1780, published in the *Transactions of the Batavian Academy of Arts and Sciences*. At this time there was great interest in apes and their relationship to man, and in this light Raffles' scribe Abdullah's account of Raffles' pets is revealing: he wrote that the male was: *very tame and wore trousers, a coat, and a hat given him by Mr. Raffles. He looked like a small child as left to himself he walked about the place. I noticed that his behaviour was almost like that of a human being, save only he lacked the power of speech ... He used to come and stay quietly near the table where I was writing, not capable of mischief like other monkeys. He would pick up a pen slowly and look at it; then when I said, 'Put it down at once', he would put it down in a flash ... There were actually a pair of orang-utans, a male and a female, but after four or five months sojourn in Malacca the female died one night. From that time onwards, I noticed, the male behaved like a man stricken with grief. The food given to him he left where it was, not touching a morsel of it. After six or seven days thus he also died'* (Gallop, 1994: 85, 215).

Paper: cream, wove; no watermark
Charcoal; 690 × 430 mm
Probably by a Chinese artist working in Malacca
NHD 49.31

Cryptelytrops purpureomaculatus *(J.E. Gray)*

VIPERIDAE

Mangrove pitviper

Pitvipers are nocturnal, venomous snakes, which can hunt in darkness due to the heat-sensitive pits on the upper jaw shown in this drawing. Dr Anita Malhotra has identified the species shown here as most probably the mangrove pitviper, and provided the following information: 'usually less than one metre in length, and known for its irascible nature. Clinical records of snakebite by this species suggest that it rarely causes fatalities, but there are many anecdotal records of fatal bites by fishermen, which suggests that further research on this topic is required. It was first described (in the genus *Trigonocephalus*) by J.E. Gray in 1832, so was unknown to science when this drawing was made. Primarily found in mangrove swamps, some inland populations are known, and it is distributed from Singapore, along the Straits of Malacca (on both Malaysian and Sumatran coasts), the Andaman coast of Thailand and Burma, and in the Irrawaddy delta'. From the distribution it seems likely that this unfinished drawing might date from Raffles' time in Malacca.

Paper: cream, wove; no watermark
Watercolour and pencil; 546 × 382 mm
Probably by a Chinese artist working in Malacca
NHD 49.32

Rafflesia arnoldii *R. Brown*

RAFFLESIACEAE

Kerubut; *ambun ambun* (Raffles); *pelinum sekuddi* (= Devil's *paan* box, Jack)

This plant, renowned as bearing the largest flower in the world, is a parasite, having no chlorophyll, and obtaining its nutrition from a host of the vine family (especially *Tetrastigma* spp.). It is endemic to Sumatra, and was actually discovered by a Malay servant, but Joseph Arnold to whom it was first shown has been given the credit. Also in the party, on an expedition to the territory of the Pasummah people to the south-east of Bencoolen in May 1818, were Sir Thomas and Lady Raffles. The binomial chosen by Brown commemorates both the Western parties involved (in the hierarchical fashion of the age). Arnold, however, did not live to see the sensation 'the stupendous flower of Sumatra' caused in Europe when it was published in 1820/1.

Raffles was proud of his role in the plant's discovery and in 1826 commissioned Weddell, a renowned firm of botanical engravers, to make this print, 'of which there will be only 50 or 60 copies struck off'. The print can be attributed only to the firm, and specifically neither to H[enry] nor E[dward] S[mith] Weddell, as has variously been done. The first published illustration of the open flower, by the great Francis Bauer (Fig.16), was based on immature specimens and an inadequate drawing by Arnold and the Raffleses; this print, based on subsequent gatherings, shows the stigmatic processes more accurately than Bauer was able to do.

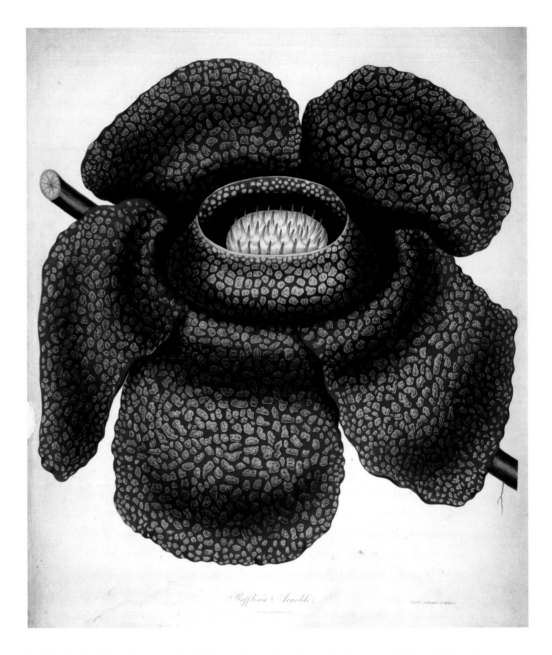

Exhibited: *The Golden Sword, Stamford Raffles and the East*, British Museum XII 1998 – IV 1999; *Spice of Life, Raffles and the Malay World*, Central Library, Liverpool VIII–X 2007.

Inscription: 'Rafflesia Arnoldi. Two Thirds of the Natural Size. Weddell. Delineavit et Sculpsit'
Hand coloured engraving, 1826; 760 × 890 mm
P 1969

Combretum indicum

(L.) Jongkind

COMBRETACEAE

Udani (Malaysia); Rangoon creeper,
drunken sailor

A large woody climber, probably originally
native from Burma to New Guinea, but now
cultivated pantropically for its attractive,
scented flowers. The young fruits are used as
a vermifuge, though should be done so with
caution as, according to Burkill, 'a large dose
produces hiccough ... an overdose causes
unconsciousness'. The young shoots, raw
or steamed, can be eaten and the juice of the
leaves used against boils and ulcers. Until
recently this plant has been known under
the name *Quisqualis indica*, the generic name
being taken by Linnaeus from a joke coined
in *Herbarium Amboinense*. According to W.T.
Stearn the Malay name for the plant was
rendered into Dutch as *hoedanig* meaning
'how, what?', which 'Rumphius translated
into Latin as *quis qualis*, expressive of his sur-
prise at the variability of the plant's growth.
The flowers open white, become pink and
end blood-red'. Recent work on African spe-
cies by the Dutch botanist C.C.H. Jongkind
has, however, shown that there is no reliable
distinction between the genera *Combretum*
and *Quisqualis*, so, sadly, the latter (taken into
Linnaean nomenclature only in 1762) disap-
pears into the synonymy of *Combretum*, which
is earlier by four years.

Paper: grey, laid; s WISE & CO 1822
Watercolour and bodycolour over pencil;
525 × 850 mm
Probably by A Kow
NHD 48.1

Uvaria grandiflora *Hornemann*

ANNONANCEAE

Akar pisang-pisang jantan, akar larak (Malaysia)

A large woody climber native from southern China and Burma through the Malay Peninsula to Indonesia and the Philippines. Its fruits are aromatic and edible and, according to Burkill 'the Malays cook its leaves with rice, under the idea that they relieve flatulence'. The climbing stems have been used as a substitute for rattans. It was introduced from Sumatra into the Calcutta Botanic Garden in 1804, by William Roxburgh junior, and Nathaniel Wallich later considered it 'one of the greatest ornaments' which that great garden possessed, on account of its sumptuous flowers. The name, but with no description, was coined by William Roxburgh senior, and, ironically, as with several such names was first validated by means of a description published in distant Copenhagen. Wallich sent much living material from Calcutta to the city of his birth, where plants were grown and described by J.W. Hornemann in catalogues of the botanic garden.

Paper: grey, laid; VEIC 1819
Watercolour and bodycolour over pencil;
520 × 370 mm
Probably by A Kow
NHD 48.2

Calophyllum inophyllum *L.*

GUTTIFERAE

Penaga laut, *pudek* (Malaysia);
Alexandrian laurel

A moderate sized tree occurring on the
coasts of the Indian and Pacific Oceans as
far east as Tahiti. It has numerous uses,
not least for its hard, close-grained timber
(Bornean mahogany), which is used for
boats, railway sleepers and cabinet making.
The seeds are rich in oil and resin, and the
oil has been used for lighting and for medici-
nal purposes such as skin complaints.
The leaves, roots, bark and flowers are all
medicinal and have been used for sore eyes,
heat stroke and haemorrhoids. The scented
flowers have been worn as hair ornaments
by women in Amboyna. The species was
named by Linnaeus, from specimens col-
lected in Sri Lanka by Paul Hermann, and
descriptions and illustrations in the works
of Plukenet and van Rheede based on
Indian material.

Paper: grey, laid; s WISE & CO 1822
Watercolour and bodycolour over pencil,
heightened with gum arabic; dissections ink;
516 × 353 mm
Probably by A Kow
NHD 48.3

Cyrtandra pendula *Blume*

GESNERIACEAE

Asam batu, meroyan panas (Malaysia)

A herb with creeping stems, of damp habitats
in the Malay Peninsula, Sumatra and Java.
The sour leaves have been used as a flavour-
ing, and a decoction of the plant for post-natal
fever. In 1974 this drawing was referred by
Mildred Archer to B.L. Burtt of the Royal
Botanic Garden Edinburgh, a great expert on
the family Gesneriaceae. He thought that it
might well represent *Cyrtandra macrophylla*,
one of the species described from Sumatra by
William Jack, posthumously published in the
Transactions of the Linnean Society of London
in 1823. However, if it belongs to this species
Burtt noted that the artist had failed to show
the very small leaves that should be found
opposite the base of the stalks of the large
leaves. Further taxonomic work is required
on this large and difficult genus, and it may
turn out that these two species are synony-
mous, in which case Jack's name would have
priority over C.L. Blume's widely used one
(which dates from 1826).

Inscribed in Jawi: *selabang*
Paper: grey, laid; STACEY WISE & CO 1819
Watercolour and bodycolour over pencil; dissections
ink; 544 × 376 mm
Probably by A Kow
NHD 48.4

Syzygium aromaticum (*L.*)

Merrill & L.M. Perry

MYRTACEAE

Cengkeh (Malaysia); cloves

A small tree native to the Moluccas, prized from ancient times in China and Europe for its aromatic flower buds. It has a long and complex history of trade and cultivation, which in the seventeenth and eighteenth centuries were closely guarded by the Dutch East India Company. Following the French invasion of the Netherlands in 1795 the British EIC was able to enter the Dutch possessions and Christopher Smith, nurseryman of the Calcutta Botanic Garden, was sent to the Moluccas to collect nutmeg and clove plants. After failing to thrive in India, a spice plantation was set up in Penang initially run by William Hunter, and from 1804, until his death in 1807, by Smith. Cloves are widely used as a spice and flavouring, but also for the extraction of clove oil, which is used medicinally (against tooth-ache) and (in conjunction with arsenic) for colouring kris blades. Linnaeus, in 1753, created the genus *Caryophyllus* for the clove, but, like many commercially important plants, it has had a complicated nomenclatural history before coming to rest in the genus *Syzygium*.

Note. An almost identical drawing is at Kew, the composition slightly slimmed down, but undoubtedly by the same artist. It has no annotations, but may well be from the Prince collection (see NHD 48.21).

Exhibited: *The Golden Sword*, *Stamford Raffles and the East*, British Museum XII 1998 – IV 1999.

Paper: grey, laid; VEIC 1819
Watercolour and bodycolour over pencil, heightened with gum arabic; dissections pencil; 532 × 370 mm
Probably by A Kow
NHD 48.5

Bauhinia cf. kockiana *Korthals*
LEGUMINOSAE

This drawing is unfinished; perhaps there was
no time to colour the flowers before the sailing
of the *Mariner*. From the shape of the leaves the
species depicted is probably *Bauhinia kockiana*, a
large, woody climber with orange flowers, which
occurs from Sumatra eastwards to Borneo. This
species was described from Sumatra in 1841
by the Dutch botanist Pieter Willem Korthals,
and named after Hendrik Merkus, Baron de
Kock, who, from 1826 to 1830, was Lieutenant
Governor of the Dutch East Indies.

Paper: grey, laid; J WHATMAN 1816
Watercolour over pencil, heightened with gum arabic;
535 × 367 mm
Probably by A Kow
NHD 48.6

Chonemorpha sp.
APOCYNACEAE

The shape of the corolla tube shows this plant
to be a species of *Chonemorpha*. About ten
members of this genus of climbers are known
from India and China to Indonesia. However,
although the genus is in need of revision, the
plant shown here matches no known species.
From his other work it seems unlikely that
this is due to wild inaccuracy on the part of
the artist, and it is perfectly possible that he
drew an undescribed species.

Inscribed in Jawi: *akar tanduk* [= horn root]
Paper: grey, laid; S WISE & CO 1822
Watercolour and bodycolour over pencil, heightened
with gum arabic; 530 × 360 mm
Probably by A Kow
NHD 48.7

Curcuma zanthorrhiza *Roxburgh*

ZINGIBERACEAE

Temu lawas, *temu raya* (Malaysia)

Not apparent from this drawing is the large size of this relation of the turmeric, the leaves of which can be taller than a man. As with many members of this genus its wild origin is uncertain, though it may have been in India. As with the similar *Curcuma zedoaria* it has been widely cultivated in SE Asia, and can become naturalised. The rhizome when grated and left standing in water loses its bitterness and can be made into a pudding. It also has medicinal properties and has been used extensively for indigestion, rheumatism, and as a tonic after childbirth. It has also been used as a dye. William Roxburgh first described the plant from specimens growing in the Calcutta Botanic Garden, which had been introduced by Christopher Smith, from his spice collecting trip to Amboyna of 1798. The epithet refers to the 'deep yellow colour' of the 'pendulous tubers', and Roxburgh noted the 'narrow purple cloud' down the midrib of the leaf – clearly shown in this drawing.

Inscribed in Jawi: *kunyit tamu* [= guest turmeric]
Paper: grey, laid; S WISE & CO 1822
Watercolour and bodycolour over pencil; dissections ink; 365 × 536 mm
Probably by A Kow
NHD 48.8

Syzygium jambos (L.) Alston

MYRTACEAE

Jambu mawar, jambu kelampok (Malaysia); rose apple

A shrub or small tree to 8 metres in height, possibly originally native to India, but widely cultivated in southern and SE Asia for its edible, greenish-white fruits. The fruits, which are rose-scented, are eaten fresh, or cooked with sugar. The plant has been used medicinally – the powdered leaves rubbed into the skin in cases of smallpox. The wood is hard, but the timber is not large enough to be used for construction purposes. The species was described by Linnaeus in 1753, in the genus *Eugenia*, based on collections made by Paul Hermann in Ceylon, and several earlier references including van Rheede's *Hortus Malabaricus*.

Inscribed in Jawi: *kedumbuk*
Paper: grey, laid; STACEY WISE & CO 1819
Watercolour and bodycolour over pencil, heightened with gum arabic; 365 × 536 mm
Probably by A Kow
NHD 48.9

Ouratea serrata *(Gaertner) Robson*

OCHNACEAE

In 1820 William Jack described *Gomphia sumatrana*, for which he recorded the Malay name *siboorn*, and it is a possibility that this drawing was made from the same material that had been available to him. Jack had some hesitation in distinguishing it from a species described and illustrated in Rheede's *Hortus Malabaricus*, to which de Candolle had given the name *Gomphia malabarica*, and both of these are now regarded as synonymous with *G. serrata*, a small tree widespread in south and SE Asia, now placed in the genus *Ouratea*. This species was first described and illustrated in 1788 (in the genus *Meesia*), also based on the Rheede illustration, by the German botanist Joseph Gaertner in his pioneering book on the fruits and seeds of plants.

This appears to be the plant Burkill knew as *Ouratea crocea*, the leaves of which he recorded as being chewed by 'jungle tribes', the timber of which was used for 'boats, pumps, and blocks'.

Paper: grey, laid; VEIC 1819
Watercolour and bodycolour over pencil, heightened with gum arabic; dissections pencil; 375 × 538 mm
Probably by A Kow
NHD 48.10

Poikilospermum suaveolens

(*Blume*) *Merrill*

URTICACEAE

Tentawan, akar murah (Malaysia)

A climbing, dioecious, woody epiphyte
occurring from north-east India, through
Thailand, Burma, Malaysia and Indonesia
to the Philippines and Sulawesi. The stems
if cut yield drinkable water, and the plant
has medicinal properties and has been used
in treating eye diseases. In the Philippines
the aerial roots are collected and smoked. It
was first described in 1825 by Carl Ludwig
Blume in his pioneering *Bijdragen tot de Flora
von Nederlandsch Indië*, but a near identical
generic name to that in which he placed his
species (*Conocephalus*) was subsequently
found to have already been used for a liver-
wort, so E.D. Merrill had to transfer it to
the less than euphonious *Poikilospermum*.
Although the flowers are sweet smelling (and
hence the epithet) it seems curious that it was
cultivated in at least one European hothouse
in the 1820s (and illustrated in the *Botanical
Register*), doubtless from Indian plants
from the Calcutta Botanic Garden sent by
Nathaniel Wallich – who was as assiduous
in distributing living plants as he was of her-
barium specimens.

Paper: grey, laid; VEIC 1819
Watercolour and bodycolour over pencil;
dissection pencil; 369 × 533 mm
Probably by A Kow
NHD 48.11

Unknown ginger

ZINGIBERACEAE

It is impossible to identify the ginger shown in this drawing, or even to assign it to a genus. The floral details show the characteristic single fertile stamen of this family (second and third from right), but the petaloid structures are not very clear (there should be 3 'petals' and 3 petal-like staminodes). However, only one 'petal' and a lip-like staminode are shown here. As the artist is unlikely to have had a lens this is hardly surprising, as these structures are very hard to observe and interpret. Given that the drawing was made in Sumatra, where much work on gingers still requires to be undertaken, it is even possible that this represents a species of an undescribed genus. E.J.H. Corner identified this drawing as an *Amomum*, but in that genus the leafy shoot is stem-like, whereas the leaves in this drawing are more like those of a *Boesenbergia*, but in that genus the lateral staminodes should be more prominent.

Paper: grey, laid; STACEY WISE & CO 1819
Watercolour and bodycolour over pencil; dissections ink; 540 × 375 mm
Probably by A Kow
NHD 48.12

Dissochaeta cf. vacillans *(Blume) Blume*

MELASTOMATACEAE

The floral details of this drawing are not quite clear enough to allow of identification to species level, though Dr Gudrun Kadereit, the expert on the genus, considers *Dissochaeta vacillans* a possibility. This is a small tree widely distributed in western Malaysia, Sumatra, Java and Borneo, described as a variable species (of the genus *Melastoma*) from western Java by C.L. Blume in 1827. William Jack was particularly interested in the family Melastomataceae and published (posthumously, in the *Transactions of the Linnean Society*, in 1823) a monograph of the Malayan species, all of which he placed in the genus *Melastoma*. *Melastoma gracilis*, one of the species he described from Sumatra, is now placed in *Dissochaeta*, but that cannot be the species depicted here as it has short, straight, truncate anthers.

Paper: grey, laid; VEIC 1819
Watercolour and bodycolour over pencil; dissections ink; 536 × 372 mm
Probably by A Kow
NHD 48.13

Freycinetia sumatrana *Hemsley*

PANDANACEAE

The genus to which this plant belongs was
described only in the year this drawing was
made (named after Louis de Freycinet,
the French commander of the *Uranie* voy-
age to the South Seas), and the species
only in 1896. In Raffles' day only a single
genus of the screw-pine family was known,
Pandanus, posthumously described by
Sydney Parkinson (the Edinburgh-born
artist on Cook's *Endeavour* voyage, who
died in Java in 1771), based on a Latinized
form of the Malay name. Whoever wrote
the Jawi name on this drawing clearly
thought that this drawing showed the 'fra-
grant pandan', a name that applies to two
species (*P. odorus* and *P. tectorius*) grown
in SE Asia and the Pacific for their fragrant
leaves (neither of which produces flowers).
Both genera are dioecious, having male and
female inflorescences on different plants,
but *Freycinetia* differs in usually being a
climber and in having the female spike
often in groups of three, as shown here
(the stalk of one of them being hidden).

Exhibited: *Art and the Man: The Raffles Family
Collection*, British Library IV–VIII 2008.

Inscribed in Jawi: *pandan wangi* [= fragrant
pandan]
Paper: grey, laid
Watercolour and bodycolour over pencil; details
pencil and ink wash; 545 × 375 mm
Probably by A Kow
NHD 48.14

Costus speciosus

(J.G. König) J.E. Smith

COSTACEAE

Setawar, tawar

An aromatic herb with leafy shoots that can reach three metres in height. It is widespread, occurring from the Himalaya into India and SE Asia, both wild and cultivated. The rhizome is eaten as a famine food in India, and has many medicinal uses; powdered it is taken internally against coughs, colds and rheumatism. A decoction of the boiled plant is used externally against fever, and scrapings of the stem applied to leprous skin. The plant is also considered to have aphrodisiac and magical properties against evil spirits. The plant was known and illustrated in both the great seventeenth-century works on south and SE Asian medicinal botany (*Hortus Malabaricus* and *Herbarium Amboinense*) and J.G. König, a pupil of Linnaeus, cited both of these works when he described the plant in the Linnaean system in 1778. König found the plant, both wild and cultivated, during his expedition to Malacca from Tranquebar in South India where he was based as a missionary. He placed it in a new genus named after his patron Sir Joseph Banks, but (with a slightly different spelling) this had been used previously (in fact twice, so great was the desire to flatter Banks) and it fell to J.E. Smith, President of the Linnean Society, to transfer it to the genus *Costus*.

Inscribed in Jawi: *setawar*
Paper: grey, laid; J WHATMAN 1816
Watercolour and bodycolour over pencil, heightened with gum arabic; 537 × 373 mm
Probably by A Kow
NHD 48.15

Arachnis flos-aeris

(L.) H.G. Reichenbach

ORCHIDACEAE

Bunga kesturi (Malaysia); scorpion orchid

This spectacular orchid is native to Peninsular Malaysia, Sumatra and Java and also cultivated in gardens for its musk-scented flowers. It is probably the 'noble Orchideous plant' that Raffles thought comparable in magnificence to his 'great flower', i.e., *Rafflesia*. He observed this orchid 'on rocks, or roots, in several of the Islands in the Straits of Malacca … the wonder is its magnificent inflorescence, which forms an erect spike six feet high, with upwards of one hundred large-spreading brown and white chequered fragrant flowers, between two and three inches in diameter' (Raffles, 1830: 535). The species was originally described in the genus *Epidendrum* by Linnaeus, based on a description and fine engraving in Englebert Kämpfer's *Amoenitatum Exoticarum* (1712). The great German traveller and botanist Kämpfer made notable travels in Persia, and spent two years in Japan (1690–2), but it was on Java, working as a surgeon for the Dutch East India Company, that he found this orchid where it was known locally as *katong'ging*.

Inscribed in Jawi: *anggrik* [= orchid]
Paper: grey, laid; S WISE & CO 1822
Watercolour over pencil; 722 × 490 mm
Probably by A Kow
NHD 48.16

Unknown dicotyledon

The plant in this drawing defied identification by E.J.H. Corner, a great expert on the Malaysian flora who examined the collection in 1957, as it more recently has, by botanists of the Forest Research Institute Malaysia. This suggests that, while the drawing is undoubtedly very beautiful, it may not be botanically accurate. The vernacular name on the drawing has been translated as 'mouse-deer flower', but this, unfortunately, does not help with identification.

Inscribed in Jawi: *jupak*
Annotation: Boonga Palandoo [i.e., *bunga pelanduk*] (pencil)
Paper: grey, laid; s WISE & CO 1822
Watercolour and bodycolour over pencil, heightened with gum arabic; dissections pencil; 535 × 370 mm
Probably by A Kow
NHD 48.17

Lansium domesticum

Corrêa da Serra

MELIACEAE

Langsat

A small tree, native to western Malaysia but cultivated elsewhere in the region for its edible fruit. The form shown here is the wild one (see also NHD 48.27). The edible part is the fleshy outer seed coat (an aril), which can be eaten raw or preserved in syrup. Various parts, including the astringent bark, seeds and leaves, are used medicinally, for example, against dysentery, for fever and sore eyes. The fruit walls are aromatic when burnt and repel mosquitoes. The species was described by the Portuguese botanist and priest José Francisco Corrêa da Serra based on a description and illustration (under the name *Lansium*) in Rumphius' *Herbarium Amboinense*. Corrêa was uncertain of its family placement, but this was correctly identified by William Jack who wrote a paper on it and other little known Malayan plants (mostly with edible fruits) read posthumously to the Linnean Society by Henry Colebrooke in 1823.

Inscribed in Jawi: *air-air*
Paper: grey, laid; s WISE & CO 1822
Watercolour and bodycolour over pencil, heightened with gum arabic; 522 × 370 mm
Probably by A Kow
NHD 48.19

Strophanthus caudatus (L.) *Kurz*

APOCYNACEAE

Tandok-tandok, dukok kijang, akar tandok hitam (Malaysia)

A trailing shrub or woody climber that can reach a height of 12 metres, occurring from Burma, Thailand and Indo-China, through Malaysia, Indonesia and the Philippines. Most members of this genus are extremely poisonous, but this one has been cultivated for its curious flowers. It was first described by Linnaeus in 1767 in the genus *Echites*, the epithet referring to the tail-like corolla lobes. Like most members of the family its fruits are paired follicles, shown well in this drawing; the first of the Malay names cited, meaning 'horn-like', refers to this.

Note. A very similar drawing (Fig.5), undoubtedly in the same hand, is at Kew annotated, probably by Nathaniel Wallich, 'Recd. from J. Prince Esq of Singapore, 1827. S. dichotomus. Strophanthus speciosus, W. Jack mss'. In another hand 'Wild Buffaloe Horned Flower'. This may show the species of *Strophanthus* sent by William Jack to Robert Brown from Bencoolen on 23 May 1821, though no specimen survives at NHM to confirm this.

Inscribed in Jawi: *tanduk kambing* [= goat's horn]; *akar seketub palu*
Paper: grey, laid; s WISE & CO 1822
Watercolour and bodycolour over pencil, heightened with gum arabic; dissections ink and ink wash; 530 × 365 mm
Probably by A Kow
NHD 48.21

Melodinus orientalis *Blume*

APOCYNACEAE

Getah ujul

A large, woody climber, native to Malaysia, Indonesia (Sumatra and Java) and Thailand. The bark contains a good fibre, but this is not used commercially, and the latex can be made into an inferior, sticky rubber. Like several of the plants depicted in this collection, it had not been described when the drawing was made, and not until two years later, in 1826, did C.L. Blume describe and name this species from Java.

Inscribed in Jawi: *gytan*
Annotations: Akar loonga Kuttan or gutan (pencil)
Paper: grey, laid; s WISE & CO 1822
Watercolour and bodycolour over pencil, heightened with gum arabic; dissections ink and ink wash; 375 × 535 mm
Probably by A Kow
NHD 48.22

Myristica fragrans *Houttuyn*

MYRISTICACEAE

Buah pala (nut), *bunga pala* (mace); nutmeg

A tree to 20 metres tall, native to eastern Indonesia, where it was cultivated from early times, and exported (via India) to Europe by the sixth century. In the seventeenth and eighteenth centuries its cultivation was closely guarded by the Dutch, but this ended during the Napoleonic Wars and in 1795 Christopher Smith was sent from Calcutta to obtain plants that were grown firstly in India, then at Penang. The mildly hallucinogenic grated nut has long been a popular spice in Europe, but the other parts of the fruit are also used, the fleshy seed coat (aril), when dry, being known as mace. In Malaysia and Indonesia the outer fruit wall soaked in salt water, boiled and candied, is eaten as a sweetmeat. Nutmeg is also important medicinally, having stimulative and carminative properties. It is somewhat odd that such an important plant was not included in Linnaeus' *Species Plantarum* and it did not enter Linnaean nomenclature until 1774, when Maarten Houttuyn described it in his Dutch version of the 12th edition of *Systema Naturae*. Linnaeus's son published a different name for the plant (*Myristica officinalis*) in his *Supplementum Plantarum* (1781).

Exhibited: *The Golden Sword, Stamford Raffles and the East*, British Museum xii 1998 – iv 1999.

Inscribed in Jawi: *buah pala* [= nutmeg fruit]
Paper: grey, laid; J WHATMAN 1816
Watercolour and bodycolour over pencil, heightened with gum arabic; dissections ink; 370 × 538 mm
Probably by A Kow
NHD 48.23

Chilocarpus costatus *Miquel*

APOCYNACEAE

Akar gerip puteh, gerit puteh

A stout climber, native to Sumatra, the west-
ern side of Peninsular Malaysia and Thailand,
where it occurs in lowland evergreen forest.
As in other members of the family the white
latex can be made into rubber, but the rub-
ber from this species is said to be 'small in
amount, and poor in quality'. The species
was described in 1856 by the Dutch botanist
F.A.W. Miquel, based on a collection made
on Sumatra by the prolific collector J.E.
Teysmann, who recorded the local name as
getah njantji – the Latin epithet refers to the
rib-like leaf venation.

Paper: grey, laid; STACEY WISE & CO 1819
Watercolour and bodycolour over pencil; dissections
ink and ink wash; 370 × 542 mm
Probably by A Kow
NHD 48.24

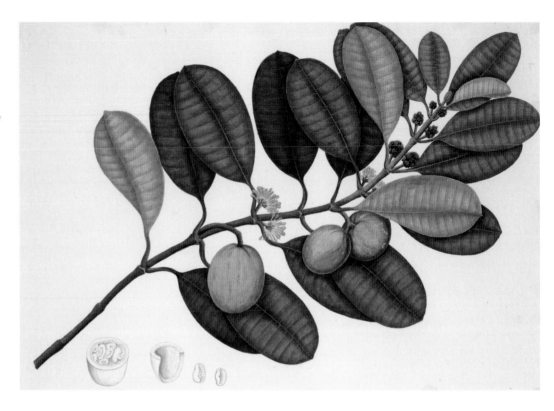

Durio zibethinus *L.*

MALVACEAE (BOMBACACEAE)

Pendok, penak (Malaysia); durian

A large tree, probably originally native
to Borneo, but extensively cultivated in
Malaysia and Indonesia for its notorious fruit.
The fruits are spiny capsules borne on the
trunks and branches, and the edible part is
an aril surrounding the seeds. E.J.H. Corner
described the smell of the fruit as 'of onions,
drains, and coal-gas' (on which account its
transport is banned on some passenger air-
lines), and the taste of the aril as 'of caramel,
cream, and as some say, strawberries and
raspberries'. In addition to the arils (which
can also be cooked as a conserve), the seeds
are eaten roasted or boiled, and the timber
can be used for making internal parts of huts.
Ash from burning the husks can be used for
making silk white. The binomial was pub-
lished in the 13th edition of Linnaeus' *Systema
Naturae*, edited by J.A. Murray and pub-
lished as *Systema Vegetabilium* (1774), based
on a description in Rumphius' *Herbarium
Amboinense*. The epithet alludes to the smell
– being taken from the Italian (and before
that Arabic) word for a civet (see NHD 47.45).

One of the most popular of all the 'Straits
Settlements' fruit images existing in many
variants – e.g., Kew (ex Hutton, Marsden and
'Chinese Plants', i.e. Kerr, collections, and
two smaller slightly later ones, of which one is
from Hugh Low's Bornean collection). At BL
are versions in the Wellesley collection (prob-
ably a copy made in Calcutta, NHD 17.33),
in NHD 42.3, and in the Hastings collection
(Add. Or. 4946). At NHM are similar ones in
the Reeves collection and IDM 31.716.

Inscribed in Jawi: *durian tembaga* [= copper durian]
Paper: grey, laid; S WISE & CO 1822
Watercolour and bodycolour over pencil, heightened
with gum arabic; 566 × 574 mm
Probably by A Kow
NHD 48.25

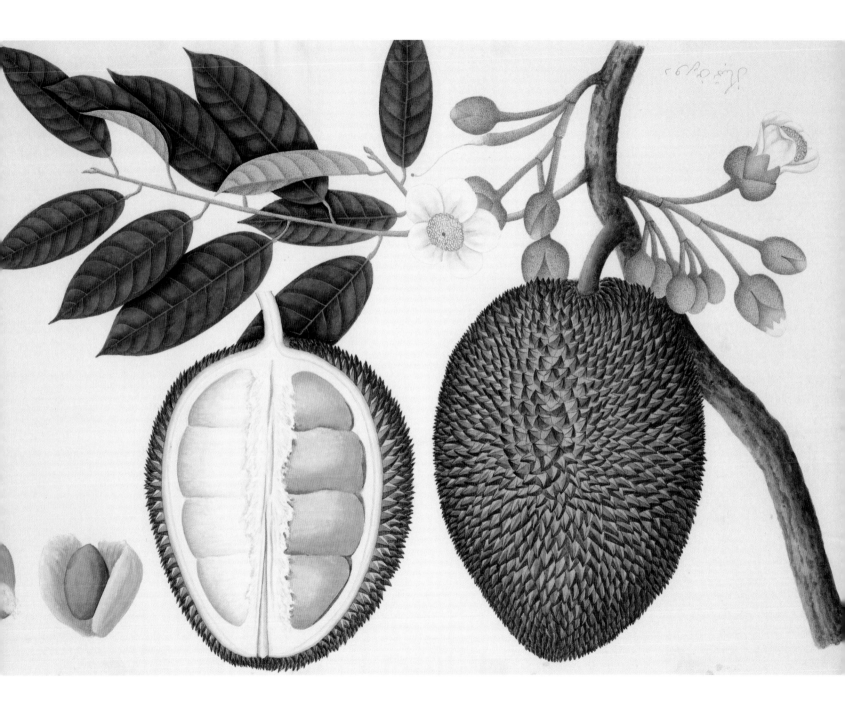

Syzygium malaccense

(L.) *Merrill & L.M. Perry*

MYRTACEAE

Jambu bol, jambu melaka, jambu merah
(Malaysia); rose apple

A tree to 20 metres tall, native to western Malaysia. It was taken to India at an early date and was recorded from Goa by the earliest Portuguese botanists (Garcia da Orta and Christobal Acosta); from there it spread to Africa. The fruit is fragrant but rather tasteless, and can be eaten raw or made into jam. The bark, powdered leaves and root have all been used for a variety of medicinal purposes. It was described in the genus *Eugenia* by Linnaeus in *Species Plantarum* (1753) based on specimens collected in Ceylon by Paul Hermann and earlier descriptions in Rheede's *Hortus Malabaricus* and Caspar Bauhin's *Pinax* (1623). Bauhin knew it from the early Portuguese writers, under the name *Persici ossiculo fructus malaccensis rubens*.

Inscribed in Jawi: *jambu jambak*
Paper: grey, laid; S WISE & CO 1822
Watercolour and bodycolour over pencil, heightened with gum arabic; dissections pencil, ink and ink wash; 535 × 370 mm
Probably by A Kow
NHD 48.26

Setaria italica *(L.) P. Beauvois*

GRAMINEAE

Sekoi, *iskoi*, *rumput ekur kuching* (Malaysia); foxtail millet

An annual grass, widely cultivated from southern Europe and Africa to SE Asia and Japan. The grains are tiny, but ripen only ten weeks from sowing, so were well suited, according to Burkill, to cultivation by the 'wandering tribes of the Malay forests'.

There is a specimen of this in the collection William Jack sent, at the request of Lady Hastings, wife of the Governor-General of India, to the Edinburgh University Museum, now in the herbarium of the Royal Botanic Garden Edinburgh (Fig. 12). However, it seems that Jack misidentified it for another commonly grown Indonesian cereal. The specimen is annotated in Jack's sprawling hand: 'Jawa. Malay name. It is extensively cultivated in Java, and the name has even been derived therefrom'. The etymology of the name of the island from any grain crop is probably fanciful, but the name Jack cites actually refers to the superficially similar barnyard millet (*Echinochloa crusgalli*).

Paper: cream, wove; H van Longlier ... & C De Liag... fabr... papier A Bruxelles
Watercolour and bodycolour; 398 × 518 mm
Probably by a Chinese artist
NHD 48.18

Lansium domesticum

Corrêa da Serra

MELIACEAE

Duku

This is the cultivated form of the *langsat* shown in NHD 48.19. The *duku*, a robust tree, has been selected for its rounded, thicker-skinned fruits, which split easily into five parts and are free from latex. It is commonly grown in Java. E.J.H. Corner wrote that: 'Good varieties of both kinds are among the best Malayan fruits. Those without seeds are the sweetest; and, as such are smaller than fruits with seeds: only the uninitiated choose the larger. Trees grown from seed will fruit in 15 years. The fruit generally ripens between June and August, but there may also be another crop early in the year, as with mangosteens and durians. Like most Malayan fruit-trees, the cultivation of *Langsat* and *Duku* cannot be extended profitably into countries with a pronounced monsoon climate, for they do not like the dry season.'

Annotation: Boah Dookoo (pencil)
Paper: cream, wove, ?Oriental; no watermark
Watercolour and bodycolour over pencil, leaves
heightened with thick gum arabic; 463 × 618 mm
Probably by a Chinese artist
NHD 48.27

Ananas comosus *(L.) Merrill*

BROMELIACEAE

Nanas (Malaysia); pineapple

The pineapple originated in South America, but was widely dispersed to the rest of the tropics by the Spanish and Portuguese. Since at least the seventeenth century it has been extensively cultivated in Malaysia and Indonesia for its fruit, but also formerly for its fibre, used for thread, twine, and woven into cloth. It was described by Linnaeus in *Species Plantarum* (1753) as *Bromelia ananas*, on which Philip Miller of the Chelsea Physic Garden based the new genus *Ananas* the following year. This is a case where the earliest published epithet cannot be transferred to a new genus, because it would make a 'tautonym', which, while allowed by zoologists, is forbidden in botanical nomenclature. In 1754 Linnaeus wrote a Latin dissertation (for defence by his pupil Olof Stickman) on the plants of Rumphius's *Herbarium Amboinense*. In this latter work is a magnificent plate of the pineapple (under the name *Anassa domestica*) on which Linnaeus entirely based his own *Bromelia comosa*, the epithet referring to the tuft of leaves on top of the fruit. Not until 1917 did the American Elmer Drew Merrill, in his own great interpretation of *Herbarium Amboinense*, make the present combination.

Note. Closely related to a drawing in the Farquhar collection (SHM 1995.3138).

Exhibited: *Spice of Life, Raffles and the Malay World*, Central Library, Liverpool VIII–X 2007.
Paper: cream, wove; no watermark
Watercolour and bodycolour over pencil;
460 × 648 mm
Probably by a Chinese artist
NHD 48.28

Anacardium occidentale L.

ANACARDIACEAE

Kajus, gajus, janggar; cashew nut

A small tree or shrub, native to tropical America, but widely cultivated in the tropics, and probably taken to Malacca and Goa by the Portuguese. As seen in this drawing the nut is borne on the end of a swollen, red stalk ('pedicel'). The nut has a hard shell (the 'pericarp', shown black in the longitudinal section), within which is an oily kernel containing a poisonous substance that must be cooked to make it edible; oil from the shell is used in brake linings and clutches. The pedicel is also edible and can be eaten raw; in Brazil and Goa juice from it is fermented and made into drinks. Sap produced by cutting the bark makes a black stain that can be used for marking cotton, and various parts of the tree have medicinal uses. It was described by Linnaeus in *Species Plantarum* based on a large number of earlier references (which include native and non-native localities in both the New and Old Worlds), and on specimens collected by Paul Hermann in Ceylon.

Note. Closely related to a drawing in the Farquhar collection (SHM 1995.3062).

Annotation: Kashoo (pencil)
Paper: cream, wove; no watermark
Watercolour and bodycolour over pencil, heightened with gum arabic; 454 × 642 mm
Probably by a Chinese artist
NHD 48.30

Artocarpus heterophyllus *Lamarck*

MORACEAE

Nangka; jak fruit

A large tree, native to southern India and cultivated in Malaysia, though less popular than the native *chempedak* (*Artocarpus intiger* (Thunberg) Merrill). The large, compound, fruits, which can exceed 50 kg in weight, are borne on the trunks ('cauliflorous') and not, as shown here, dangling from slender twigs! Burkill recorded the taste as 'mawkishly sweet and mousy, agreeable to natives of the East, but not to Europeans', and the interesting observation that in Malaysia bags were placed over the half-ripe fruit, to encourage ants to guard the fruit against attack from other insects. The timber is valuable and has been used for construction purposes, and for musical instruments and cabinet making. A dye obtained by boiling the wood is used in Burma and Thailand for colouring the robes of Buddhist monks; the roots are used medicinally in the treatment of fever. It was described by Lamarck in the *Encyclopédie Méthodique. Botanique* (1789) based on an illustration in Rumphius' *Herbarium Amboinense* (*Saccus arboreus major*) and specimens in the herbarium of Philibert Commerson collected from a tree cultivated in the royal garden on Mauritius.

Note. Some similarities to a drawing in the Farquhar collection (SHM 1995.3067).

Annotation: Boah Nanca or Jack (pencil)
Paper: cream, wove; no watermark
Watercolour and bodycolour over pencil, leaves heightened with thick gum arabic; 468 × 658 mm
Probably by a Chinese artist
NHD 48.31

Nephelium ramboutan-ake

(*Labillardière*) *Leenhouts*

SAPINDACEAE
Pulasan

A small to moderate sized tree, occurring from north-east India, through Burma, Malaysia and Indonesia to Borneo and the Philippines, both native in forest, and in cultivation (for its fruit). It differs from the rambutan in that the 'spines' of the fruits are not developed. The seeds, which can be roasted and used to make a drink, are rich in fat, which has been used as a lamp oil. The timber, though hard, is little used, and the roots have medicinal properties – being used against fevers and as a vermifuge. This species is better known under the name *Nephelium mutabile*, but the French traveller and botanist Jacques Julien Houtton de Labillardière in 1801 coined the epithet that now has to be used. He did so in a lecture on two species that he placed in the genus *Litchi* from the Moluccas, where they were cultivated having been introduced by the Chinese.

Annotation: Pulisang (pencil)
Paper: cream, wove; no watermark
Watercolour and bodycolour over pencil;
458 × 660 mm
Probably by a Chinese artist
NHD 48.32

Nephelium lappaceum *L.*

SAPINDACEAE

Rambutan

With the durian, perhaps the most characteristic of all SE Asian fruits. A moderate sized tree, occurring from Yunnan and the Philippines southwards through Indo-China, Malaysia and Indonesia, both native in forest and widely cultivated. Many races are grown (including one with yellow fruit) for their sweet pulp, which is the fleshy outer layer of the seed (technically a 'sarcotesta'). The fruit walls, roots, leaves and bark are used medicinally for a variety of complaints, including fevers. The timber is hard and used for a variety of purposes and the fruit is used to dye silk black. The species was first described in 1767 by Linnaeus, who, rather surprisingly, given its widespread use, cited no earlier literature. His description was based on a specimen in his herbarium that is no longer extant; the Latin epithet refers to the bur-like fruit.

Annotation: Ramby Hootun (pencil)
Paper: cream, wove, ?Oriental; no watermark
Watercolour and bodycolour over pencil, leaves heightened with thick gum arabic; 462 × 620 mm
Probably by a Chinese artist
NHD 48.39

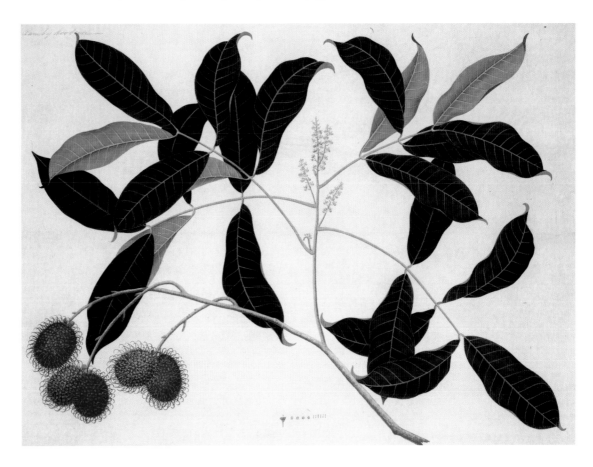

Theobroma cacao *L.*

MALVACEAE (STERCULIACEAE)

Pokok choclat; cacao, cocoa

A tree, native to the Andean foothills, but cultivated since Mayan times for its fruit, which was used (originally with chilli and maize) to make a drink. It was distributed from the New World by the Spanish, and various ways were found to make the drink more palatable – firstly with sugar, later with milk. Although cultivated earlier in the Philippines, the first record from Malaysia was by J.G. König in Malacca in 1778, and William Hunter noted a few plants being grown experimentally in Penang in 1802. It was described by Linnaeus in *Species Plantarum*, based on a variety of earlier illustrations and descriptions. From these the type of the species has been chosen as an illustration in Sloane's *Voyage to …Jamaica* (1725), with a supporting specimen in his herbarium. Given Sloane's interest in chocolate, this seems a happy choice. It was the bequest of Sir Hans Sloane's collections to the nation that led to the setting up of the British Museum in 1753, which included material that now forms the core both of the British Library and the Natural History Museum.

Note. Like the durian, another popular image that appears in many variants: e.g., Farquhar collection (SHM 1995.3021); Court collection (RBGE, ex Kew, see Fig.3); 'Chinese Plants' (Kew); Wellesley collection (BL NHD 17.28).

Paper: cream, wove; no watermark
Watercolour and bodycolour over pencil, leaves heightened with thick gum arabic; 462 × 620 mm
Probably by a Chinese artist
NHD 48.35

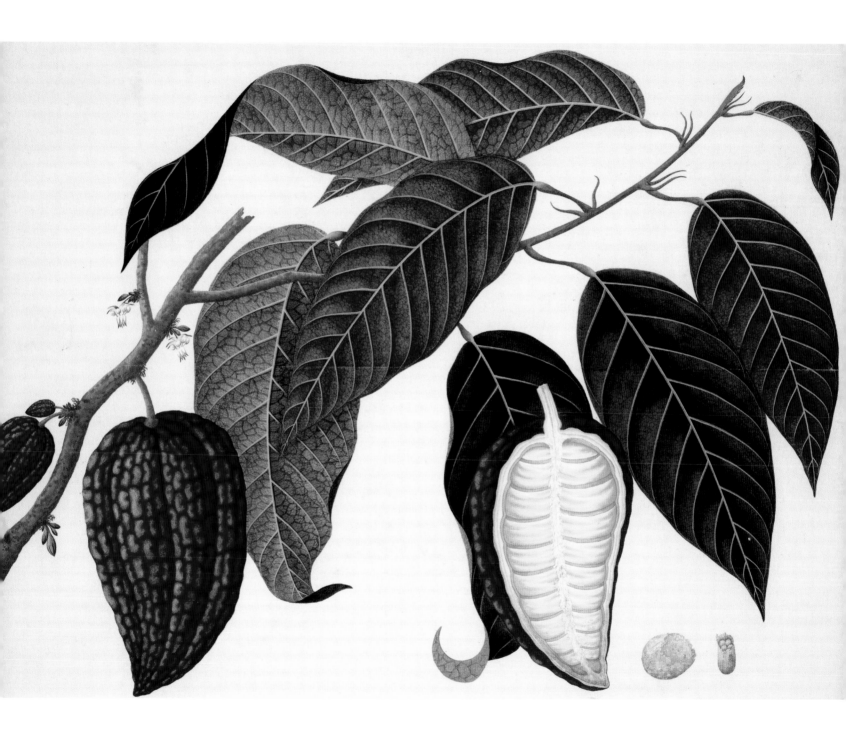

Annona squamosa L.

ANNONACEAE

Buah nona, *seri kaya* (Malaysia); custard apple, sweetsop

A small fruit tree, native to the West Indies, but widely cultivated all over the tropics for its delicious fruit. It was already in Java before the Dutch period, and probably came there either from India (via the Portuguese) or the Philippines (via the Spanish). While the fruit is edible and delicious, the seeds are poisonous and have been used to kill lice. The leaves have been used medicinally, applied externally to abscesses and to fly-infested wounds.

Note. Some similarities to a drawing in the Farquhar collection (SHM 1995.3073).

Annotation: Custard Apple (pencil)
Paper: cream, wove, ?Oriental; no watermark
Watercolour and bodycolour over pencil, heightened with gum arabic; 470 × 620 mm
Probably by a Chinese artist
NHD 48.37

Flacourtia rukam

Zollinger & Moritzi

FLACOURTIACEAE

Rukam (Malaysia); coffee plum

A small evergreen tree to 12 metres high; the trunk and branches are spiny, with thorns that are often branched and up to 10 cm long. It is found throughout Malaysia and Indonesia, but is often cultivated for its edible fruits, though has been 'little, if at all improved by village-cultivation'. The fruits are acidic, but can be made more palatable by rubbing them between the hands to bruise them, and are said to be better eaten cooked.

The leaves are used medicinally, applied to swollen eyelids, or powdered and applied to wounds. The timber is hard and in Java is used to make pestles for pounding rice. The plant was described in 1846 by the Swiss botanist Alexander Moritzi, based on the collections made in Java between 1842 and 1844 by his compatriot Heinrich Zollinger.

Paper: cream, wove, ?Oriental; no watermark
Watercolour and bodycolour over pencil, leaves heightened with thick gum arabic; 462 × 625 mm
Probably by a Chinese artist
NHD 48.38

Syzygium aqueum

(N.L. Burman) Alston

MYRTACEAE

Jambu ayer mawar; water rose-apple

A bush or small tree to 20 metres tall, probably native in Sri Lanka and from Bangladesh through Burma into western Malaysia, where it occurs in evergreen forest up to an altitude of 1500 metres. It is also commonly cultivated in gardens throughout Malaysia and Indonesia for its juicy, translucent whitish or pinkish fruits, which are eaten raw to quench thirst. The bitter bark was said by Rumphius to be useful as a treatment for thrush, and it has been used in a ceremonial salad eaten after childbirth. It was described (in the genus *Eugenia*) by N.L. Burman in his *Flora Indica* (1768), based entirely on the illustration and description in Rumphius' *Herbarium Amboinense*. Of this tree, E.J.H. Corner wrote: 'When the Water Apple flowers or is in fruit, you must look within the crown to enjoy its fairy spangles.'

Paper: cream, wove, ?Oriental; no watermark
Watercolour and bodycolour over pencil, leaves heightened with thick gum arabic; 468 × 624 mm
Probably by a Chinese artist
NHD 48.33

Mangifera indica *L.*

ANACARDIACEAE

Mangga, mempelam (Malaysia); mango

This renowned fruit tree is native to India, and thrives best in areas with a markedly seasonal climate, with dry conditions at fruiting time. It is therefore not particularly well suited to cultivation in much of Indonesia and Malaysia, where it has sometimes been grafted on to native species such as *Mangifera foetida*. The fruits of countless cultivated forms are eaten ripe, or, when unripe, made into chutney. The bitter seed and astringent bark have been used medicinally, and the timber for rough building work and making packing cases. In India a yellow dye called *peori* was formerly made from the urine of bullocks forcibly fed on mango leaves.

Note. Some similarities with a drawing in the Farquhar collection (SHM 1995.3085).

Annotation: Mangoe (pencil)
Paper: cream, wove, ?Oriental; no watermark
Watercolour and bodycolour over pencil, leaves heightened with thick gum arabic; 465 × 620 mm
Probably by a Chinese artist
NHD 48.40

Archidendron jiringa *(Jack) Nielsen*

LEGUMINOSAE

Jiring (Malaysia)

A tree to 25 metres tall, occurring from
Tenasserim in Burma, through western
Thailand, Malaysia and Sumatra to Borneo,
though in some places (as in Java) it is cul-
tivated. The starch-rich seeds have a nasty
smell, but are eaten 'after two or three boil-
ings on successive days' (Burkill). A purple
dye (for silk) is obtained from the pods, and
the leaves and bark are used medicinally for
skin complaints and chest pains; the wood is
used only for firewood and coffins. This draw-
ing is the type of *Mimosa articulata* Hunter,
but as this name was not published until 1909
the oldest name for the species is *Mimosa jir-
inga* (now placed in the genus *Archidendron*),
published by Raffles' botanist William Jack
in *Malayan Miscellanies* in 1820. Jack took the
binomial (while 'correcting' the spelling of
the epithet) from Roxburgh's catalogue of the
Calcutta Botanic Garden (which lacks spe-
cies descriptions) and cited the Malay name
as *Bua Jiring*.

Note. Other versions in British Library (NHD 17.57);
Natural History Museum (Fleming 257); 'Chong
collection' (no. 22).

Paper: Chinese
Watercolour and bodycolour over pencil, heightened
with gum arabic; 475 × 305 mm
Probably by a Chinese artist
NHD 49.1

Gmelina villosa *Roxburgh*

LABIATAE (VERBENACEAE)

Bulang (Malaysia)

A shrub or small tree, widespread from Burma, the Malay Peninsula and adjacent islands, to Java. It was described by William Roxburgh from material growing in the Calcutta Botanic Garden introduced by Hunter from Penang in 1802 – the very same material shown in this drawing. According to Burkill, when the Portuguese held Malacca they called the root of this plant, which they used medicinally, *Rais Madre de Deos* – the root of the Mother of God! At this time it was exported from Malacca to Goa, but it was believed that only roots growing facing north-wards were useful. The leaves and fruit are still used medicinally, as a poultice for head-aches and as a cure for tooth-ache. Under the name *Gmelina integrifolia* (of which this draw-ing is the type) Hunter recorded it as com-mon in roadside hedges on Prince of Wales Island, and that the 'fruit contains a juice of a disagreeable smell, and gives a very perma-nent stain, of a yellowish-brown colour'.

Note. Other versions in Natural History Museum ('Roxburgh' 6); 'Chong collection' (no. 15).

Annotations: Gmelina integrifolia A B a b c e f g h (ink)
Paper: Chinese
Watercolour and bodycolour over pencil, heightened with gum arabic; 459 × 303 mm
Probably by a Chinese artist
NHD 49.2

Gmelina integrifolia

Breynia coronata *J.D. Hooker*

PHYLLANTHACEAE (EUPHORBIACEAE)

A small shrub, native to Thailand and west‑
ern Malaysia. Burkill recorded no economic
uses for this species, but that it was known
in Malaysia by three common names, one of
which, *hujan panas*, means 'hot rain' referring
to the red fruits the size of raindrops, which
is applied to several similar looking species.
Hunter intended to give the plant (which
grew 'everywhere among the underwood' of
Prince of Wales Island) the name *Phyllanthus
agynus*, for which this drawing is the type.
Hunter's name, however, was not published
until 1909, by which time it had been given
a different one by Joseph Hooker, based on
material from Perak.

Note. Other versions in Natural History Museum
('Roxburgh' 3); 'Chong collection' (no. 18).

Annotations: Agyneia microcarpa a b c d e f g (ink);
Phyllanthus R[oxburgh] (pencil)
Paper: Chinese
Watercolour and bodycolour over pencil;
465 × 294 mm
Probably by a Chinese artist
NHD 49.3

Abrus precatorius *L.*

LEGUMINOSAE

Akar saga betina; coral pea

A climbing legume, famous for its beautiful scarlet and black seeds, which are often used as beads. On this account the plant, probably originally native to Africa, has been widely dispersed by man, and now occurs throughout the tropics. Partly due to their extreme hardness, the seeds have also been used historically in India and SE Asia as a unit of weight (the average weight of a seed being 1.5275 grains troy). A paste from the seeds, mixed with solder, is used by Malay goldsmiths when soldering jewellery. Although the seeds are highly poisonous, the leaves and roots, which contain glycyrrhizin, the active principle of liquorice are used medicinally – according to Burkill the 'Malays boil the leaves and roots, drink the decoction, or they chew them with betel-nut for coughs'. The plant was mentioned in Hunter's 'Flora of Prince of Wales Island' as 'growing among underwood on the plain'.

Annotation: Abrus precatorius ?Var (pencil)
Paper: Chinese
Watercolour and bodycolour over pencil;
447 × 315 mm
Probably by a Chinese artist
NHD 49.4

Callicarpa Americana?

Callicarpa candicans

(N.L. Burman) Hochreutiner

LABIATAE (VERBENACEAE)

Tampang besi (Malaysia)

An aromatic shrub bearing purple berries. The distribution is not entirely clear, due to taxonomic confusion in what is a difficult genus, but it certainly occurs in Peninsular Malaysia, Penang, Sumatra and Java, and probably extends to India, the Philippines and Australia. A decoction of the tender leaves is used medicinally in Malaysia for abdominal troubles. Hunter, in his Prince of Wales Island Flora, recorded the plant (under the name *Callicarpa dentata* Roxburgh) as growing 'plentifully in the forests near the bottom of the hill'. It was again collected there in 1822 (specimen no. 1834 in the EIC herbarium) by George Porter, head nurseryman of the Calcutta Botanic Garden, who was left on Penang by Wallich to re-establish the spice plantations, while Wallich travelled on to Singapore where he met up with Raffles. It was first described from Java (as a species of *Urtica*) by the Amsterdam botanist Nicolaas Laurens Burman, who recorded the local name as *moumineram*. E.J.H. Corner identified this drawing as *C. ?reevesii* Wallich, a plant from Southern China sometimes cultivated as an ornamental.

Note. Other versions in British Library (NHD 17.53); Natural History Museum (Fleming 1085).

Annotation: Callicarpa Americana? (ink)
Paper: Chinese
Watercolour and bodycolour over pencil;
462 × 302 mm
Probably by a Chinese artist
NHD 49.5

Gnetum gnemon *L.*

GNETACEAE

Meninjau, belinjau (Malaysia)

A tree to 20 metres tall, found wild in parts
of SE Asia with a markedly seasonal climate
(including eastern Malaysia, Java and the
Philippines), but also often cultivated as in
the case of the specimen depicted here from
Penang. The starch-rich fruits are edible
– raw, or, as in Java, cooked, and Hunter
recorded the taste as 'sweetish ... with a
mixture of astringency'. The bark is used for
its fibre as thread, for fishing nets, and mak-
ing bow strings. Though Hunter took this
to be related to nettles, unlike all the other
plants represented in this collection, it is, in
fact, a gymnosperm, and therefore related
to the conifers. While this is apparent from
the flowering parts ('strobili'), its leaves are
deceptively similar to those of an angiosperm.
Hunter recorded that it had been brought
to Prince of Wales Island, where it was culti-
vated in some gardens, from Amboyna.

Note. Other versions in British Library (NHD
17.64); Natural History Museum ('Roxburgh' 1,
Fleming 940); 'Chong collection' (no. 17).

Annotations: Gnetum Gnemon 1 2 3 a b c 4 a b c 5 a
b c 7 8 9 10 11 12 (ink)
Paper: Chinese
Watercolour and bodycolour over pencil, heightened
with gum arabic; 469 × 306 mm
Probably by a Chinese artist
NHD 49.6

Allophyllus cobbe (L.) *Rauschel*

SAPINDACEAE

Chungkil (Malaysia); *cheen chang* (Hunter)

An exceedingly variable and widespread plant, which occurs throughout the tropics of both New and Old Worlds. In habit it can be a shrub or tree (to 25 metres), or, as in the form depicted here, a straggling liane-like shrub; the flowers are unisexual with male and female found either on the same or on different trees. Taxonomists have generally despaired and lumped all the forms under a single species, though up to 250 distinct species have been recognised. It was first described (in the genus *Rhus*) by Linnaeus based on specimens collected in Ceylon by Paul Hermann under the local name *kobbae*. Decoctions of the leaves, roots and bark are used in the Malesian region against stomach ache and fevers; the timber is usually used only for temporary structures. Noted by Hunter in his 'Prince of Wales Island Flora' as 'found in thickets, climbing on other shrubs'.

Note. Other versions in British Library (NHD 17.60); Natural History Museum ('Roxburgh' 2, Fleming 79); 'Chong collection' (no. 8).

Annotations: Allophyllus racemosus a b c d a b h c g f e (ink)
Paper: Chinese
Watercolour and bodycolour over pencil, heightened with gum arabic; 465 × 300 mm
Probably by a Chinese artist
NHD 49.8

Allophyllus racemosus.

Mallotus cochinchinensis

(Lamarck) Müller Argoviensis

EUPHORBIACEAE

Balek angin (Malaysia)

A small, dioecious tree, widespread in SE Asia from southern China to tropical Australia – this drawing shows the male plant. The plant has various medicinal uses, for example, a decoction has been used for cleansing wounds, and a root decoction administered after childbirth. The bark provides a weak fibre that has been used in Bangka, but the light timber is used only for fuel and for making items such as match sticks and packing cases.

Note. Other versions in British Library (NHD 17.52); Natural History Museum ('Roxburgh' 12a, Fleming 802); 'Chong collection' (no. 19).

Annotations: Adelia? acuminata ♂ a b (ink)
Paper: Chinese
Watercolour and bodycolour over pencil;
470 × 305 mm
Probably by a Chinese artist
NHD 49.9

Mallotus cochinchinensis

(Lamarck) Müller Argoviensis

EUPHORBIACEAE

Balek angin (Malaysia)

This drawing shows the female plant. The taxonomic history of this species draws attention to the French influence in the discovery of the flora of Oceania and SE Asia. It was first described in 1786 by the great taxonomist (and evolutionist) Jean Baptiste Antoine Pierre Monnet de Lamarck in the second volume of his *Encyclopédie Méthodique. Botanique*. The specimen, from Java, had been given to him by the naturalist and explorer Pierre Sonnerat who travelled extensively in SE Asia, China and India. Lamarck noted that it had also been found on Java by Philibert Commerson, naturalist on Bougainville's circumnavigation of 1766–9, who ended his days in Mauritius.

Note. Other versions in British Library (NHD 17.54); Natural History Museum ('Roxburgh' 12b, Fleming 801); 'Chong collection' (no. 20).

Annotations: Adelia? acuminata ♀ a b b c a d e f f f g (ink)
Paper: Chinese
Watercolour and bodycolour over pencil;
472 × 302 mm
Probably by a Chinese artist
NHD 49.10

Adelia? acuminata. ♂

Adelia? acuminata. ♀

Clerodendrum cf. longiflorum

Decaisne

LABIATAE (VERBENACEAE)

There is some uncertainty over the identity of the plant shown in this drawing. It was recorded by Hunter as having being been 'brought from Amboyna, and flowered before it was removed from the box in which it came' and so may never have become established at Penang. Hunter considered it to be a new species, to which he gave the name *Volkameria fastigiata*, for which this drawing is the type, but his name was not published until 1909. *Clerodendrum longiflorum* was described by the French botanist Joseph Decaisne from the island of Timor, but there appears to be taxonomic confusion over these species with long, tubular, white flowers, adapted to pollination by moths.

Note. Other versions in British Library (NHD 17.49); Natural History Museum ('Roxburgh' 11, Fleming 685); 'Chong collection' (no. 16).

Annotations: Volkameria fastigiata a b (ink)
Paper: Chinese
Watercolour and bodycolour over pencil;
462 × 300 mm
Probably by a Chinese artist
NHD 49.11

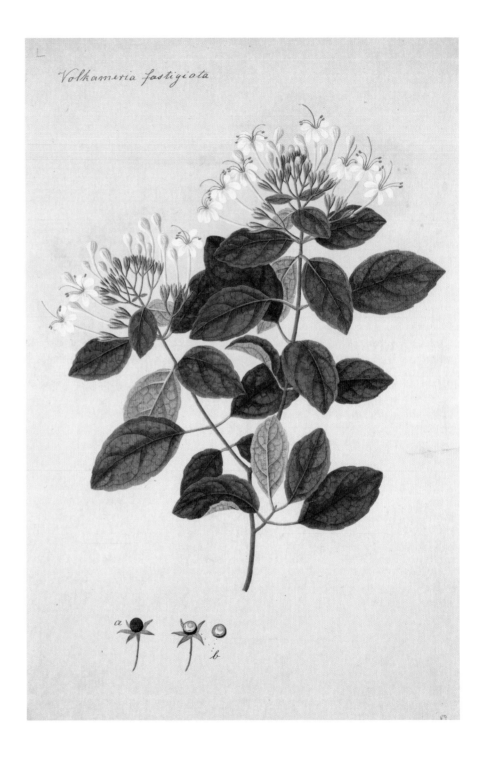

Rhodomyrtus tomentosa

(*Aiton*) *Hasskarl*

MYRTACEAE

Kemunting (Malaysia); woolly-leaved myrtle

A shrub to two metres high, widespread in India and SE Asia. The cherry-sized, dark purple fruits are edible when cooked – made into jam or tarts. The fruit has been used medicinally for dysentery, and a decoction of the root drunk to treat diarrhoea and eye complaints. The leaves have been used for magical purpose in Malaysia during exorcism ceremonies for epidemics. The red wood is fine-grained, but can only be used to make small objects. The plant was first illustrated and described in 1705 (under a long Latin phrase name) by Leonard Plukenet, from specimens collected on Crocodile Island off the coast of Fujian, China. It was first given a binomial by William Aiton, superintendent of the royal gardens at Kew, from material introduced to Kew by a Mrs Norman in 1776. Hunter, in his Prince of Wales Island Flora, described it as 'very common everywhere by the road side'.

Note. There are two drawings of this species in the Raffles collection (see also NHD 49.7) and it is not certain which of the two was in the 'Chong collection' (no. 11).

Paper: Chinese
Watercolour and bodycolour over pencil, heightened with gum arabic; 468 × 304 mm
Probably by a Chinese artist
NHD 49.12

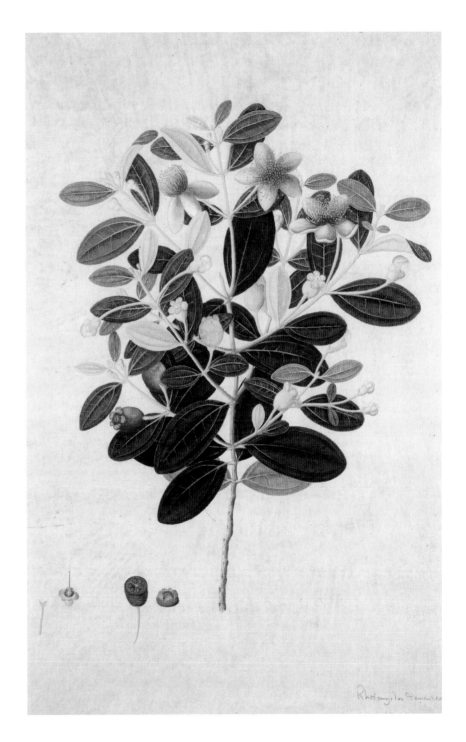

Lithocarpus sp.

FAGACEAE

Mempening, berangan (Malaysia)

This drawing, showing a male plant, is not good enough to allow identification to species level, but Professor E. Soepadmo has kindly identified the genus. Hunter must also have been very uncertain of its identity, as there is no description of anything resembling this drawing in his Prince of Wales Island Flora. The genus *Lithocarpus*, an evergreen group with valuable timber, has about 300 species, and occurs throughout the Indomalesian region and is closely related to the temperate oaks (of the genus *Quercus*). The tropical genus also has acorns for fruit, though in many species are very hard (hence the generic name, meaning 'stone fruit'), some of which, suitably prepared, are used as food.

Note. Other versions in British Library (NHD 17.61); Natural History Museum (Fleming 313).

Paper: Chinese
Watercolour and bodycolour over pencil, heightened with gum arabic; 472 × 300 mm
Probably by a Chinese artist
NHD 49.13

Tetracera indica

(Christmann & Panzer) Merrill

DILLENIACEAE

Mempelas (Malaysia)

A small, woody climber, occurring through-
out Indo-China, Thailand and Malaysia. Its
rough leaves are used as sand-paper, and,
as with many lianes, the stems have been
used for rope. The plant also has medicinal
and magical uses – the leaves and root
used against skin itch, and the leaves 'for
the treatment of a man made demented
by elephant spirits'. The species was first
described in 1779 by the German botanists
Christmann and Panzer, in a work based
on a book by the Dutch botanist Maarten
Houttuyn – they placed it in the genus
Assa, a name taken from a plant described
by Rumphius in his *Herbarium Amboinense*
(which actually referred to a different spe-
cies). In Hunter's Flora of Prince of Wales
Island he described the plant as being 'fre-
quently found in hedges by the road side',
that its flowers had 'an agreeable perfume'
and that 'it blossoms twice a year, (like
most plants on the Island, where the sun is
twice vertical) in April and October'.

Note. Other versions in British Library (NHD
17.66); Natural History Museum (Fleming 640;
'Roxburgh' 4); 'Chong collection' (no. 12).

Annotations: Euryandra scandens a b c e f g h 1
(ink); Tetracera trigyna (pencil)
Paper: Chinese
Watercolour and bodycolour over pencil, height-
ened with gum arabic; 465 × 302 mm
Probably by a Chinese artist
NHD 49.14

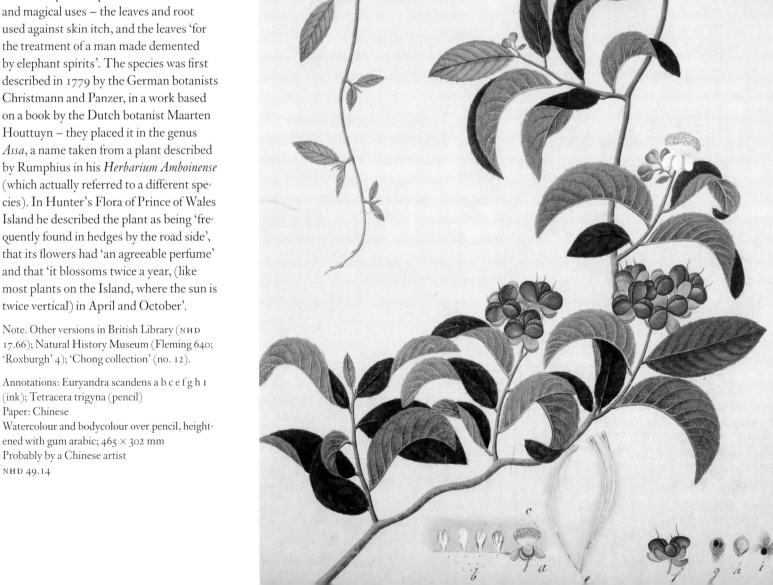

Fagraea fragrans *Roxburgh*

GENTIANACEAE (LOGANIACEAE)

Tembusu (Malaysia); *yaroon pitree* (Hunter)

A tree, native to Burma, peninsular Malaysia and Sumatra, but often cultivated as an avenue tree for its fragrant flowers. Its timber, which is pale yellow with a purplish tint, is extremely hard, and used for house building and bridges. Decoctions from the leaves and twigs have been used medicinally for dysentery-like complaints. This drawing was made from a specimen 'in a garden in the Prince of Wales's Island', and William Jack saw it in the same garden in 1819. Although he realised it was related to *Fagraea* Hunter intended to create a new genus for it commemorating Dr John Fleming, a Bengal surgeon (at one time in charge of the Calcutta Botanic Garden). Hunter's paper was not published until 1909 and meanwhile Roxburgh had realised that the plant did, indeed, belong to the genus *Fagraea* and described it in his *Flora Indica*. Hunter believed it not to be native on Penang, and Roxburgh stated that the plant 'was originally brought from China', but this was incorrect.

Note. Other versions in British Library (NHD 17.69); Natural History Museum ('Roxburgh' 7, Fleming 678); 'Chong collection' (no. 7).

Annotations: Flemingia fragrans a b c d e f g (ink); Fagraea R[oxburgh] (pencil)
Paper: Chinese
Watercolour and bodycolour over pencil, heightened with gum arabic; 460 × 307 mm
Probably by a Chinese artist
NHD 49.15

Melastoma Malabathricum

Melastoma malabathricum *L.*

MELASTOMATACEAE

Sendudok (Malaysia), *kedoodoo* (Hunter);
Singapore rhododendron

A shrub to three metres tall, widespread in
India and SE Asia where it occurs in second‑
ary vegetation. The pulp of the fruit is sweet
and edible, though stains the mouth black. It
has been used medicinally to treat a variety
of diseases including diarrhoea, and is said
often to be given to women after childbirth.
The fruits yield a black dye, and a pink dye is
obtained by boiling the leaves in a copper pan
for two hours with the bark of *Ceriops* and the
leaves of a species of *Peristrophe*. The Atlas
silk‑worm feeds on its leaves. Hunter noted
its preference for disturbed habitats and
that it 'springs up on ground which has been
cleared of the large timber'. It was described
in 1753 by Linnaeus, based on earlier speci‑
mens and descriptions from Ceylon and
Malabar. The epithet is taken from *malabath‑
ron*, the Greek name of an 'Indian or Syrian
plant, from which a costly ointment was pre‑
pared', though Linnaeus gave no reason as to
why he thought this *Melastoma* was the plant
concerned.

Note. Other versions in British Library (NHD
17.68); Natural History Museum ('Roxburgh' 5;
Fleming 1148); 'Chong collection' (no. 10).

Annotations: Melastoma Malabathricum a b d c
e d b a (ink)
Paper: Chinese
Watercolour and bodycolour over pencil;
465 × 302 mm
Probably by a Chinese artist
NHD 49.16

Cerbera manghas *L.*

APOCYNACEAE

Bentan, *bintaru*, *pompong* (Malaysia)

A small tree, occurring as a native along the coasts of SE Asia, tropical Australia and Polynesia. It is also cultivated in gardens, as recorded by Hunter in his Flora of Prince of Wales Island, for its ornamental, fragrant flowers, which are borne all year round. Oil expressed from the poisonous seeds has been used for lighting purposes in Penang, and can also be used medicinally – externally to cure itch and colds; in Burma it is used as a hair oil. The leaves and latex are emetic and purgative. The wood makes a fine charcoal that has been used in making gunpowder. The species was described by Linnaeus in 1753 based on various earlier descriptions and illustrations, some of which refer to the species depicted here, others to a similar species from India and Sri Lanka later distinguished as *Cerbera odollam*.

Note. Other versions in British Library (NHD 17.65); Natural History Museum (Fleming 1150); 'Chong collection' (no. 5).

Annotations: No. 1. Cerbera Manghas (pencil)
Paper: thin Chinese
Watercolour and bodycolour over pencil, heightened with gum arabic; 460 × 290 mm
Probably by a Chinese artist
NHD 49.17

Anodendron paniculatum

Alphonse de Candolle

APOCYNACEAE

A large climber, widely distributed through India, Sri Lanka and SE Asia. The bark yields a very fine fibre, though this is not commercially 'costing too much in labour to obtain in quantity'. One of the characteristics of members of this family is the production of white latex, which has been used for producing 'caoutchouc', a kind of rubber. This species was described in 1844 by the second of a great dynasty of Geneva botanists, based on specimens from a wide range of localities in SE Asia, including the plant from Silhet (now in Bangladesh) for which Roxburgh published the name shown on the drawing. This name, however, had earlier been used for a quite different species.

Note. Other versions in British Library (NHD 17.51); Natural History Museum ('Roxburgh' 9, Fleming 1147); 'Chong collection' (no. 6).

Annotations: Echites? paniculata a b c d e (ink)
Paper: thin Chinese
Watercolour and bodycolour over pencil, heightened with gum arabic; 465 × 300 mm
Probably by a Chinese artist
NHD 49.18

Ardisia elliptica *Thunberg*

MYRSINACEAE

Rempenai, chempenai, buah letus (Malaysia)

A shrub to four metres high, widespread from southern India and Sri Lanka through SE Asia to New Guinea, especially in swamps and along muddy river banks close to the coast. The young shoots are edible and a decoction of the boiled leaves can be taken for cardiac pains. Formerly known under the name *Ardisia littoralis* Andrews (the epithet referring to its habitat), the species was first described from Ceylon by Carl Peter Thunberg – Linnaeus' pupil, who succeeded to his Uppsala chair on the premature death of Linnaeus' son. Thunberg is best known for his work on the Japanese flora, undertaken while a surgeon for the Dutch East India Company. The circumstances were difficult, as most of the Dutch were confined to the artificial island of Dejima, but Thunberg, on account of his medical skills, was allowed to visit Edo (later Tokyo). *En route* to and from Japan Thunberg also made important collections in Java, Ceylon and the Cape of Good Hope.

Note. Other versions in British Library (NHD 17.48); Natural History Museum ('Roxburgh' 8, Fleming 433); 'Chong collection' (no. 4).

Annotations: Ardisia umbellata a b c d (ink)
Paper: thin Chinese
Watercolour and bodycolour over pencil, heightened with gum arabic; 470 × 305 mm
Probably by a Chinese artist
NHD 49.19

Stereospermum fimbriatum

(G. Don) Alphonse de Candolle

BIGNONIACEAE

Chacha, lempoyan, beka (Malaysia); fringed-flowered trumpet-flower (Don)

A tall tree of Burma and peninsular Malaysia. The dark timber is durable and used for beams and posts. The leaves are used medicinally for ear ache and skin itch, and a root decoction is given to women after childbirth. When Hunter saw it on Prince of Wales Island, where it flowered in January 'at which time the ground about the tree is richly strewed with its beautiful flowers', the species was undescribed and he coined the name *Bignonia? laciniata* for it, for which this drawing is the type. The name, however, was not published until 1909, and in the interim the species had been described by George Don in his *General History of the Dichlamydeous Plants* (1838) as *Bignonia fimbriata*. Don's name was based on a specimen in the EIC herbarium collected by Nathaniel Wallich at Moulmein in 1827. The name was coined by Wallich in his 'Numerical List' of this collection, but it fell to Don to provide a description and validate Wallich's name.

Note. Other versions in British Library (NHD 17.59); Natural History Museum (Fleming 680); 'Chong collection' (no. 14).

Exhibited: *The Golden Sword, Stamford Raffles and the East*, British Museum XII 1998 – IV 1999.

Paper: Chinese
Watercolour and bodycolour over pencil, heightened with gum arabic; 480 × 300 mm
Probably by a Chinese artist
NHD 49.20

Dillenia excelsa *(Jack) Gilg*

DILLENIACEAE

Simpoh paya (Malaysia), *kayu sipur*
(Malay – Jack)

A large, evergreen tree that can reach 40
metres in height, occurring from Thailand,
through Malaysia and Sumatra, to Java,
Borneo and the Philippines. The timber is
used for house building. This drawing was
doubtless made from the specimen that
'flowered in the Honourable [East India]
Company's spice plantation' on Penang.
Hunter intended to call it *Dillenia secunda*
(of which this drawing is the type), but
before this was eventually published, in 1909,
William Jack had described the same spe‐
cies (in the genus *Wormia*) from Bencoolen.
George Porter also collected this species
on Penang in 1822, and his specimen in the
East India Company herbarium was named
Wormia oblonga by Wallich, but Jack's name
has priority over this.

Note. Other versions in British Library (NHD
17.67); Natural History Museum (Fleming 1151);
'Chong collection' (no. 13).

Paper: thin Chinese
Watercolour and bodycolour over pencil, heightened
with gum arabic; 460 × 300 mm
Probably by a Chinese artist
NHD 49.21

Dillenia (Wormia) excelsa

Murraya paniculata (L.) Jack

RUTACEAE

Kemuning (Malaysia); Chinese box, Chinese myrtle

A small, aromatic tree, widespread as a native in SE Asia (to tropical Australia), but also often cultivated. The yellow wood, especially of the roots which is beautifully grained, is valued for making walking sticks and, as noted by Hunter, 'the Malays make the sheaths and handles of their creeses' from it. The leaves are used medicinally for various complaints. In Burma and Thailand a powder obtained from the bark is used by women as face make-up. A yellow dye is obtained from the shoots, and it is also cultivated for its fragrant flowers. Linnaeus had described it in 1767 under the genus *Chalcas*, based on a plate of a plant called *Camunium* in Rumphius's *Herbarium Amboinense*. Hunter, who knew it on Prince of Wales Island from a single tree 'in the garden of Lieut. Col. Polhill', from which this drawing must have been made, considered it to belong to a new and undescribed genus, and annotated the drawing accordingly, but William Jack (while at Bencoolen in 1820) realised that the plant was best placed in the genus *Murraya*.

Note. Other versions in British Library (NHD 17.56); Natural History Museum ('Roxburgh' 10, IDM 39.217).

Annotations: Xestoxylon odoratum a b c d e (ink)
Paper: thin Chinese
Watercolour and bodycolour over pencil, heightened with gum arabic; 470 × 510 mm
Probably by a Chinese artist
NHD 49.22

Parkia speciosa *Hasskarl*

LEGUMINOSAE

Petai (Malaysia), 'faba foetida' (Hasskarl)

A tree to 25 metres tall, native to Malaysia, but also often cultivated for its edible pods. Hunter recorded that it flowered in May and December, and that the 'Malays are very fond of the seeds, which taste something like garlic, and of the pulp which surrounds them'. According to Burkill 'when the pods have been eaten, this [objectionable] smell is exhaled by the eater'. When this drawing was made, the tree was undescribed (at least in Western taxonomy) and Hunter intended to call it *Mimosa pedunculata*, of which this drawing is the type. His name and description were not published until 1909 by which time the German botanist Justus Karl Hasskarl had described it under the present name, from material cultivated in the Dutch botanic garden at Bogor, Java. Hasskarl contributed greatly to the study of the Javanese flora during his time on the island, and played a key role in the introduction of cinchona to the Dutch East Indies (an altogether more successful venture than the much vaunted British one in India). The generic name *Parkia* commemorates the great Scottish explorer of Africa, Mungo Park, and was coined by Robert Brown.

Note. Other versions in British Library (NHD 17.62); Natural History Museum (Fleming 1145). [NHD 17.63 and Fleming 1146 are 'companions' to this image showing leaves and an inflorescence; 'Chong collection' (no. 21) is a composite with leaves, inflorescence and a single pod all on one plate].

Paper: thin Chinese
Watercolour and bodycolour over pencil, heightened with thick gum arabic; 455 × 300 mm
Probably by a Chinese artist
NHD 49.24

? Cissus sp.

VITACEAE

This rough sketch is of interest as the name it bears, '*Cissus angustifolia*', is that of the plant Jack identified as the host of his *Rafflesia titan* (= *R. arnoldii*). However, Jack described the host vine as having 'ternate and quinate' (i.e., 3- and 5-lobed) leaves, as does *C. angustifolia*, a plant described by Roxburgh from Sumatra. The current identity of Roxburgh's species is not known, though it could perhaps have been a narrow-leaved form of the *Rafflesia* host, now known as *Tetrastigma leucostaphylum* (Dennstedt) Alston, which does usually have 5-lobed leaves. The plant shown here has simple leaves and is probably a species of *Cissus*. Might Raffles' collectors have intended to collect the *Rafflesia* host (perhaps to accompany a drawing of *Rafflesia* itself), but gathered a simple-leaved vine by mistake?

Annotation: Cissus angustifolia (pencil)
Paper: cream, wove; J WHATMAN 1820
Pencil; 560 × 380 mm
Artist unknown
NHD 49.27

Senna alata (L.) *Roxburgh*

LEGUMINOSAE

Gelenggang, *daun kurap* (Malaysia); ringworm cassia, seven golden candlesticks

A herb that can become slightly woody and reach two metres in height. Originally native to the tropics of the New World, it is now a common pantropical weed. It reached the East Indies at an early date and Georg Eberhard Rumphius in the seventeenth century (under the name *Herpetica*) described its medicinal properties as used in Amboyna, where he worked as a surgeon for the Dutch East India Company. The leaves are still used medicinally for skin diseases including ringworm, and, like other members of the genus, a decoction of the leaves can be taken as a purgative. The winged pods (to which the specific epithet refers) can be eaten raw or steamed, and the seeds act as a vermifuge. It was described in the genus *Cassia* by Linnaeus in *Species Plantarum* (1753), based on a number of earlier descriptions in works on Surinam (by the intrepid traveller and entomologist Maria Sybilla Merian), the West Indies (by the French missionary Charles Plumier), and the catalogues of various European botanic gardens.

Note. Other versions in British Library (NHD 17.58); Natural History Museum (Fleming 1149); 'Chong collection' (no. 9).

Annotations: a b c d e f (ink)
Paper: thin Chinese
Watercolour and bodycolour over pencil, heightened with gum arabic; 300 × 475 mm
Probably by a Chinese artist
NHD 49.23

V The Collections

'Ardently attached to Science, he laboured successfully to add to the knowledge and enrich the museums of his native land.'

Being a polymath Raffles collected extensively over a wide range of fields, but, as Nigel Barley (1999) pointed out 'it is natural history that provides the model by which we may understand all the other Raffles collections'. The natural history drawings were one of the most important elements of the whole, but, for reasons already discussed, represent the mere tip of what, up to 2 February 1824, had been a volcano (a metaphor more apt in the circumstances than the conventional iceberg). The huge diversity within the collections has been presented in significant exhibitions twice within living memory – in 'Raffles Reviewed: Sir Stamford Raffles 175 years later' held at the National Museum of Singapore in 1994, and in the exhibition 'The Golden Sword: Stamford Raffles and the East' at the British Museum in 1998/9. The book of the latter exhibition (Barley, 1999) is easily available and gives a good taste, in words and pictures, of the riches involved. Nonetheless it is necessary to give a brief summary of the other collections here – their content, history and present whereabouts – as a context for the natural history drawings.

Given the destruction of the Sumatran collections, most of what has survived dates from Raffles' first oriental period, and very largely from his time in Java 1811–16. This material, some 30 tons, was brought back to London in 1816, and used extensively as the 'material culture' basis for his *History of Java*. These collections included what was classified as 'ethnographic': artefacts made in Java, among which were musical instruments (including two gamelan sets), batik cloth, shadow puppets (*wayang kulit*), amulets in the form of coins and bronze antiquities including zodiac beakers. There was also ethnographic material from Japan, a spinoff from Raffles' (unachieved) ambitions to develop British trade links with that reclusive empire. There were also printed and manuscript materials, including drawings by Western artists, especially of archaeological remains, related to Raffles' great publication. When Raffles

returned east in 1817 the artefacts, including the gamelans, were left mainly with the Duke of Somerset at Park Lane House, London, the manuscript Malay letters with William Marsden (at Edge Grove, near Watford), and books with his uncle William Raffles (in Spitalfields). The drawings associated with the *History of Java* were deposited with various friends and relations, including the Duchess of Somerset and Raffles' cousin Elton Hamond. Most of this material eventually found its way back into Raffles' hands when he returned to London in 1824 and was inherited by his widow, though she also had to gather up stray material (including the gamelans) after his death in 1826. In 1830 Sophia gave many of her husband's manuscripts to the Royal Asiatic Society, and on her death in 1858 her executors offered the remaining collections to the British Museum for a thousand guineas – a generous offer that was churlishly declined. In 1859 the collections were again offered to the BM, but as a gift, by Raffles' nephew and heir, the Rev. William Charles Raffles Flint (whose wife, Jenny Rosdew Mudge, was Sophia's niece). This time the collection was accepted, but the material was stuffed, higgeldy-piggeldy into a single large glazed display case. Flint protested and at least slight amends were made, but the diversity was a challenge to the Museum's classification system and so was broken up, with parts of the collection going to several different departments (an ithyphallic figurine banished to the *musaeum secretum*), and the printed material and some of the drawings to what would become the British Library. (For completeness one should add that of related natural history material from the Javanese period, collected by Thomas Horsfield, the zoological specimens were presented to the India Museum in Raffles' name in 1813 and 1817, and what survives of them is now in the Natural History Museum. Horsfield's botanical specimens and nature prints sent to Banks have also ended up in the NHM, but the related botanical drawings are now largely at Kew).

Some of the Raffles collection – drawings, manuscripts and artefacts – was retained by the Flint family, which was eventually inherited by the Rev. W.C.R. Flint's granddaughter, Muriel Rosdew Raffles-Flint, daughter of the Archdeacon of Cornwall, who in 1908 married John Hughes Drake, a prosperous sugar broker. Major Drake had a distinguished First World War and in 1938 the Drakes bought and retired to the sporting estate of Inshriach in Inverness-shire. The following year, 1939, Mrs Drake presented five volumes of drawings of Javanese antiquities to the BM, keeping only the natural history drawings, the Malay and Indonesian letters, some butterflies, shells and fossils, some architectural and topographical drawings.

THE 'RAFFLES FAMILY COLLECTION'

After the purchase of the Minto–Raffles letters by the India Office Library in 1969 the Drake family, with the encouragement of Dr John Bastin, deposited there the remaining material, the 'Raffles Family Collection', on permanent loan, in two batches in July 1969 and November 1970. This consisted of the natural history drawings (NHD 47, 48, 49), miscellaneous family correspondence (MSS. Eur. D.742), one coloured (P1969) and five uncoloured (P2246, 2249–52) copies of the *Rafflesia* print, and what were then known as the 'Raffles Drawings' (WD 2969–3005) – the last a rather diverse collection, mainly topographical and architectural, largely by Western artists, mainly related to Raffles' *History of Java*, but some (including images of the Singapore Institution) dating from after his death. These drawings were published by Mildred Archer and John Bastin in 1978, including several images of relevance to the present work – a beautiful watercolour of Fort Cornwallis, Penang by William Westall, the artist on the Flinders voyage to Australia on which the botanist was Robert Brown; drawings of the Dutch Governor's house at Buitenzorg (Bogor) on Java, taken over by Raffles and in which both Horsfield and Joseph Arnold stayed. But of most direct relevance in the present context are two drawings by one of Raffles' Chinese artists of Pematang Balam, Raffles' country house near Bencoolen (Fig.18).

After the death of his parents in 1970 and the decision to sell Inshriach, Jack Drake found further material, including the Malay letters in exquisite Jawi calligraphy, in a green velvet box in the attic, and these formed the final donation to the India Office Library.

In 1962 Mrs Archer published a pioneering catalogue of the natural history drawings of the India Office Library (incorporated into the British Library in 1982), and, following their deposit, started to research the Raffles natural history drawings (with the assistance of zoological staff of what was then the British Museum (Natural History) and the botanist E.J. H. Corner). However, other interests called and she seems to have abandoned the work.

THE NATURAL HISTORY DRAWINGS

Mildred Archer's notes on the collection fortunately survive and have been an invaluable starting point for this belated realisation of her intentions. As noted in the Introduction this is a rather heterogeneous collection, of which the major elements were recognised by Mrs Archer. This, however, seems largely to have been forgotten in the intervening years, and the idea that it was a uniform collection, all (romantically) made after the burning of the *Fame* came to prevail. The source of this idea was, primarily, a label on the binding (by R. Ackermann Junr., 191 Regent Street) of a volume in which a large number of the drawings were mounted when in possession of the Drake family. In Raffles' hand, this reads:

No. 1. Drawings of Birds and Plants done after the burning of the Fame. Bencoolen. March 1824.

The volume was intact when deposited in 1969, as it had been when John Corner first examined it at Inshriach in 1957. It was doubtless in poor condition, so the drawings of birds, mammals and plants were removed and mounted individually in two groups, but retained in the same sequence, to form NHD 47 and NHD 48. The individual drawings of NHD 49 that were never in the volume were also mounted in the same style, so that the collection now looked more uniform than it originally had. The belief that all these drawings

were made after the burning of the *Fame* requires qualification, and some of the plant drawings of NHD 48, and the 'miscellaneous' drawings of NHD 49, turn out to have an earlier origin. Given the virtual absence of annotations it would seem that Raffles took little if any interest in the drawings after his return to England, doubtless with other concerns on his mind and it seems unsurprising that he might have amalgamated earlier drawings with those genuinely made at Bencoolen, and considered this an unimportant matter. Using drawing styles, accurate identifications of the organisms depicted, papers and watermarks, it is possible to be more precise about the origins of the various elements.

Birds and mammals (NHD 47)

These occupied the first part of the Drake volume, and were most probably made in Bencoolen in February and March 1824, post-*Fame*: they are uniform in style, and are probably all the work of J. Briois whose name appears on eight. They consist of 44 birds, 6 mammals, and one mammal body-part. Curiously some of the birds are duplicated (e.g., NHD 44.1/2, 15/16), with one of such pairs on a thicker paper with an 1816 watermark. It seems possible that the artist kept reference copies of some of the drawings (possibly for his own collection), which would explain why he was able to produce 'new' versions for Raffles in a short space of time. In the rush of packing it seems possible that some of the 'stock' copies (those on earlier, thicker paper) were included by mistake, accounting for the duplications. Briois' name appears only on bird drawings, but from the pencil suggestions of backgrounds in the mammal ones, it seems likely that he is also responsible for those.

Plants (NHD 48)

Also in the Drake volume, these 40 drawings fall into two distinct groups: 'botanical' drawings lacking ruled borders, and some much bolder drawings of exotic fruits with ruled, ink borders. The former are almost certainly the ones made at Bencoolen, and are extremely finely painted (in a fairly traditional Chinese style) botanical studies of plants that could all have been found in the vicinity.

The second group belong to the genre of sets of exotic fruits made in large numbers for EIC servants in Malacca, Penang and elsewhere, in the hybrid 'Straits School' style, but with unusually heavy glazing with gum arabic. While it is possible that Raffles could have acquired these from the stock of an artist working in Bencoolen in 1824, the curious bunch of *Setaria* (NHD 48.18), as explained on page 31, suggests a different, earlier, origin. The pineapple (NHD 48.28) is also revealing, as there is an almost identical drawing in the Farquhar collection (SHM 1995.3138), which must have been made in Malacca. It is therefore possible that Raffles had some of this group even before going to Java.

Miscellaneous drawings (NHD 49)

Mrs Archer recorded that these drawings, depicting 29 plants, one bird, one reptile, and one mammal, were not in the Drake volume, and that, in contrast to NHD 47 and NHD 48, there was 'no evidence' to prove that these drawings were made in 1824. Among the plants are four distinct groups.

The most important are nos 1–24, which Archer did not recognise, despite the fact that other versions of most of them exist in another British Library collection. Yu-Chee Chong (1987) was the first to identify these as versions of the drawings made for Dr William Hunter in Penang in 1802–4, but this information seems not to have reached the British Library. The link with Raffles is clear, as Hunter was Superintending Surgeon on Java, where he died in December 1812. Raffles paid tribute to Hunter in his 1813 address to the Batavian Society of Arts and Sciences, and is known to have acquired material at the sale of his effects – these drawings clearly among them, and therefore almost certainly among the drawings that Raffles brought home in 1816. Hunter was clearly concerned about the survival of these paintings, which are unusual in the number of versions or copies that are still extant – the set sold by Chong in 1987 (studied by Forman, 1989, nine of which are now in the Penang Museum), versions in the Fleming and 'Roxburgh' collections at NHM, and copies (probably by Calcutta artists) in the Wellesley collection (NHD 17).

Other works – Plants:

[A] Drawings of nutmeg and cloves, probably, as suggested by Archer, by the Bencoolen artist (supported by the fact that there is an almost identical version of the clove NHD 48.5 at Kew, which, though not annotated, is almost certainly from the collection made for John Prince).

[B] A rough pencil sketch of a vine (*Cissus* sp.). The name on this drawing is that of the species Jack believed to be the host of *Rafflesia*. Although a misidentification, this suggests that this is also a Bencoolen drawing.

[A] Two drawings with 1829 watermarks, which postdate Raffles' death. One is a copy from the last part of Roxburgh's *Plants of the Coast of Coromandel*. The other is a sprig of fruiting peaches, in a style similar to that of William Hooker, probably copied from an as yet unidentified work.

Animals:

[A] An unfinished drawing of a hornbill, of which there is an identical version in the Farquhar collection.

[B] A charcoal study of the head and hands of an orang utan, probably drawn in Malacca, where Raffles is known to have kept two as pets.

[C] An unfinished drawing of the head of a mangrove pit-viper, most likely to have been drawn in Malacca.

RELATED BOTANICAL COLLECTIONS

Herbarium Collections of William Jack

Elmer Drew Merrill, an American botanist who specialised on the Philippine flora, also undertook pioneering research in the bibliography and nomenclatural history of Southeast Asian plants, including a detailed study of Rumphius' *Herbarium Amboinense*. As part of these interests Merrill published, in 1952, a meticulously detailed account of William Jack's botanical work – with a list of the genera and species he described and their currently accepted names. As has already been stated Jack's descriptions are so accurate that someone with a good knowledge of the Southeast Asian flora can identify his species even in the absence of specimens. Merrill did, however, seek out the surviving herbarium specimens, though at a time when the extent of the Jack collection at RBGE was not fully known (Figs.12, 22). The Edinburgh collection has been described earlier, but it is appropriate to note here the other collections in which Jack specimens are to be found.

Jack sent specimens to his friend Nathaniel Wallich from Penang, Singapore and Sumatra. Much of this material appears to have gone missing before Wallich took the East India Company herbarium from Calcutta to London in 1828, where it was sorted, named and a lithographic catalogue produced. The Catalogue lists 9148 numbered species (most with multiple collections), but has not yet been made into a searchable form, so the number of Jack specimens is not known, though only 30 have been noted by Burkill and Merrill. Of these the majority are from Penang (only 3 from Singapore and one from Car Nicobar) and none from Sumatra. Of the Penang specimens one is a *Tacca* Jack intended to name after Lady Raffles, eventually published as *Tacca cristata* Jack, and not now regarded as distinct from *T. integrifolia* Ker Gawler. The top set of the EIC herbarium was originally given to the Linnean Society, but duplicates were widely distributed, and several partial sets have ended up at RBGE. None of the Jack numbers is among these, suggesting that Jack did not send enough material to enable Wallich to make duplicates, so the only specimens will be in the 'top set', now at Kew.

At the Natural History Museum are specimens sent by Jack to Robert Brown; the number is unknown, but a filmy fern bears the number '59', so there could be up to at least that number scattered through the herbarium. There are also at least five sheets of *Nepenthes* (including the types of *N. rafflesiana*) sent to Brown by Jack from Singapore in 1819.

Jack also sent specimens to A.B. Lambert: 'all the specimens described in the first Volume of the "Malay Miscellanies": among which are three splendid species of that most remarkable genus of plants, *Nepenthes*.' (Don in Lambert, 1828). The herbarium was sold after Lambert's death, and the Jack/Raffles material (lots 111, 255) was purchased by two dealers, William Pamplin and Obadaiah

Fig.22. *Hibiscus tiliaceus*, specimen collected by William Jack while with Raffles at Singapore in June 1819; one of those sent by Jack to the Edinburgh University Museum in 1820 at the request of the Marchioness of Hastings.
Royal Botanic Garden Edinburgh

Fig.23. *Nepenthes rafflesiana*, specimen collected by Nathaniel Wallich while at Singapore with Raffles in 1822.
Royal Botanic Garden Edinburgh

Rich respectively. Rich was buying on behalf of the French botanist Benjamin Delessert whose herbarium is now at Geneva, and Merrill lists seven specimens there – four of which belong to Gesneriaceae and one to Melastomataceae, families on which Jack (posthumously) published important papers in the *Transactions of the Linnean Society*. (Also in the Delessert herbarium is a specimen of a wild pepper collected by Raffles in Sumatra, named after him *Chavica rafflesii* by the Dutch botanist F.A.W. Miquel in 1843).

The final herbarium in which Merrill discovered Jack material (a mere four specimens) is the Rijksherbarium at Leiden. These arrived via the herbarium of the Dutch botanist J.K. Hasskarl who worked in Java from 1837 to the 1850s. These bear Jack's own writing and it is assumed that they were left behind in Bencoolen, which reverted to the Dutch in 1825, and ended up at Buitenzorg.

Botanical Drawings

A number of related collections of botanical drawings made in Southeast Asia for EIC servants throw light on the Raffles collection. Those in the collections of Kew and RBGE, and those made for William Farquhar now in Singapore, have been described in the Introduction.

The wax models of a Rafflesia *flower*

One of Raffles' last letters (Kew DC 1 f. 226), of 11 May 1826, concerns the commissioning of a life-size wax model of a *Rafflesia* flower for William Hooker – which Hooker doubtless wanted for his famously well illustrated lectures in Glasgow. Raffles died only two months after the letter was written, and as the model that survives at Kew is the one made for the Horticultural Society, acquired with 'several models of the same in different stages of growth' in May 1855, the Hooker version would appear not to have been made. Raffles did not name the model maker, but it may well have been William Tuson who made wax fruit models for the Horticultural Society, and anatomical models for Herbert Mayo the anatomist and physiologist. The Horticultural Society model cost £12 in 1825, but Raffles proposed charging Hooker £20 for his. (Fig.21). Another version was made for the Linnean Society, and, according to Robert Sweet (1825), Raffles also had one himself.

RELATED ZOOLOGICAL COLLECTIONS
Specimens

As described in Chapter 11, after falling out with Diard & Duvaucel, Raffles took charge of their zoological specimens and drawings. William Jack made scientific descriptions of them, named those he believed to be undescribed, added local information supplied by a committee of 'Sultans and Rajahs', and wrote it all up in two papers (the first on mammals, the second on birds and miscellaneous fauna). The collections were despatched to the India Museum in London in two batches in 1820, on the ships *Mary* and *London*; the papers were read to the Linnean Society and published under Raffles' name in the Society's *Transactions*. The drawings and specimens remained in the India Museum but the

latter, doubtless preserved using inadequate techniques in Bencoolen, and poorly stored in London, were subject to what might be called 'invertebrate revenge' – from moths, dermestid beetles and other plagues visited upon preserved animal skins.

In 1819 Horsfield left Java for London, and immediately started working at the India Museum on his collections, resulting in his *Zoological Researches in Java* (1821–4), and two parts of a catalogue of butterflies (1828–9). In 1836, at an age when most people would be thinking of retiring (63), he became superintendent of the India Museum, a post he held until very shortly before his death some twenty-three years later. In this productive old age it fell to him to publish catalogues of the Museum's zoological collections – mammals (1851), and, with his assistant Frederic Moore, birds (1854, 1856–8) and butterflies (1857–9). In these catalogues are 19 mammal and 51 bird species noted as 'Raffles' collections. Tragically the India Museum began to be broken up in 1860, when it had to move out of East India House (prior to its demolition), and at this point some zoological material went to the British Museum. Over the next two decades, before its final demise in 1879, the unfortunate India Museum was moved (and whittled) several times, and the bulk of its zoological collections, including the Raffles mammals, were accessioned by the BM in 1880. Of surviving Raffles mammals nine species are represented at NHM, including the types of an otter (*Lutra simung*) and a squirrel (*Sciurus vittatus*); but the specimens of the sun bear, tapir and siamang, among others catalogued by Horsfield, have not survived.

The bulk of Raffles' post-*Fame* Sumatran zoological collections (including mammals, birds, reptiles, insects, zoophytes, etc.), was presented in 1827 by Lady Raffles to the Museum of the Zoological Society of London. These numerous and important specimens were listed, also by Horsfield, in the catalogue of Raffles' zoological collections appended (anonymously) to Lady Raffles' *Memoir*. Listed as being in the Zoological Society Museum were 173 species of bird and 53 of mammal (though these also include Horsfield's earlier Javanese material); of purely Sumatran specimens were about 50 species of fish, and over 20 species of reptile, and more than 700 of insect (320 beetles, 200 butterflies) that were probably also in the Zoological Society Museum. In 1855 this museum was also dispersed – the types and some other specimens, together valued at £500 – going to the BM. A large amount of the remainder (to a value of £700) was split between the new University Colleges of Galway and Cork, and other material went to other British museums.

Raffles bird specimens from both the disbanded museums are still at NHM, including the types of 11 species (and probably other non-types that are harder to track). The Raffles family retained some natural history specimens, which also eventually ended up in the national collection. In 1839 Lady Raffles donated some Sumatran mammals to the BM (Lankester, 1906), but which seem not to have survived. And in 1947 the Drake family still had a cabinet of butterflies, and also some shells and fossils. What was by then the British Museum (Natural History) did not want the butterflies, but accepted the molluscs, of which 39, including one type, are extant at NHM.

JAMESON'S EDINBURGH MUSEUM

It is not completely certain that Raffles ever met Robert Jameson, Regius Professor of Natural History at Edinburgh University from 1804 to 1854. Although not yet housed in the magnificent purpose-built building designed by W.H. Playfair, and opened in 1820, the Museum Jameson built up from 1804 was well known and widely advertised, so, given his interests in natural history, Raffles might well have visited it on his brief passage through Edinburgh in 1817. Certainly he knew of Jameson through his naturalists Arnold and Jack, and in a letter of 8 December 1822, Raffles told Wallich that 'The Skeleton of another [dugong] is now in preparing for the Edinburgh Museum, so that you may announce it as going home from hence in the *Venilia*'. In 1825 Raffles corresponded with Jameson, and his curator William MacGillivray, about the donation of specimens, and Jameson replied asking for anything that could be spared, informing Raffles that he had been elected an honorary member of the Wernerian Natural History Society in

recognition of his contributions to Natural History (BL MSS Eur. D 742/3). It is not certain how many specimens were among those registered as a 'Collection of Quadrupeds, birds and sponges. Presented by Sir Stamford Raffles' (NMS z.1825.31.1). The University Museum was incorporated (with a certain bitterness) into the Edinburgh Museum of Science and Art in 1865, and the remaining collections survive in what is now the National Museums of Scotland. Unfortunately the early records and poor labelling do not allow of unambiguous identification of Raffles specimens, but the dugong skeleton (NMS z.1822.4), originally registered as 'Dugong or Mermaid from Java', under the name Capt. Farquhar, may be the Raffles 1822 specimen, (the donor, perhaps, being the ship's captain who transported it), and a mounted specimen of a stink badger might well be part of the 1825 donation.

In NMS is another zoological specimen related to Raffles' 'circle' (Fig.24). The Marchioness of Hastings, who was responsible for Jack's herbarium specimens being sent to the Museum, also presented zoological material from India and Southeast Asia. In June 1821 in the *Edinburgh Magazine and Literary Miscellany* (8: 561) the Marchioness is reported to have presented a 'perfect skeleton of the Tapir of Malacca, the only one ever brought to Europe'. Neither exact provenance, nor collector's name, is recorded (the aristocratic intermediary was doubtless thought more important), but given his interest in the animal (which he was the first to describe, though not publish) William Farquhar is a possibility. Although in Singapore at this date, he could easily have arranged for a specimen from Malacca, if that really was the source; but another possibility is that the tapir was a Sumatran specimen, and that Raffles or Jack was involved (Raffles had sent a stuffed specimen to Prince Leopold in 1820). The specimen, of which the skull survives (NMS z.1820.8), is of an immature animal (which, interestingly bears marks of a tiger attack), so cannot be the captive specimen of the Barrackpore menagerie (of which there is an illustration in the Hastings collection BL Add. Or. 4973).

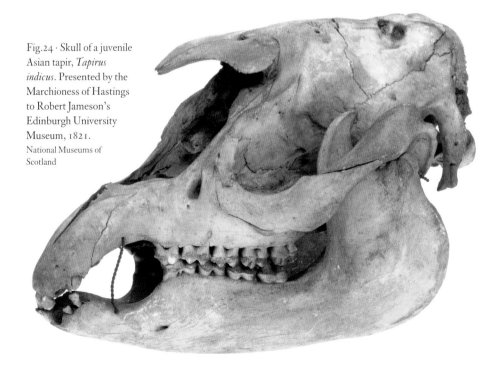

Fig.24 · Skull of a juvenile Asian tapir, *Tapirus indicus*. Presented by the Marchioness of Hastings to Robert Jameson's Edinburgh University Museum, 1821.
National Museums of Scotland

VI The Artists

As described in Chapter II documentation exists for the employment of artists by Raffles for three locations and periods: Malacca in 1810/11, Bencoolen 1818–24, and Singapore in 1822/3. In the first of these his *munshi* Abdullah was very specific that the artist was 'from Macao' and specialised in fruits and flowers (perhaps the black-border series of NHD 48). The nationality of the team of 'five or six' artists recorded by Lady Raffles at Bencoolen was not noted, but Raffles in a letter to Banks of 26 VII 1820 (NHM R. Brown MSS B.69 folder xiv) referring to his work with Jack at Bencoolen wrote of his intention to study 'fish and Madrepores [corals] ... of the latter we have a great variety and I hope to succeed with my Chinese Draftsmen in making coloured Drawings of them'. Similarly, in a letter to Wallich (written off the coast of Borneo, after he had left Singapore in 1823), Raffles stated that the artist painting flowers for him in Singapore had been a 'China Man'. This is hardly surprising as in the East Indies there was, by this stage, a long tradition of using Chinese artists to draw natural history subjects, just as there was of using Indian artists in India. Chinese artists had been used for such a purpose by William Marsden, a predecessor of Raffles at Bencoolen in 1771–9 (now NHD 1 & 2).

This Chinese school of natural history painting for Western patrons has been discussed by various authors including Mildred Archer (1962: 59–62), Hulton & Smith (1979: 49–50), Gill Saunders (1995: 78–81) and Fa-Ti Fan (2004: 40–57), and in greater detail, and of more particular relevance to the Raffles collection, by Kwa Chong Guan and Ivan Polunin (in Khim, 1999: 27–39). The history goes back to 1698, when James Cunninghame obtained nearly 800 Chinese drawings of flowers for James Petiver, which ended up in the collection of Sir Hans Sloane (and therefore, eventually, the NHM). It has been noted by all of these authors that both the painting style (particularly the emphasis on fine brushwork known as *gongbei*), and the subjects – including 'flowers and birds' (*hua niao*) and 'vegetables and fruits' (*su guo*) – reaching back to the Song Dynasty (960–1279) – predisposed Chinese artists to be able to adapt more easily than Indian ones to the sort of work required by British patrons. It is often rather glibly implied that it is easy to recognise a Chinese style in such natural history paintings, but Mildred Archer was more honest in admitting that 'sometimes the difference between a Chinese drawing and an Indian is slight'. This notwithstanding, the characteristics of the Chinese natural history style have been given by Saunders as a 'subtle, confident use of watercolour ... showing the underside of leaves by using a paler shade of solid green ... the inclusion of blemishes, the marks of disease, age or insect damage, on the leaves or fruit'. Additional characteristics given by Archer are, a 'greater softness of texture ... a more shiny surface and a less wiry line ... branches meander in more hesitant rhythms. Shading is softer and less abrupt and twigs and branches are touched with silver grey White flowers are usually given circular blue backgrounds'.

In the 1770s Joseph Banks commissioned the Scottish surgeons John and Alexander Duncan to obtain Chinese drawings for him in Canton (Guangzhou), and their own volume of breathtakingly subtle paintings, mainly of cultivated plants, is on permanent loan to the RBGE. It is by no means impossible that the Duncans, who retired to Arbroath, could have known William Hunter who came from neighbouring Montrose. With the Hunter paintings in the Raffles collection (NHD 49.1–24) we come to the problematic hybrid 'Straits Style', and the vexed question: Indian or Chinese? Yu-Chee Chong (1987), who has seen vast amounts of Chinese export art, attributed them 'undoubtedly' to the 'artists employed by Dr. William Roxburgh', that is, to Indian artists. However, the Chinese paper, the blue clouds around the white flowers, the fine painting of the *Callicarpa* (NHD 49.5) and *Clerodendrum* (NHD 49.11) and the elegant *mise en page* contradict this and suggest a

Chinese artist – despite the 'harder' outline and colouring (which could simply be dictated by the nature of the plant depicted), and the use of gum arabic.

At almost exactly the same time that Hunter was in Penang, William Kerr, a Kew gardener sent to China by Banks, sent back Chinese drawings to the EIC. In 1804, of particular interest in the present context, was a set of 'Drawings of Malacca Fruits' (presumably similar to the Raffles 'black-border' set), and in 1806 a further collection, almost certainly the 392 drawings now at Kew annotated 'Chinese Plants'. Of work produced for EIC servants based in China, the most extensive series, and most directly comparable in inspiration and extent to Raffles', was that commissioned by John Reeves, a tea inspector, who went to Canton in 1812. These superb drawings of fish, birds and plants are now split between the NHM and the Lindley Library of the Royal Horticultural Society.

These Chinese works, as has been frequently pointed out, are hybrid in nature: between east and west; naturalism and stylization; art and science. But as suggested above, a further element of hybridity seems to enter the picture when members of this artistic community reached the Straits of Malacca. It should be borne in mind that British involvement in the area was mediated through the EIC bases of Calcutta and Madras. Here it is necessary to mention Richard Parry, a predecessor of Raffles as Resident at Bencoolen, 1807 to 1811. Parry took with him an Indian artist to draw plants and animals who, unusually, signed some of his works – Manu Lal, native of Patna. 14 of his animal drawings survive at BL (NHD 2) and around 125 of plants (including an extensive series of nutmegs) at Kew. But this use of an Indian artist in the region has been cited, by Archer and others, as exceptional.

When Raffles stayed with William Farquhar in Malacca in 1810/11, Farquhar was actively building up his collection of natural history drawings; this collection is therefore of particular importance and relevance to the Raffles drawings. It has been sumptuously reproduced and closely analysed by Ivan Polunin and Kwa Chong Guan (in Khim, 1999): Polunin unequivocally attributes the entire collection of 477

drawings to a mere two Cantonese artists (whom he charmingly denominates 'Stumpy' and 'Tendril'). To the present author this seems unlikely in view of the diverse styles of the drawings (there are surely at least two botanical artists, and the fish are surely by a different hand from the 'birds and flowers', different again from the artist of the animals in landscapes?). Guan, moreover, noted two characteristics of the works that go against traditional Chinese style and technique, as specified in enormously influential artists' manuals such as the *Mustard Seed Garden Manual of Painting* (1679, with at least 20 subsequent editions) and the *Ten Bamboo Studio Album*. These are the use of pencil underdrawing (explained as being necessary to show Farquhar drafts, and therefore allow for corrections); and the highly stylized roots of some of the trees 'like the teeth of a garden rake' – in absolute contradiction of the strictures laid down in the *Mustard Seed Manual*, and unlike the varied and gnarled roots of traditional Chinese representation. The whole question of attribution is vexed and probably irresolvable and, from the Chinese annotations, it seems beyond question that Farquhar used chiefly Chinese artists. But could there also have been an Indian influence? Farquhar was in Madras long before he went to Malacca, and might he, like Parry, have taken at least one painter with him, whose work might have modified the (also imported) Chinese style? It should be remembered that Indian influence in the region (in matters of trade, culture and, historically, religion) was huge, and of very long standing. Subjects are also suggestive here. As Polunin pointed out the Jerusalem thorn (*Parkinsonia aculeata*) and two of the palms (*Borassus flabellifer* and *Phoenix sylvestris*) are unlikely to have been painted in Malacca. These species, by contrast, are common around Madras, which Farquhar revisited in 1816 (he could, of course, have taken a Chinese painter back there from Malacca). But there certainly was at this time in South India, especially Tanjore, a school of Indian painters able to turn their hands to natural history, such as the plants and the falcons (not to mention a cassowary) made for Raja Serfoji of Tanjore (NHD 7). Here this can only be left in the air as a question that merits investigation by more competent art historians than the present author, but with a plea that

Fig.25. Detail of silver leaf from drawing NHD 47.36.

they should look west as well as east when accounting for the 'Straits Style' of natural history painting.

RAFFLES' ARTISTS

Given the conventions and social relations of the time it is scarcely surprising that neither Raffles nor his wife recorded the name of any of his draftsmen, far less details of their methods or practice. One can only speculate on the operations of the team of five or six working at Bencoolen – did they, as in the workshops of Canton, each have a specialism, as draftsman or colourist, or was the breakdown by subject matter – one doing birds, another plants, and yet another the 'fish and madrepores'? The 'Straits School' hybridity is also evident in the Raffles' drawings – for example, the thick gum arabic used on the black-border fruit series is atypical of otherwise similar work for other patrons. And then there is the enigmatic 'J. Briois'.

J. BRIOIS

The very fact that he signed his work shows him to be exceptional, and, despite Mildred Archer's unsupported speculation that he was of mixed race, 'the son of a French father but ... born and bred in Bencoolen', surely more likely to indicate that he was, simply, French. Of possible relevance here is the fact that there was a family of this name in Bengal (doubtless Calcutta) at this time: a Madame Briois married a Monsieur J.B. de Fontaine on 17 March 1816 (EI Register 1817, ed 2 p 468) and a Miss Virginia Briois died on 4 November 1817 (EI Register 1818, ed 2 p 474). There is unfortunately no record of these people in the Company's records of Burials or Marriages (which might have given further details), possibly because they were Roman Catholic.

Archer noted an hybridity in Briois' bird drawings – 'the placing of the birds on stumps or branches lightly indicated in pencil recalls European bird drawings of the late eighteenth century. But the meticulous detail with which the paintings are executed giving the illusion of real feathers is characteristic of Chinese artists'. However, the latter is also characteristic of Indian bird drawings, and it must be pointed out that it is even harder to distinguish Chinese from Indian bird paintings, than it is ones showing plants! There are strong similarities between Briois' style and that of the bird drawings in the Barrackpore ('Gibbons & Buchanan' – NHD 2) and Wellesley (NHD 28) collections – both in technique and layout. For example, an identical layout, on a forked (pencil) branch, is seen in the drawing of the pair of common ioras in NHD 47.3 and NHD 2.206. It has been suggested above that Briois is probably the artist of the drawings made for Diard & Duvaucel (NHD 4). Might the French zoologists, who certainly went to Barrackpore to study the captive tapir, have found Briois working there as a draftsman and engaged him to accompany them to Sumatra? The arrangement for the zoological establishment was that Raffles paid Diard & Duvaucel a monthly allowance of 500 dollars on behalf of Government (later disallowed), and this specifically included 'the draftsmen, &c. *engaged by you*' as expressed in a letter of 7 March 1819 (*Memoir* p 372, emphasis added). Although there is no mention of Briois in their correspondence published by Lady Raffles, or of his being on the boat from Calcutta with Jack and the zoologists, it seems possible that he was recruited there, made the drawings sent back in 1820, and stayed on in Bencoolen and made the post-*Fame* drawings for Raffles.

Only two traces of Monsieur Briois have been found in the archives; firstly, his name is on a list of (entirely European) staff working in the Resident & Secretary's Office at Bencoolen on 1 February 1824, his salary being Madras Rupees 100 (APAC P/11/20 no 36). Secondly, he was considered of sufficient status as an 'inhabitant' of Bencoolen to sign the eulogy presented to Raffles on 26 January 1824, prior to his ill-fated departure from the settlement (l.c. no 43).

Use of silver leaf

One of the most notable features of Briois' bird paintings is his extensive use of silver- (and occasionally) gold-leaf. The use of precious metals in zoological painting has seldom been noted, but Fa-Ti Fan (2004: 56) stated that 'to reproduce the iridescent hues of fish scales, the [Chinese] artists [in Canton] made use of silver and gold powder'. Gold-leaf is also found, but very sparingly, in two pheasant drawings in the Wellesley collection (NHD 28 5, 9). Briois' use was on a far larger scale, though with unhappy subsequent results as the silver has tarnished, and intended iridescence turned to grey sludge (Fig.25).

A KOW

An important discovery in the Singapore records (APAC G/34/156 ff. 144/5) made by Mildred Archer, when working on this collection in the early 1970s, throws light on at least one of Raffles' Chinese artists. On 20 February 1828 Robert Fullerton (Governor of the Straits Settlements, based in Penang) proposed that 'A Kow' should be transferred from Singapore to the Botanical Establishment at Prince of Wales Island, employed on a salary of 70 Rupees per month. Fascinatingly this artist possessed a testimonial from John Prince, dated 25 October 1827, to the effect that he had 'been employed as draftsman under the late Governor at Bencoolen', and by Prince at Singapore, that he was 'proficient in the art, and an exceeding well behaved, attentive man'; under the Singapore Government he 'drew 100 Madras Rupees per month' and from Prince '20 Dollars per month'. In Chapter 11 we encountered John Prince, and

the uncharitable comments upon him made by William Jack on their trip to Nias. Raffles left Prince, as the most senior civil servant, in temporary charge of Bencoolen in 1824, and Prince subsequently went on to Singapore. Mrs Archer was cautious – allowing only that 'some of the present drawings may well be the work of this 'A Kow''. But the discovery of a drawing at Kew of *Strophanthus caudatus* from Prince's collection (Fig.5), more elaborate in composition, but undoubtedly in the same very fine hand as the Raffles drawing (NHD 48.21), makes it almost beyond doubt that A Kow is the artist of the whole of the botanical 'post-*Fame*' set NHD 48.1–27. Of this man's name Frances Wood has suggested that the 'A' might represent a title, perhaps equivalent to 'Mr' and that 'Kow' could be a Cantonese version of the surname pronounced in the north as 'Gao'.

Appendix of Duplicates and Miscellaneous Material

Nectarinia jugularis (*L.*)

Paper: cream board; J WHATMAN 1816
Watercolour, bodycolour, pencil, silver-leaf and gum arabic; 238 × 364 mm
Almost certainly by J. Briois
NHD 47.2

Cissa chinensis (*Boddaert*)

Inscribed in Jawi: *sijerai*
Paper: cream, wove; no watermark
Watercolour, bodycolour and pencil; 270 × 370 mm
Almost certainly by J. Briois
NHD 47.14

Pycnonotus bimaculatus (*Horsfield*)

Probably a copy of NHD 47.17
Paper: cream, wove; J WHATMAN 1820
Watercolour, bodycolour and pencil; 266 × 368 mm
By J. Briois (signed)
NHD 47.18

Ceyx erythaca (*L.*)

Probably a copy of NHD 47.9
Inscribed in Jawi: *burung udang*
Paper: cream, wove; no watermark
Watercolour, bodycolour, pencil, silver- and gold-leaf, and gum arabic; 220 × 250 mm
Almost certainly by J. Briois
NHD 47.10

Cymbirhynchus macrorhynchos (*J.F. Gmelin*)

Probably a copy of NHD 47.15
Paper: cream, wove; no watermark
Watercolour, bodycolour, pencil, silver-leaf and gum arabic; 244 × 365 mm
Almost certainly by J. Briois
NHD 47.16

Caloenas nicobarica *L.*

Inscribed in Jawi: *dundun*
Paper: cream, wove; no watermark
Watercolour, bodycolour, pencil, gold- and silver-leaf and gum arabic; 334 × 526 mm
Almost certainly by J. Briois
NHD 47.37

Lophura ignita (*Shaw*)

Exhibited: *The Golden Sword, Stamford Raffles and the East*, British Museum XII 1998 – IV 1999
Paper: cream, wove; J WHATMAN 1820
Watercolour, bodycolour, pencil, gold, and silver-leaf and gum arabic; 430 × 532 mm
Almost certainly by J. Briois
NHD 47.44

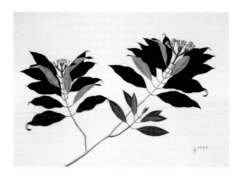

Syzygium aromaticum (*L.*)
Merrill & L.M. Perry

Annotation: Clove (pencil)
Paper: cream, wove; no watermark
Watercolour and bodycolour over pencil, leaves heightened with thick gum arabic; 465 × 626 mm
Probably by a Chinese artist
NHD 48.29

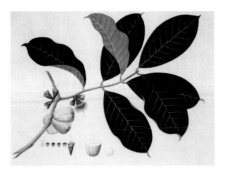

Syzygium malaccense (*L.*)
Merrill & L.M. Perry

Paper: cream, wove; no watermark
Watercolour and bodycolour over pencil, leaves heightened with thick gum arabic; 460 × 618 mm
Probably by a Chinese artist
NHD 48.36

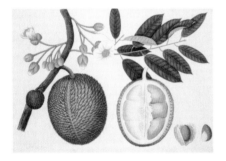

Durio zibethinus *L.*

Exhibited: *The Golden Sword, Stamford Raffles and the East*, British Museum XII 1998 – IV 1999; *Spice of Life, Raffles and the Malay World*, Central Library, Liverpool VIII–X 2007
Inscribed in Jawi: *durian bakul* [= basket durian]
Paper: grey, laid; S WISE & CO 1822
Watercolour and bodycolour over pencil, heightened with gum arabic; 372 × 538 mm
Probably by A Kow
NHD 48.20

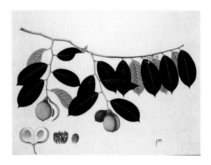

Myristica fragrans *Houttuyn*

Annotation: Nutmeg (pencil)
Paper: cream, wove, ?Oriental; no watermark
Watercolour and bodycolour over pencil, leaves heightened with thick gum arabic; 465 × 618 mm
Probably by a Chinese artist
NHD 48.34

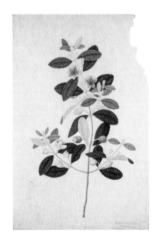

Rhodomyrtus tomentosa
(*Aiton*) *Hasskarl*

Paper: Chinese
Watercolour and bodycolour over pencil; 472 × 308 mm
Probably by a Chinese artist
NHD 49.7

Syzygium aromaticum

(L.) Merrill & L.M. Perry

Paper: Cream, wove; blind stamp 'Bristol Board',
J WHATMAN 1816
Watercolour and bodycolour over pencil, heightened
with gum arabic; dissections ink and ink wash;
370 × 392 mm
Probably by A Kow
NHD 49.25

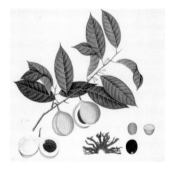

Myristica fragrans *Houttuyn*

Paper: Cream, wove; blind stamp 'Bristol Board',
J WHATMAN 1816
Watercolour and bodycolour over pencil, height-
ened with gum arabic; dissections ink wash;
370 × 383 mm
Probably by A Kow
NHD 49.26

Aglaia cucullata *(Roxburgh) Pellegrini*

This drawing is a copy of part of plate 258 from
volume 3 of Roxburgh's *Plants of the Coast of
Coromandel*, published in 1820. This appears
to belong with NHD 49.28, and was made after
Raffles' death. The name is odd and must be
a later annotation; it was not taken from the
publication, where it was called *Amoora cucul-
lata*. In fact no such binomial as *Sterculia indica*
existed at that time.

Annotation: Sterculia Indica (ink)
Paper: cream, wove; blind stamp 'TURNBULL
SUPERFINE LONDON BOARD', watermark
J WHATMAN 1829
Watercolour and bodycolour over pencil;
558 × 444 mm
Unknown English artist
NHD 49.29

Prunus persica *(L.) Batsch*

This unfinished drawing of a peach post-dates
Raffles' death. It is similar in style to the work
of the fruit painter William Hooker but is more
likely (as with its partner *Aglaia cucullata*, NHD
49.29) to be a copy from an as yet unidentified
publication.

Paper: cream, wove; blind stamp 'TURNBULL
SUPERFINE LONDON BOARD', WATERMARK
J WHATMAN 1829
Watercolour and bodycolour; 558 × 444 mm
Unknown English artist
NHD 49.28

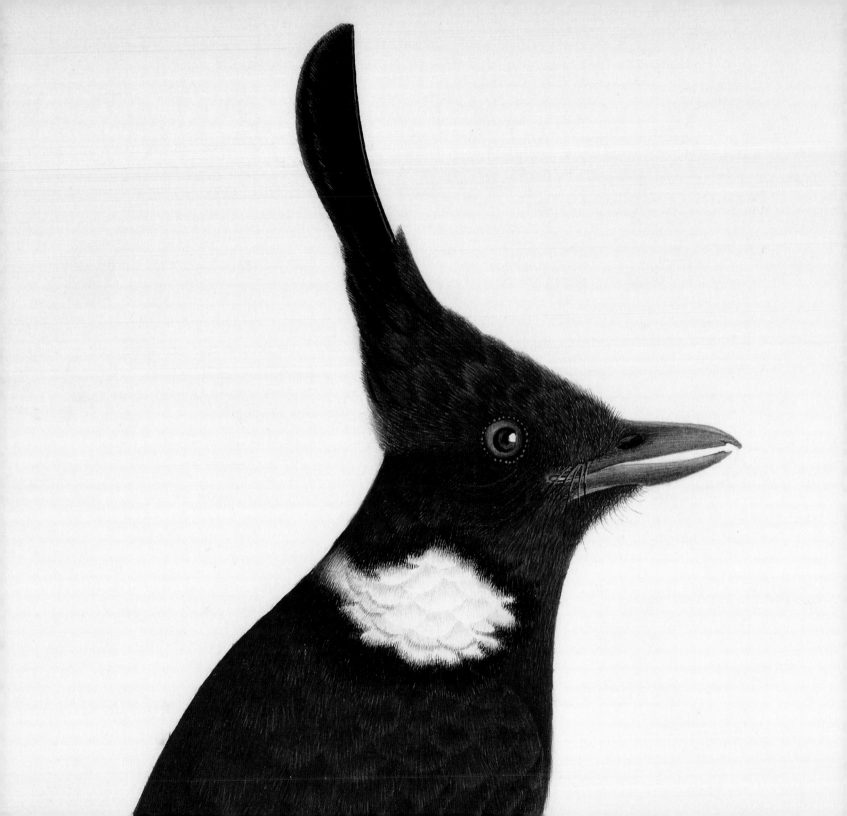

Selected Bibliography

ARCHER, M. (1962)
Natural History Drawings in the India Office Library. London: H.M.S.O.

ARCHER, M. & BASTIN, J. (1978)
The Raffles Drawings in the India Office Library London. Kuala Lumpur: Oxford University Press.

BARLEY, N. (ED.) (1999)
The Golden Sword: Stamford Raffles and the East. London: British Museum Press. [Includes a chapter 'Raffles the Naturalist' by John Bastin].

BASTIN, J. (1973)
Dr Joseph Arnold and the discovery of Rafflesia Arnoldi in West Sumatra in 1818. *Journal of the Society for the Bibliography of Natural History* 6: 305–372.

BASTIN, J. (1981)
The letters of Sir Stamford Raffles to Nathaniel Wallich 1819–1824. *Journal of the Malaysian Branch of the Royal Asiatic Society* 54: 1–73.

BASTIN, J. (1990)
Sir Stamford Raffles and the study of natural history in Penang, Singapore and Indonesia. *Journal of the Malaysian Branch of the Royal Asiatic Society* 63: 1–25.

BASTIN, J. (1994)
Lady Raffles: by Effort and Virtue. Singapore: National Museum.

BROWN, R. (1821)
An account of a new genus of plants, named Rafflesia. *Transactions of the Linnean Society* 13: 201–234, tt. 15–22. [Also a preprint].

BROWN, R. (1844)
Description of the female flower and fruit of Rafflesia Arnoldi, with remarks on its affinities; and an illustration of the structure of Hydnora africana. *Transactions of the Linnean Society* 19: 221–247, tt. 22–30. [Also a preprint].

BURKILL, I.H. (1916)
William Jack's letters to Nathaniel Wallich, 1819–1821. *Journal of the Straits Branch of the Royal Asiatic Society* 73: 147–268.

BURKILL, I.H. (1935)
A Dictionary of the Economic Products of the Malay Peninsula. 2 vols. London: Crown Agents for the Colonies.

CHONG, YU-CHEE (1987)
Exploring the East Indies. London: Yu-Chee Chong.

CORNER, E.J.H. (1951)
Wayside Trees of Malaya, second edition, 2 vols. Singapore: Government Printing Office.

CORNER, E.J.H. (1964)
The Life of Plants. London: Weidenfield & Nicolson.

CORNER, E.J.H. (1975)
Prototypic organisms XIII: tropical trees "thick twig, big leaf". *Theoria to Theory* 9: 33–43.

COWAN, J.M. (1954)
Some information on the Menzies and Jack collections in the herbarium, Royal Botanic Garden, Edinburgh. *Notes from the Royal Botanic Garden Edinburgh* 21: 219–227.

CRIBB, P.J. (2002)
Hugh Low's plant portraits, in *A Botanist in Borneo: Hugh Low's Sarawak Journals 1844–1846* (ed. R.H.W. Reece), pp. 109–134, tt. 1–66. Kota Kinabalu: Natural History Publications (Borneo).

DESMOND, R. (1982)
The India Museum 1801–1879. London: H.M.S.O.

FAN, FA'TI (2004)
British Naturalists in Qing China: Science, Empire, and Cultural Encounter. Cambridge, Massachusetts: Harvard University Press.

FORMAN, L.L. (1989)
The illustrations to William Hunter's 'Plants of Prince of Wales Island'. *Kew Bulletin* 44: 151–161.

GALLOP, A.T. (1994)
The Legacy of the Malay Letter. London: The British Library for the National Archives of Malaysia.

GALLOP, A.T. (1995)
Early Views of Indonesia. London: The British Library & Jakarta: Yayasan Lontar.

HOOKER, W.J. (1835)
... a brief memoir of the author [William Jack], and extracts from his correspondence. *Companion to the Botanical Magazine* 1: 121–147.

HORSFIELD, T. (ED.) (1821–4)
Zoological Researches in Java, and the Neighbouring Islands. [Facsimile edition, with biographical introduction by John Bastin. Singapore: Oxford University Press Pte. Ltd., 1990. Introduction reprinted for the author as *The Natural History Researches of Dr Thomas Horsfield (1773–1859), first American naturalist of Indonesia*, Eastbourne, 2005].

HORSFIELD, T. (1851)
A Catalogue of the Mammalia in the Museum of the Hon. East-India Company. London: W.H. Allen & Co.

HORSFIELD, T. & MOORE, F. (1854, 1856–8)
A Catalogue of the Birds in the Museum of the Hon. East-India Company. 2 vols. London: W.H. Allen and Co.

DEL HOYO, J., ELLIOT, A. & CHRISTIE, D. (EDS) (1992–2007)
Handbook of the Birds of the World. 12 vols [continuing]. Barcelona: Lynx Editions.

HULTON, P. & SMITH, L. (1979)
Flowers in Art from East and West. London: British Museum.

JACK, W. (1820–2)
Descriptions of Malayan Plants I–III. Facsimile reprint of articles in *Malayan Miscellanies*. Leiden: Boerhaave Press, 1977. [Reprinted, with 'unpublished appendix', edited by W.J. Hooker in *Botanical Miscellany* 1: 273–90, 1830; 2: 60–89, 1833. *Journal of Botany* 1: 358–380, 1834. *Companion to the Botanical Magazine* 1: 147–157, 1835; 219–224; 253–272, tt. 14, 15, 1836].

JACK, W. (1823)
On the Malayan species of Melastoma. *Transactions of the Linnean Society* 14: 1–22, t. 1.

JACK, W. (1823)
On Cyrtandraceae, a new Natural Order of plants. *Transactions of the Linnean Society* 14: 23–44, t. 2.

JACK, W. (1823)
Account of the Lansium and some other genera of Malayan plants. *Transactions of the Linnean Society* 14: 114–130, t. 4.

KHIM, G.G. (ED.) (1999)
The William Farquhar Collection of Natural History Drawings. 2 vols. Singapore: Goh Geok Khim. [With b/w reproductions of all drawings, and 139 in colour; notes on organisms and article on artists by Ivan Polunin; 'Drawing Natural History in the East Indies' by Kwa Chong Guan; and a biography of Farquhar by John Bastin. The last reprinted for the author as *William Farquhar: First Resident and Commandant of Singapore*, Eastbourne, 2005].

LAMBERT, A.B. (1828/9)
A Description of the Genus Pinus, second edition (folio), 2 vols. London: Messrs Weddell.

LANKESTER, E. RAY (ED.) (1906)
The History of the Collections Contained in the Natural History Departments of the British Museum, vol 2. London: Trustees of the British Museum. [The account of birds, pp. 79–515, is by R. Bowdler Sharpe].

MABBERLEY, D.J. (1985)
Jupiter Botanicus: Robert Brown of the British Museum. Braunschweig: J. Cramer.

MABBERLEY, D.J. (1999)
Robert Brown on Rafflesia. *Blumea* 44: 343–350.

MACKINNON, J. & PHILLIPPS, K. (1993)
A Field Guide to the Birds of Borneo, Sumatra, Java and Bali. Oxford: Oxford University Press.

MATTHEW, H.C.G. & HARRISON, B. (EDS) (2004)
Oxford Dictionary of National Biography. Vols 1–60. Oxford: Oxford University Press. [Articles on Hastings, Jack, Minto, Raffles, etc.].

MERRILL, E.D. (1952)
William Jack's genera and species of Malaysian plants. *Journal of the Arnold Arboretum*. 33: 199–251.

RAFFLES, SOPHIA, LADY (1830)
Memoir of the Life and Public Services of Sir Thomas Stamford Raffles, F.R.S. &c. London: John Murray. [Facsimile reprint, with introduction by John Bastin, Singapore: Oxford University Press, 1991].

RAFFLES, T.S. (1821)
Descriptive catalogue of a zoological collection, made on account of the Honourable East India Company, in the island of Sumatra and its vicinity *Transactions of the Linnean Society* 13: 239–274.

RAFFLES, T.S. (1822)
Second part of the descriptive catalogue of a zoological collection *Transactions of the Linnean Society* 13: 277–340.

RIDLEY, H.N. (1909)
Plants of Prince of Wales Island, from a MS. in the British Museum by Sir [sic] William Hunter, surgeon to the East India Company. *Journal of the Straits Branch of the Royal Asiatic Society* 53: 49–127.

SAUNDERS, G. (1995)
Picturing Plants: an Analytical History of Botanical Illustration. London: Zwemmer in association with the Victoria & Albert Museum.

SWEET, R. (1825)
Remarkable flower [*Rafflesia*]. *News of Literature and Fashion* 3(56): 10.

WELLS, D.R. (1999–2007)
The Birds of the Thai-Malay Peninsula. 2 vols. London: Christopher Helm.

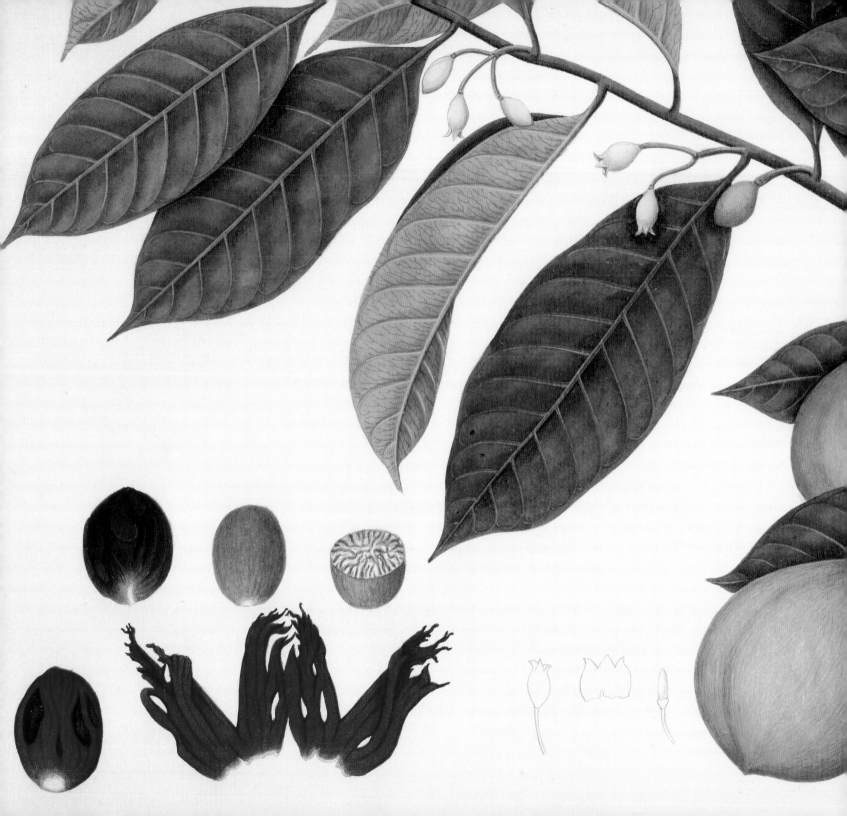

Index of Organisms

Echinosorex gymnura
(Raffles), *87*
Echites? paniculata sensu
Hunter, 145
elephant, 40
Euryandra scandens sensu
Hunter, 141
Eurylaimus lemniscatus
sensu Raffles, 60
faba foetida, *150*
Fagraea fragrans Roxb., *142*
fireback, crested, *82, 83, 168*
Flacourtia rukam Zoll.
& Moritzi, *126*
Flemingia fragrans Hunter, *142*
flycatcher-shrike, black-
winged, *50*
Freycinetia sumatrana
Hemsl., *107*
frogmouth
Blyth's, 66
Sunda, *66*
Gmelina
integrifolia Hunter, 130
villosa Roxb., *130*
Gnetum gnemon L., *134*
goat, wild of Sumatra, 88
Gomphia
malabarica DC., 103
sumatrana Jack, 103
gymnure, Raffles', *87*
'Halcyon collaris' sensu
Horsfield, 56
Harpactes
diardii (Temminck), *69*
diardii sumatranus
W.H. Blasius, 69
Hemipus hirundinaceus
(Temminck), *50*
Hibiscus tiliaceus L., *159*
hornbill, Sunda wrinkled, *85*

iora, common, *48*, 165
Iora scapularis, 48
Irena
puella (Latham), *64*
puella crinigera Sharpe, 64
jak fruit, *121*
jay, crested, *70*
kingfisher
blue-eared, *58*
collared, *57*
oriental dwarf, *57, 167*
langsat, *110*, 118
Lanius
insidiator sensu Raffles, 62
macrourus Raffles, 53
no. 12, 50
schach L., *71*
schach bentet (Horsfield), 71
Lansium domesticum
Corr. Serr., *110, 118*
laurel, Alexandrian, *97*
leopard, clouded, 44
Leptospermum spp., 74
Lithocarpus sp., *140*
Lophura
ignita (Shaw), *82, 83, 168*
ignita rufa (Raffles), 82
Loranthus spp., 48
Lutra
perspicillata Geoffroy, 90
simung Lesson, 90, 160
sumatrana Gray, *90*
mace, 113
magpie, green, *59*, 167
magpie-robin, oriental, *52*
mahogany, Bornean, 97
malkoha
chestnut-breasted, *79*
Raffles', *77*
red-billed, *79*

Mallotus cochinchinensis
(Lamarck) Müll.
Arg., 136, *137*
Mangifera
foetida Lour., 128
indica L., *128*
mango, *128*
mangosteen, 37, 38
Matonia pectinata R. Br., 27
Melastoma
gracilis Jack, 106
malabathricum L., *143*
Melia excelsa Jack, 18
Melodinus orientalis Blume, *112*
Merops
sumatranus Raffles, 54
viridis L., 54, 55
millet
foxtail, *30, 31, 117*
barnyard, 117
Mimosa
articulata Hunter, 129
jiringa Jack, 129
pedunculata Hunter, 150
minivet, scarlet, *72*
mistletoes, 48
moonrat, *87*
Murraya paniculata
(L.) Jack, *149*
Mustela nudipes Desmarest, 90
Myristica
fragrans Houtt.,
113, 168, 169
officinalis L. f., 113
myrtle
Chinese, *149*
woolly-leaved, *139, 168*
Myrtus tomentosa Ait., 139
Nectarinia
jugularis (L.), *48, 167*

jugularis ornatus (Lesson), 48
Nepenthes rafflesiana Jack,
33, 36, 45, 158, 159
Nephelium
lappaceum L., *12, 123*
mutabile Blume, 122
ramboutan-ake (Labill.)
Leenh., *122*
nightjar, savannah, 67
nutmeg, 26, 38, *113,
158, 168, 169*
orang utan (Bornean),
19, 28, 92, 158
orchid, scorpion, *109*
oriole
black-naped, *65*
European golden, 64
Oriolus
chinensis L., 64, 65
chinensis maculatus
Vieillot, 64
otter, hairy-nosed, *90*
Ouratea
crocea sensu Burkill, 103
serrata (Gaertn.)
Robson, *103*
owl, bay, 76
Pandanus
odorus Ridl., 107
tectorius Parkinson, 107
Parkia speciosa Hassk., *150*
Parkinsonia aculeata L., *164*
parrot, blue-backed or
Müller's, *75*
partridge
grey-breasted, hill-, *80*
long-billed, *81*
peach, *169*
pepper, 34
Pericrocotus
flammeus (Forster), *72*

General Index